HAVANA
THEN & NOW

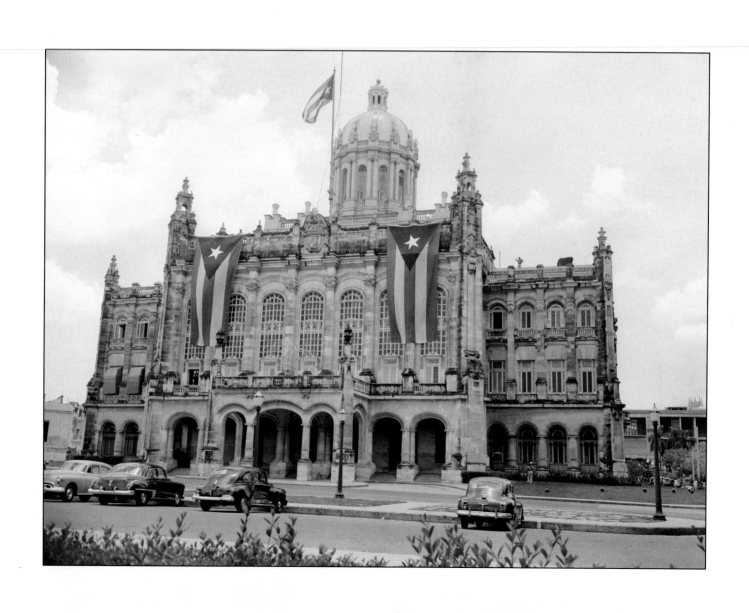

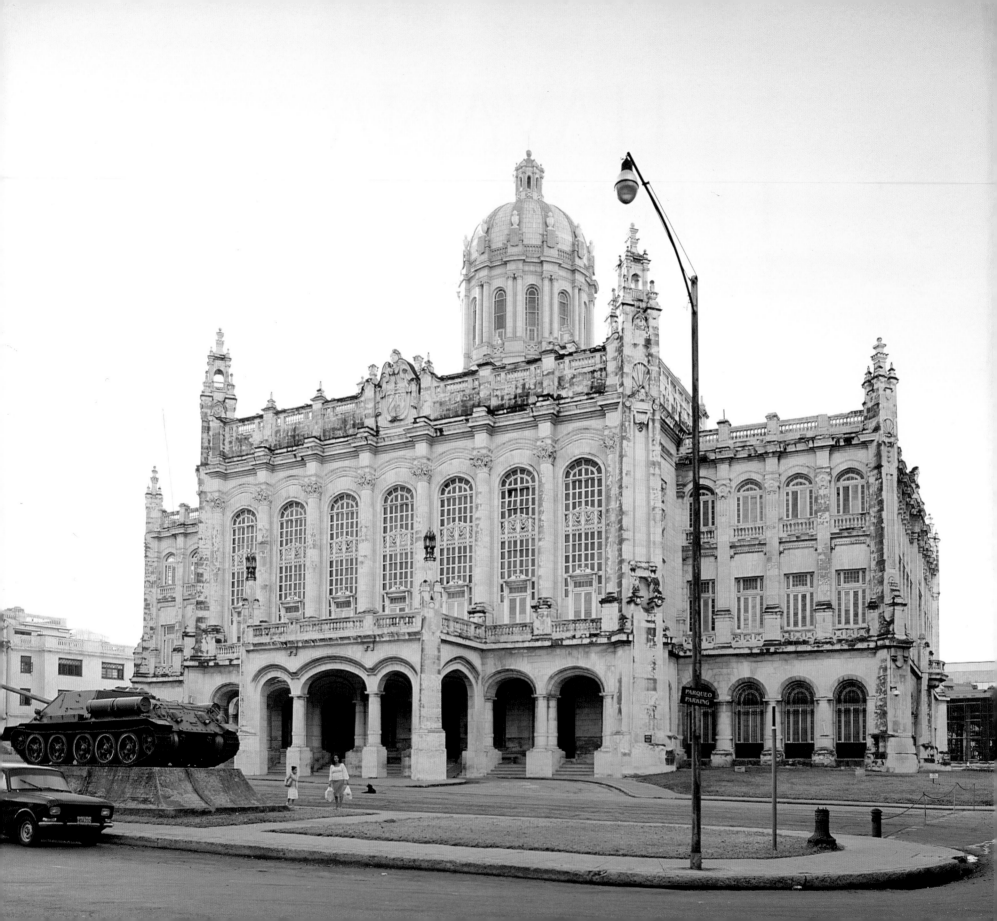

HAVANA
THEN & NOW

LLILIAN LLANES

THUNDER BAY
P·R·E·S·S

San Diego, California

Thunder Bay Press
An imprint of the Advantage Publishers Group
5880 Oberlin Drive, San Diego, CA 92121-4794
www.thunderbaybooks.com

Produced by PRC Publishing,
The Chrysalis Building
Bramley Road, London W10 6SP, United Kingdom

An imprint of Chrysalis Books Group plc

ISBN-13: 978-1-59223-207-9
ISBN-10: 1-59223-207-8

Library of Congress Cataloging-in-Publication Data
Llanes, Llilian
 Havana then & now / Llilian Llanes.
 p. cm.
 ISBN 1-59223-207-8
 1. Havana (Cuba)--Pictorial works. 2. Havana (Cuba)--History--20th century–Pictorial
works. 3. Architecture--Cuba--Havana--Pictorial works. 4. Historic
sites--Cuba--Havana--Pictorial works. I. Title: Havana, then and now. II. Title.

F1799.H343L53 2004
972.91'23064'0222--dc22 2004046018

Printed and bound in China

2 3 4 5 6 09 08 07 06 05

Acknowledgments:

Thanks to Dominica Ojeda and Haydée Gutierrez for their support and collaboration
in the production of this book. English translation by Eve Slateford. I would also like to
credit the following sources for providing information for this book: *La Habana Moderna*
by Alejo Carpentier, *American Architects in Cuba: 1900–1930* by José A. Gelabert-Navia,
La Habana (Biografía de una provincia) by Julio Le Riverend Brusone, *The City as
Landscape: Jean Claude Nicolás Forestier and the Great Urban Works of Havana, 1925–1930*
by Jean-François Lejeune, *Apuntes para una historia sobre los constructores cubanos* by
Llilian Llanes, *1898–1921: La transformación de la Habana a través de su arquitectura* by
Llilian Llanes, *El Vedado de los Generales y Doctores* by Llilian Llanes, *Memorias de una
cubanita que nació con el siglo* by Renée Méndez Capote, *Diccionario geográfico, estadístico,
histórico, de la Isla de Cuba* by Jacobo de la Pezuela y Lobo, *Problemas de la nueva Cuba* by
Foreign Policy Association, *La vivienda en Cuba en el siglo XX* by Roberto Segre, *La
urbanización de las murallas: dependencia y modernidad* by Carlos Venegas, *Arquitectura
cubana contemporánea* by Joaquín Weiss, and *La arquitectura colonial cubana* by
Joaquín Weiss.

Picture Credits:

The publisher wishes to thank the following for kindly supplying the photographs that
appear in this book:

© Corbis 28, 40, 50. © Bettmann/Corbis 12, 52, 62, 66, 76, 80, 92, 94, 98, 104, 122, 126,
132, 134, 138, 140. © E. O. Hoppé/Corbis 48. © Hulton-Deutsch Collection/Corbis 6,
20, 142. © Rykoff Collection/Corbis 54. © Underwood & Underwood/Corbis 38, 64.
© Library of Congress 10, 14, 18, 22, 26, 34, 36, 46, 58, 60, 70, 74, 88, 118, 120, and 136
All other "then" pictures courtesy of the author's collection.
All "now" pictures taken by Simon Clay (© PRC Publishing).

For cover photo credits, please see back flap of jacket.

Pages 1 and 2: The Presidential Palace then (photo: © Bettmann/Corbis) and the
same building today (photo: Simon Clay © PRC Publishing); see pages 104 and 105 for
further details.

INTRODUCTION

Havana is without doubt one of the most attractive cities in Latin America. From its founding to the present day, much has been written about the city by its many visitors and a catalog of rich and varied events have occurred here that transcend its size and importance.

This book will, of course, touch on the city's turbulent history, but its purpose is not to put forward new historical theories or document Havana's most significant events. It will instead illustrate—by means of archival and modern photographs—the changes this unique city has undergone. For many, Cuba is simply a political phenomenon, being one of the last bastions of Communism in the world, but this book will show that it should also be admired for its beauty. This book offers the reader a pictorial journey of Havana, and will explore the most important sites in the city. Not all features of the city's development can be included, but the works of art and sites chosen allow the reader to experience Havana's historic and artistic evolution up close.

One of the first cities founded by the Spanish in the New World, Havana has always been the most important city in Cuba. Its magnificent natural harbor and strategic location on the north of the island made it a vital port for Spanish ships on their way to overseas territories or sailing homeward laden with treasures from the Americas. Over time, the old city would be the object of desire for those disputing the ownership of territory in the New World.

Despite periods of great instability, Havana experienced substantial growth during the colonial period and found itself at the forefront of modern thinking. Being a stopping point for those either on the way to or returning from the New World, there existed a unique exchange of ideas with those from afar that kept the city up to date with worldwide advances. Havana thus became the most significant city on the island, so much so that when the port dwindled, it still remained a prominent trading post. The most important urban and architectural monuments in Old Havana date from the colonial era, spanning from the eighteenth to the mid-nineteenth century. This era brought great modernization to the city, which halted with the outbreak of the Cuban War of Independence in 1868. The end of the war in 1898 came with the intervention of the United States. At this point the young nation experienced a cultural change in direction, as, after traditionally being subject to European influences, it was now subject to American pragmatism.

When the republic was established in 1902, Havana started to blossom and quickly reestablished itself as the most forward-thinking city in the country. The speed of its expansion surprised visitors returning for the first time since the end of colonialism. In fact, the capital grew faster during the first few decades of the twentieth century than ever before. French urban planner J. C. N. Forestier was brought in to undertake the city's first modern urbanization program, the results of which can be seen today in modern Havana.

In the 1940s Havana continued to grow, but at the same rate as luxurious districts emerged, deprived pockets were also appearing. This was the first sign of the mounting inequality across the country. Despite this, the growth continued and Havana became a very desirable destination for tourists, especially for Americans looking to escape the winter and enjoy the warm Cuban climate.

Architecture in the nineteenth century had taken on a predominantly neoclassical appearance, but at the start of the twentieth century eclecticism was the language of choice and the inclusion of Beaux Arts thinking completely transformed construction in the newly established republic. With the arrival of new construction techniques from the United States, project times were cut and architectural styles in vogue there at the time were introduced. More and more international styles were introduced by Cuban architects, some of whom showed an authentic desire to rescue traditional elements of the local architecture. The wealth of formal ideas in Cuban architecture has created the unique environment that can be found in Havana's diverse urban landscape today.

At the end of the 1950s, two things happened to change the city's appearance: the first was the construction of the bay tunnel that further encouraged the city's expansion, this time toward the east; the other was the appearance, in the district of El Vedado, of high-rise apartment buildings, the construction of which changed the panorama of the city.

Even after the tremendous social changes the country had experienced at the end of the twentieth century, Havana appeared frozen in time architecturally. In fact, since the revolution in 1959, there has not been a construction plan implemented that was consistent with the significant population growth. All private initiatives having been rejected, planning has been left to the state, whose principal objectives have not been to stimulate Havana's growth but rather to develop the inner cities and rural areas. In some ways, during the second half of the twentieth century Havana was paying for its former privileges, as no architectural projects of note appeared. However, substantial renovation projects have begun in Old Havana, which was declared a UNESCO World Heritage Site in 1982. With the recent political changes and the shift toward tourism as the country's main source of income, there has been substantial interest in increasing the number of new high-rise hotels and renovating the existing ones. It could be said that the shortage of construction over the last forty years has had its advantages: in the first place, the city's expansion slowed; and secondly, none of the historic buildings and monuments have been demolished. The main colonial buildings, plus those found in what was called Habana Moderna during the time of the republic, have been restored or at least preserved. It can only be hoped that this sentiment continues, as there are very few cities in the world that have preserved the original appearance of their most prominent districts.

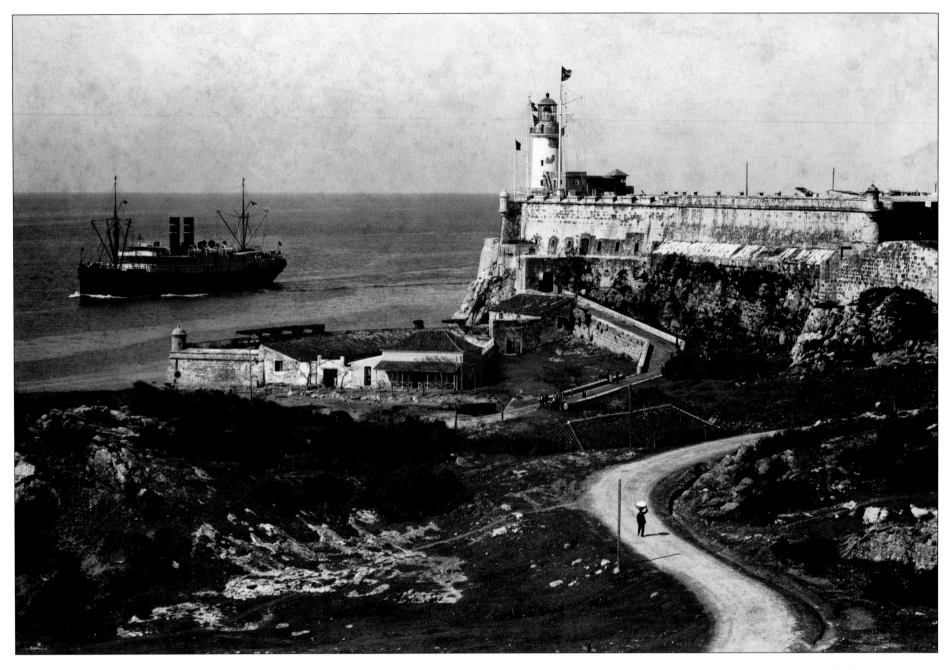

Built in the sixteenth century, the Castillo de los Tres Reyes del Morro rises strategically over the mouth of Havana Bay. It formed part of the system of fortifications designed by the Italian engineer Giovanni B. Antonelli to defend the Spanish Caribbean from frequent pirate attacks. It has an irregular shape due to the rocky outcrop on which it sits, jutting out over the cliff.

There are two gun batteries, and a deep moat completes the defenses that remained impregnable to enemy attack for many years. However, they finally succumbed to a siege by English soldiers in 1762 and could not repel the task force commanded by Admiral George Pocock that breached the walls of the castle before taking the city.

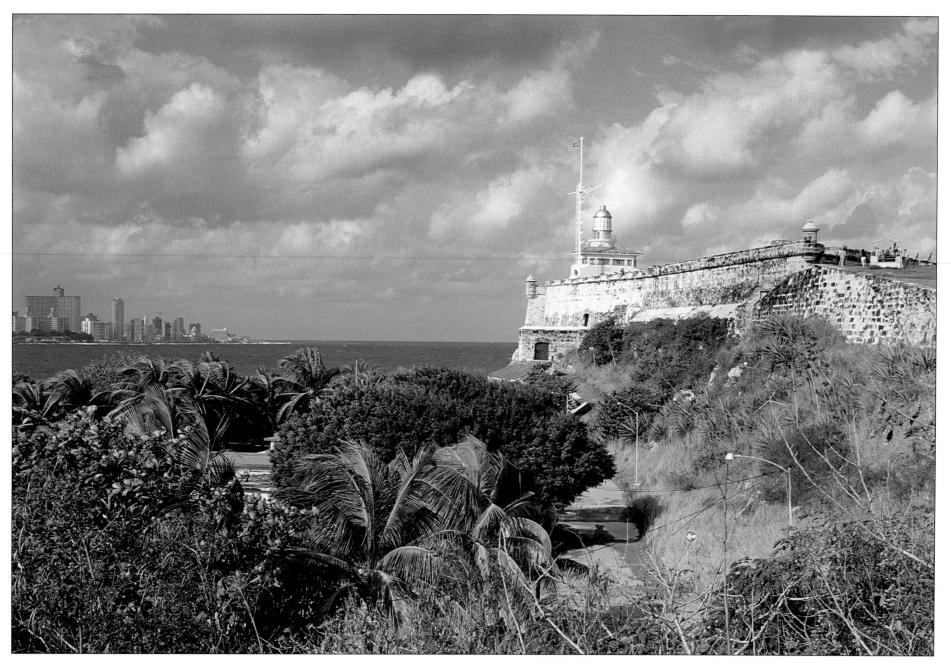

The Castillo del Morro is now a symbol of the city. The beacon of the Morro lighthouse—originally built in 1845 but modified over the years—shines out across the grounds and the fortress, which, despite measuring a hundred feet in height, can be covered by waves on particularly stormy days. Nowadays its only function is to guide ships safely around the bay, but it still houses the twelve cannons, known as the "Twelve Apostles," that were placed there at the beginning of the seventeenth century. Now declared a World Heritage Site along with other parts of colonial Havana, it was restored around 1990 by the Ministry of the Revolutionary Armed Forces, which currently owns the site.

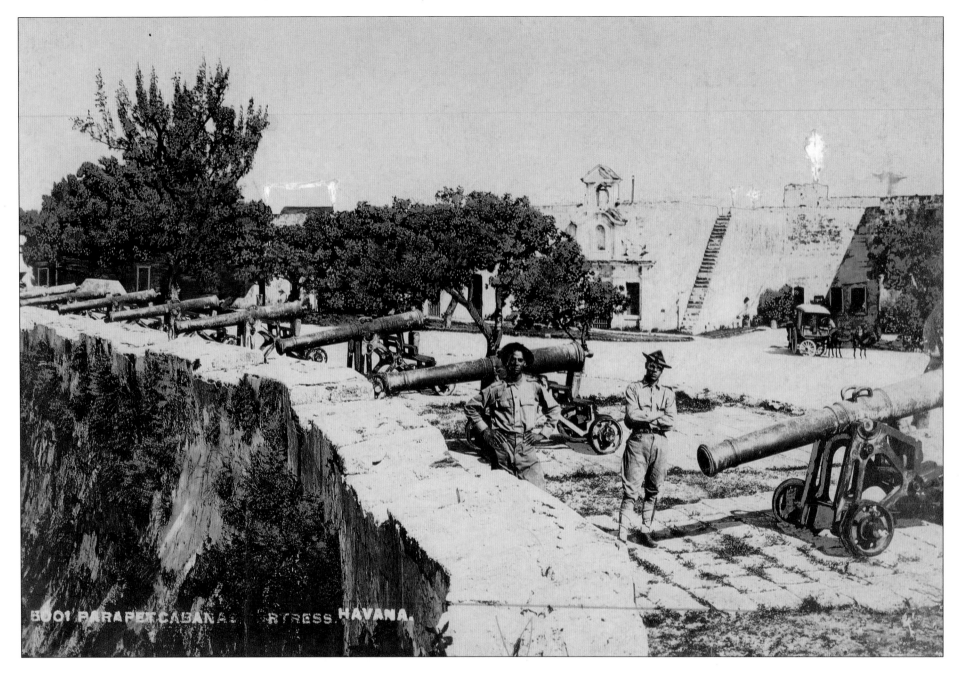

Situated where the English navy entered the bay in 1762, the Fortaleza de San Carlos de la Cabaña—so named for King Charles III of Spain, who commissioned it—became the most important fort of its time due to its size and the complexity of its defense systems. Following the plans of architect Silvestre Abarca, the walls of this solid structure are 2,300 feet long and take up an area of some twenty-five acres of land within the bay area. Built between 1763 and 1774, it took so much time and money to finish that it is said that when the king of Spain was informed of its completion, he went to a window of the palace and exclaimed, "Bring me a spyglass. That castle has cost so much we should be able to see it from Madrid!"

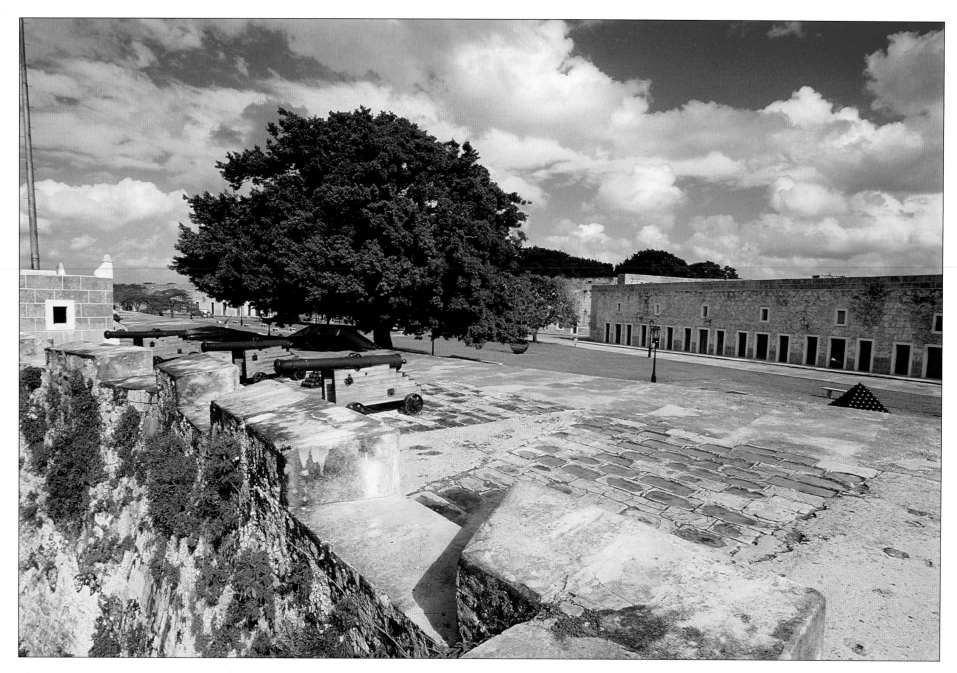

The fortress wasn't to prove its military capability because, after its completion, Havana was never attacked again by an enemy navy. During the Cuban wars of independence in the nineteenth century, it was used as a prison and its defensive ditches were the scene of many executions of Creole rebels by firing squads. During the 1980s it was restored by the Ministry of the Revolutionary Armed Forces and converted into a museum complex.

In colonial times, when Havana was a walled city, it was customary to announce the closing of the gates at nine o'clock each evening by firing a cannon either on a ship anchored in the port or from the fortress. This tradition has been reinstated, and every evening a group of soldiers dressed in the costume of the colonial era carries out the ceremony on the fortress grounds.

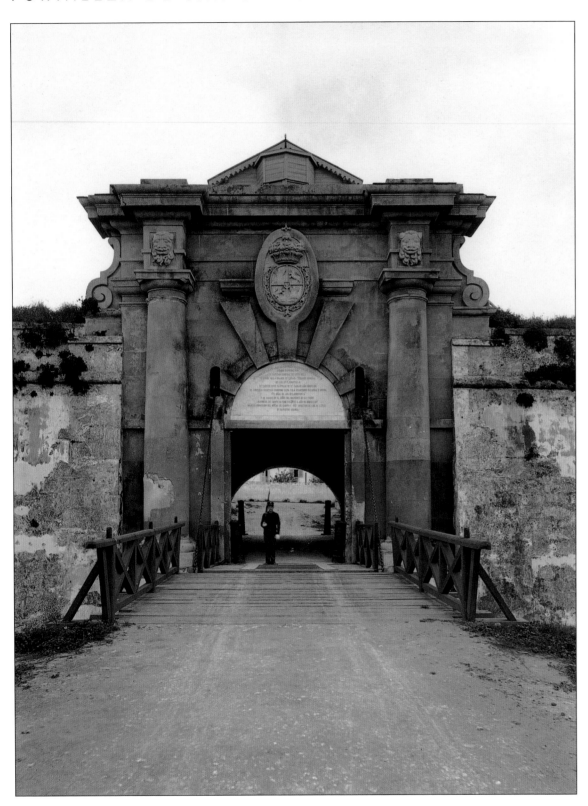

The fortress has architectural as well as military significance—the main entrance is particularly beautiful, as is customary with colonial buildings. This portico, designed by Pedro de Medina, who had been brought over from Cadiz to assist in the construction of the fortress, is remarkable due to its architectural virtuosity. It is large and noted for its simplicity, with decoration based on geometric patterns in the Baroque style of the period. Access to the fortress, which is surrounded by a deep ditch in the rock, was by means of a bridge—originally built of wood—which crossed the void to the monumental entrance.

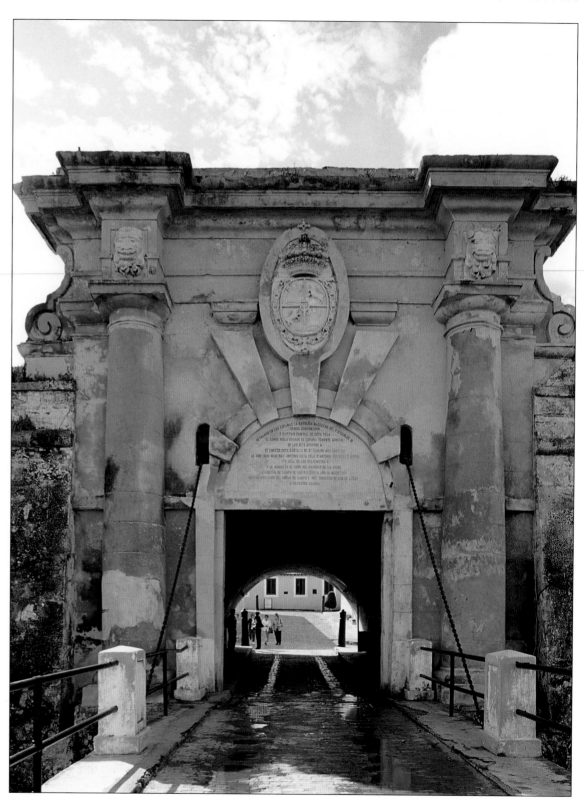

As part of the restoration of the Fortaleza de la Cabaña, the portico was restored to its original state. The bridge was also rebuilt with modern materials to safeguard it against the growing number of daily visitors to this historic and architectural treasure. In this picture, the office that Che Guevara was to occupy after the revolution in 1959 can be seen through the entrance. Today it is a museum that still houses some of his belongings. Open to the public since 1990, the fortress now boasts ample exhibition space and is home to a number of cultural events, such as a book fair and the Bienal de la Habana—an important third-world art exhibition.

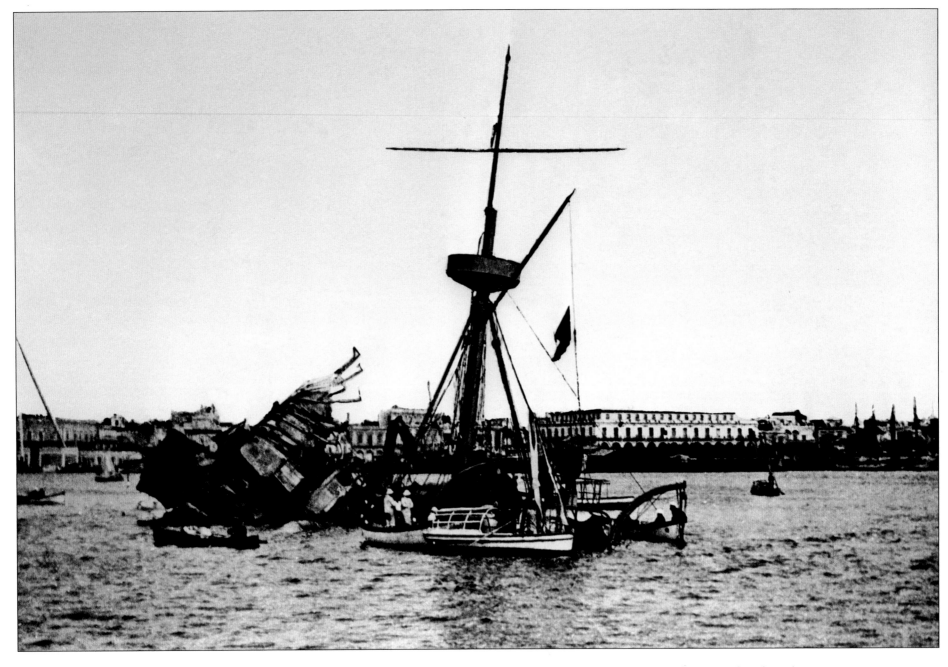

Discovered in 1508 and named Carenas Port by the Spanish mariner Sebastián de Ocampo, Havana Bay has seen events that have more than once turned the tide of history. The bay has witnessed the attack on the early town by the French pirate Jacques Sores, the capture of the city by the English in the seventeenth century, and the explosion of the USS *Maine* in 1898—an event that drew the United States into the War of Independence, a conflict instigated by the Cubans against the Spanish colonial powers twenty years previously. In this 1898 photograph, the remains of the ship can still be seen in the port. Behind the ship, the so-called Barrio de la Muralla is visible, the area of the nineteenth-century city that grew from the old city wall to the Paseo del Prado, where the vast Tacón Prison was built in 1835.

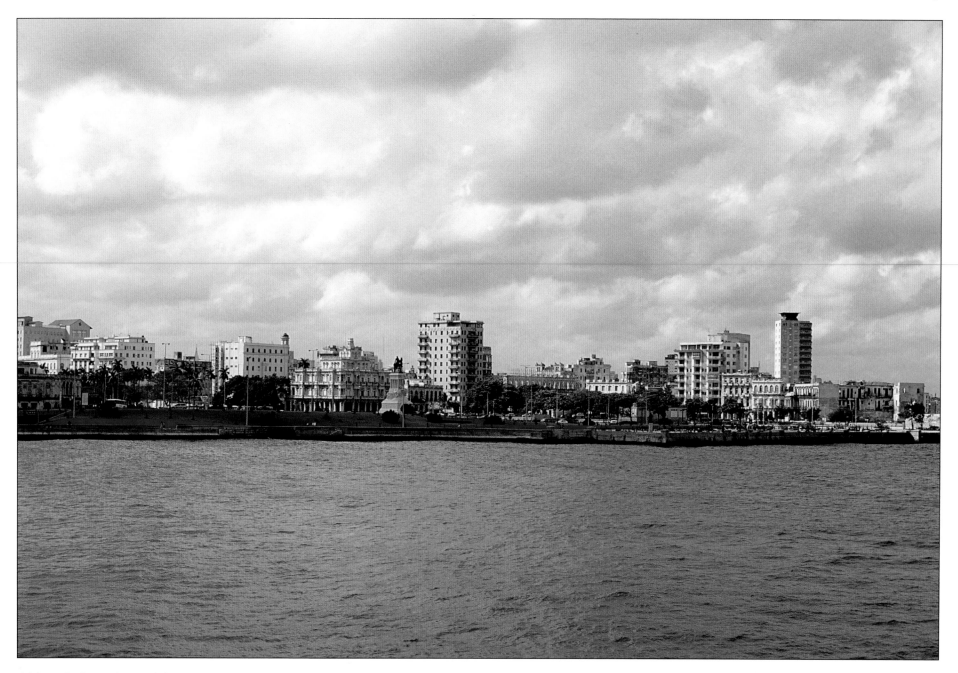

Although the sinking of the *Maine* on February 15, 1898, was possibly caused by an accident within the ship's magazine, it resulted in the death of 266 sailors and the intervention of the United States in the war. The ship was eventually raised in March 1912, taken out to sea, and sunk in deeper water.

Today on the site of the Tacón Prison stands a park in which the cell that Cuban revolutionary leader José Martí was imprisoned in between 1869 and 1870 can still be seen. A monument to eight medical students executed by the Spanish in 1871 has also been built.

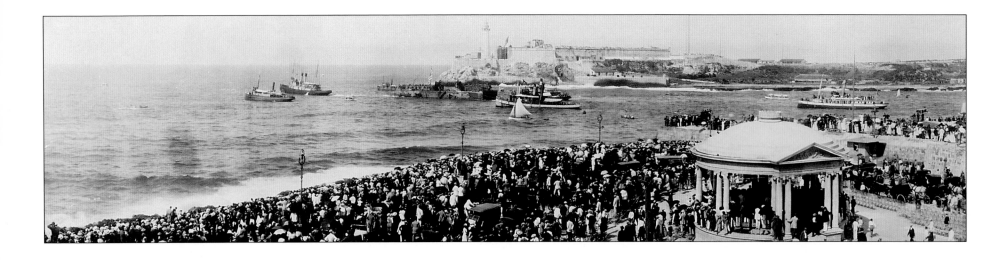

At the beginning of the twentieth century, Havanans' favorite pastime was still a walk in the open air, particularly in the Paseo del Prado area or in the Malecón district, from the Castillo de la Punta as far as San Lázaro cove. They would gather there to hear the sound of the waves or watch the boats enter the bay. People flocked to the Castillo, where a bandstand, shaped like a temple with a domed roof, was built. There one could hire a chair for ten centavos and listen to these concerts—when the noise of the constant traffic did not drown out the bands.

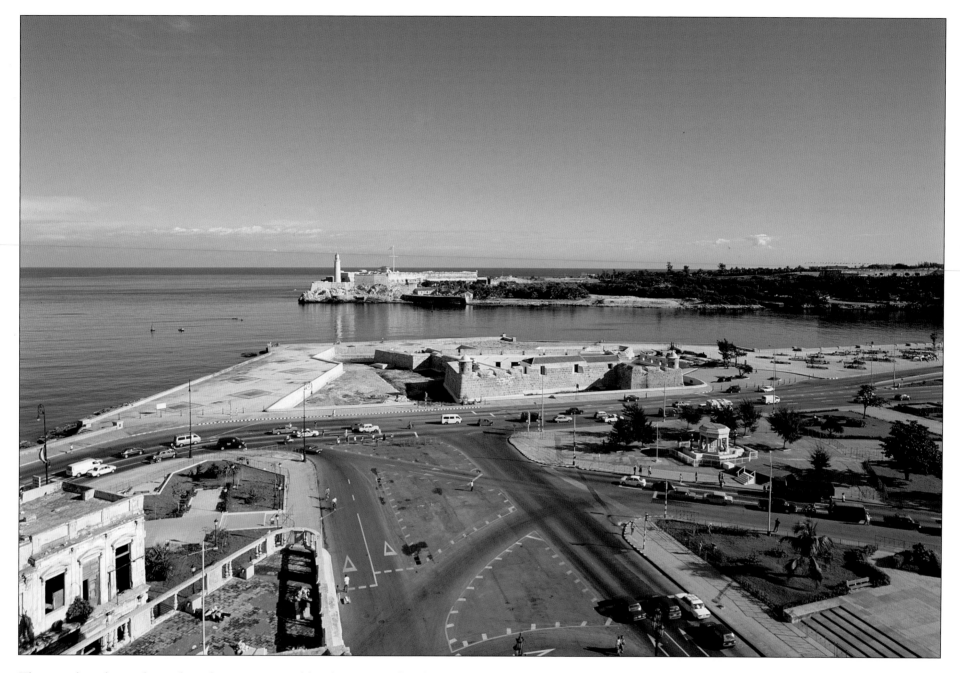

This area has changed significantly over time and has lost many of its features from the past. The bandstand was badly damaged by a cyclone in 1926 and disappeared completely when the French town planner J. C. N. Forestier reorganized the grounds. Later, there were more changes when the tunnel linking this side of the bay with the east was built. The tunnel, designed and constructed by the French company Societé des Grands Travaux de Marseille, was opened in 1958 and stretches for 2,400 feet under the sea. Only the Castillo de la Punta, which has undergone a recent restoration, has retained the same appearance.

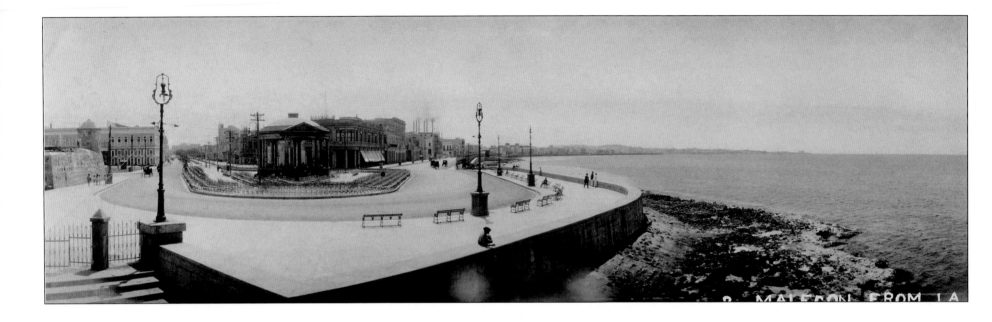

This photograph from the turn of the twentieth century shows the wide pavements where El Prado ends and the Malecón begins. There are lanterns and benches that face not toward the coast but toward the street, as Havanans loved to pass the time watching the traffic during their evening strolls. Others preferred to sit on the seawall, a custom that continues to this day. On the left side of El Prado is the intimidating building of the Tacón Prison, which had a high profile in the city because of its size and strategic location. In front of the prison one of the bastions of the Castillo de la Punta can be seen, and in the center is the traffic circle. Off to the right are the first buildings lining what, in 1902, was called Avenida del Golfo. It would later be named Avenida de la República and in 1908 it was renamed again to Avenida del General Antonio Maceo—but it will always be known in Havana as the Malecón.

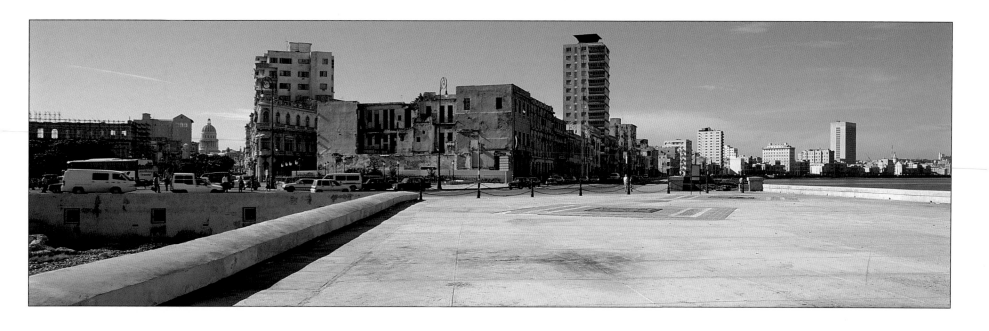

This part of the Malecón has undergone many changes during the twentieth century. First a hurricane wiped out the bandstand, then the Tacón Prison was demolished to make way for a park as part of Forestier's plans to widen the entrance to the port. Later, work on the bay tunnel meant that more space had to be given up to ease the flow of traffic along the Malecón. As the years passed, new buildings appeared and others have disappeared, either due to the heavy winter seas or the regrettable lack of maintenance. However, as this photograph illustrates, thanks to the City Historians' Office, La Punta has reclaimed its ancient ditches and wide esplanade that were lost when the traffic circle was built.

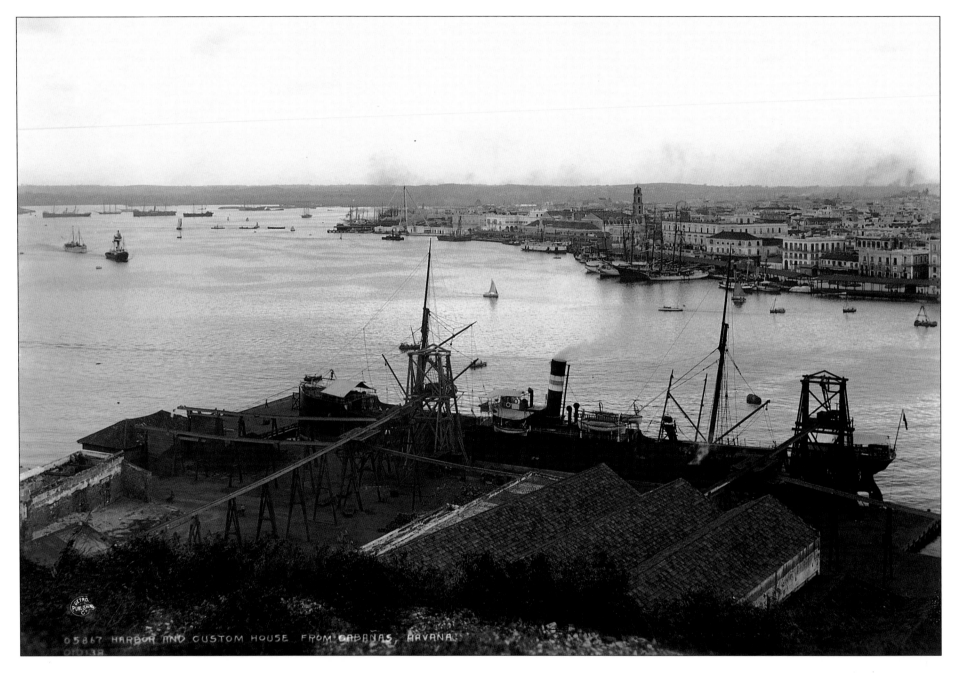

At the beginning of the twentieth century, the boats of many nations could be seen waiting at the port to load or unload merchandise. American, Japanese, Dutch, and Spanish ships would bring beef from Uruguay, rice from Japan, gin from Rotterdam, and export sugar, rum, and tobacco from Cuba. Alongside these were ocean liners carrying thousands of passengers from neighboring countries to Europe in little more than ten days. This photograph, taken at the beginning of the twentieth century, shows the mooring where the coal that was used in the ships was unloaded; the mooring was later used for unloading grain. On the other side of the water lies the colonial part of the city, showing the full extent of the area after three hundred years of growth.

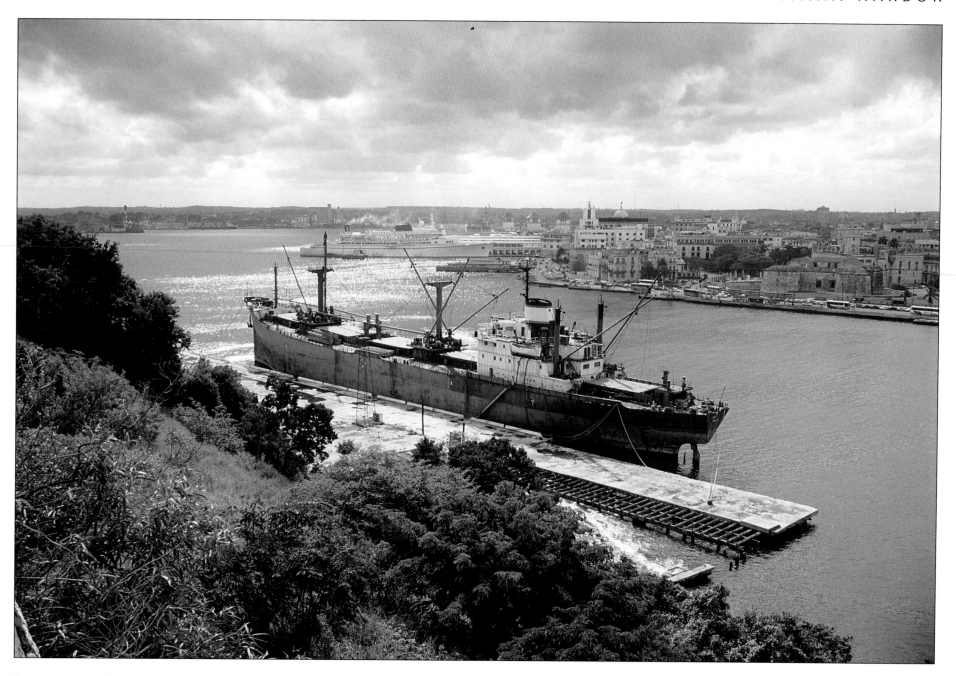

In recent times the harbor has not been as busy as it once was. The old wharf that was once so busy fell into disuse, and this ship—moored here for many years—became a permanent part of the landscape. In the distance, the city's main colonial buildings can be seen. The Castillo de la Real Fuerza de la Habana is the oldest fortification in the city; beside it the Plaza de Armas and El Templete mark the spot where the city of San Cristóbal de la Habana was founded. Between them are other twentieth-century buildings such as the Aduana (Customs House) and the building that currently houses the Ministerio de la Marina (Ministry of the Navy). In front of this building rests one of the many cruise ships that frequently visit the harbor.

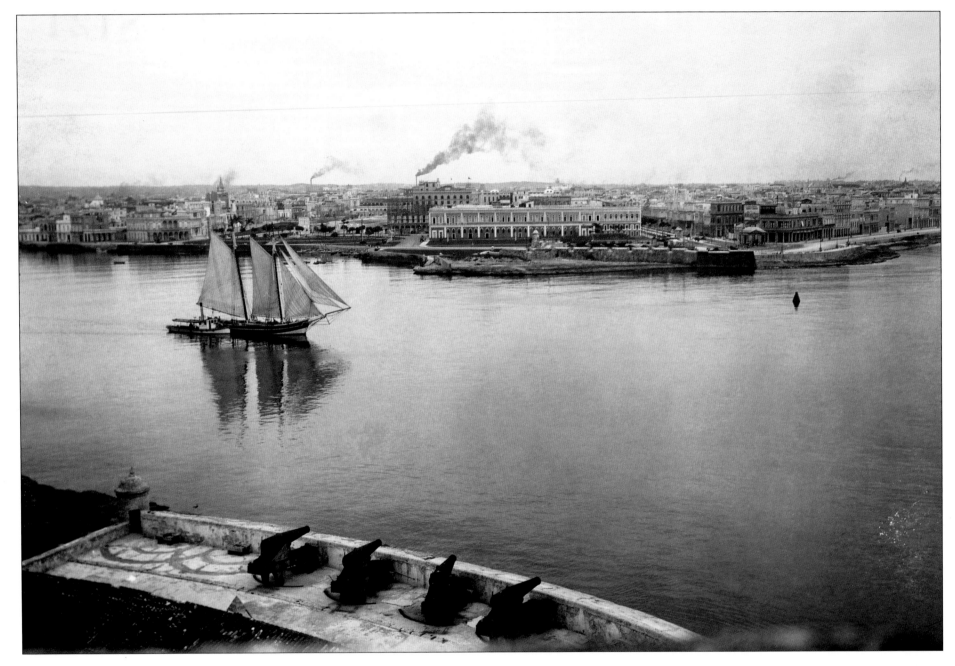

This picture, taken at the beginning of the twentieth century from the Castillo del Morro, shows an overview of the city at that time. The old city was designed on a grid system, but once outside the city walls this gave way to territorial divides that simply followed the line of the roads. The Paseo del Prado is particularly important in this respect, as the old quarter lies to the left of this road. Around the Paseo itself is the Barrio de Extramuros (the Area Outside the City Walls) and to the right following the coast toward El Vedado is the area now known as Centro Habana, which is located between the parallel roads, Galiano and Belascoaín.

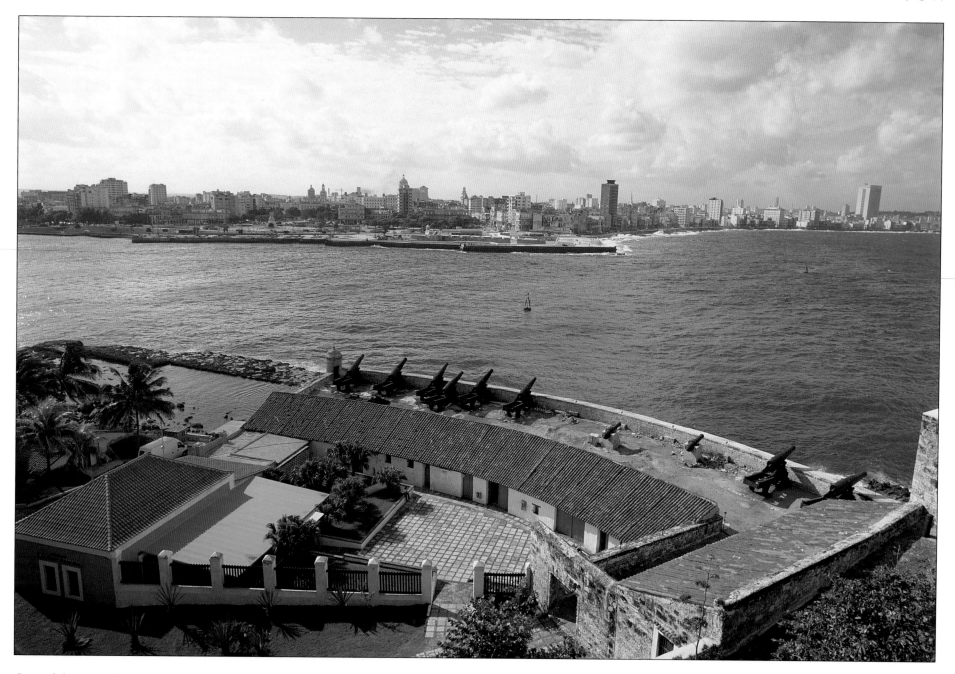

One of the capital's most important symbols was built along the coast in the twentieth century. The Malecón, which follows the line of the coast from the mouth of the Río Almendares, could be thought of as the city's protective façade. Its construction, which began in 1900, was set in motion by the Americans who were aiming to improve sanitary conditions along the coast region, which was made up of areas of boggy, foul-smelling wasteland where both animals and men bathed. The first section—from the Castillo de la Punta to the Calle Lealtad—was completed in General Leonard Wood's lifetime and the successive republican governments later continued the work until it stretched along the entire coast.

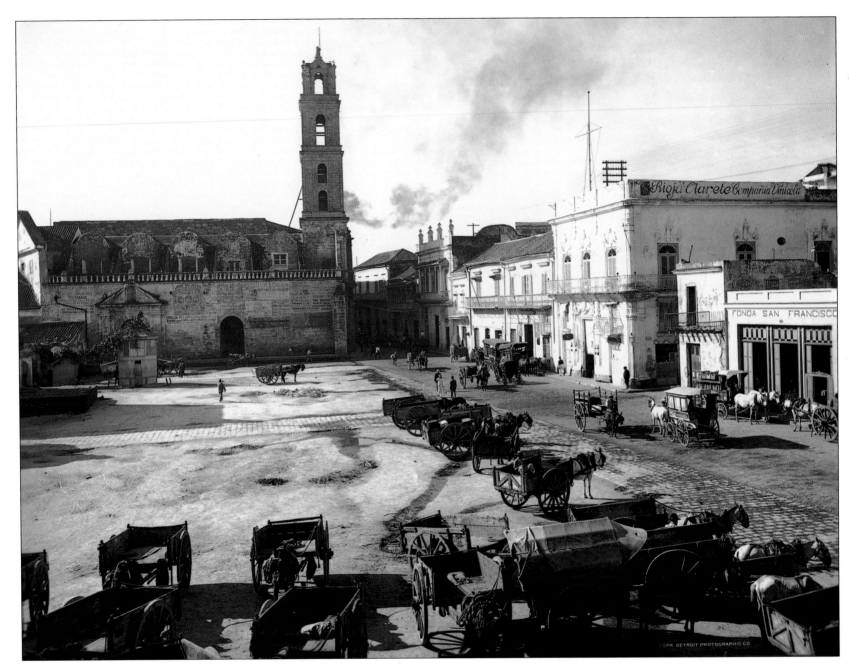

Located near the port, the Plaza de San Francisco was the main market in Havana until the emergence of the Plaza Nueva—known today as the Plaza Vieja—in the eighteenth century. An irregular-shaped space by the main quay, it took its name from the church and convent of San Francisco de Assisi built there in the sixteenth century. The church had the highest tower in the city and was very popular with the residents until it was abandoned by the

Franciscan monks. In 1841 it became a warehouse. The plaza was a hive of activity in the nineteenth century due to the proximity of the customs house. Even at the beginning of the twentieth century, it was a key area for the loading and unloading of merchandise, and there were always several horse-drawn carriages waiting in the square for the daily arrival of the passenger liners.

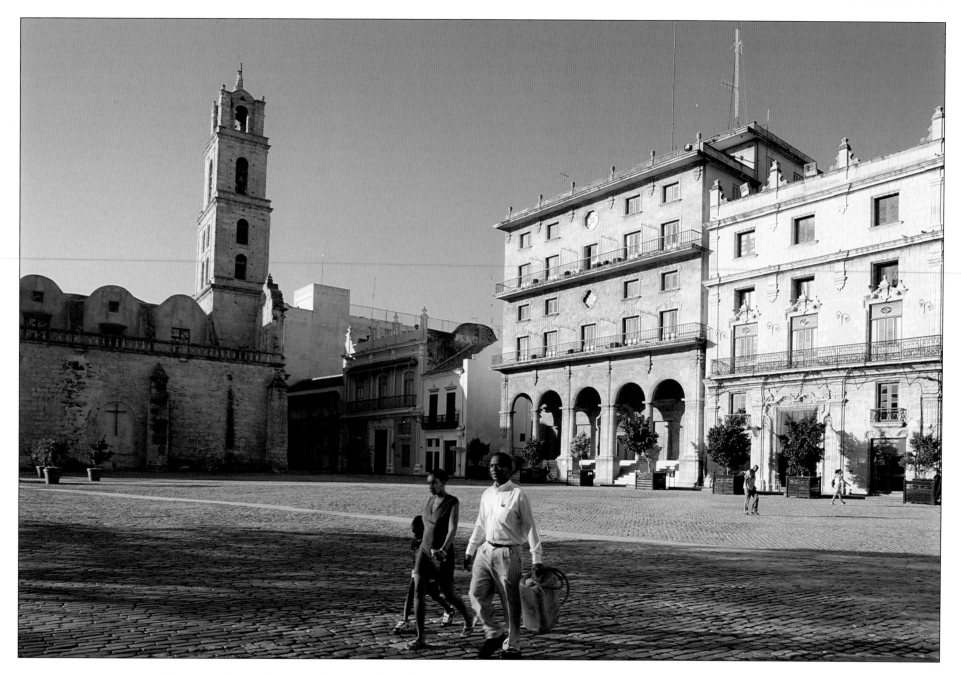

The recent restoration of the Plaza de San Francisco has transformed Old Havana into one of the city's most beautiful districts. The church and convent had been damaged by years of use and by hurricanes, but since their renovation they have been reopened to the public. The ancient basilica became a concert hall in 1994 and other buildings were gradually converted into religious and contemporary art museums. The primitive houses in Calle Oficios that survived the elements have had their facades reinstated and have also become cultural centers.

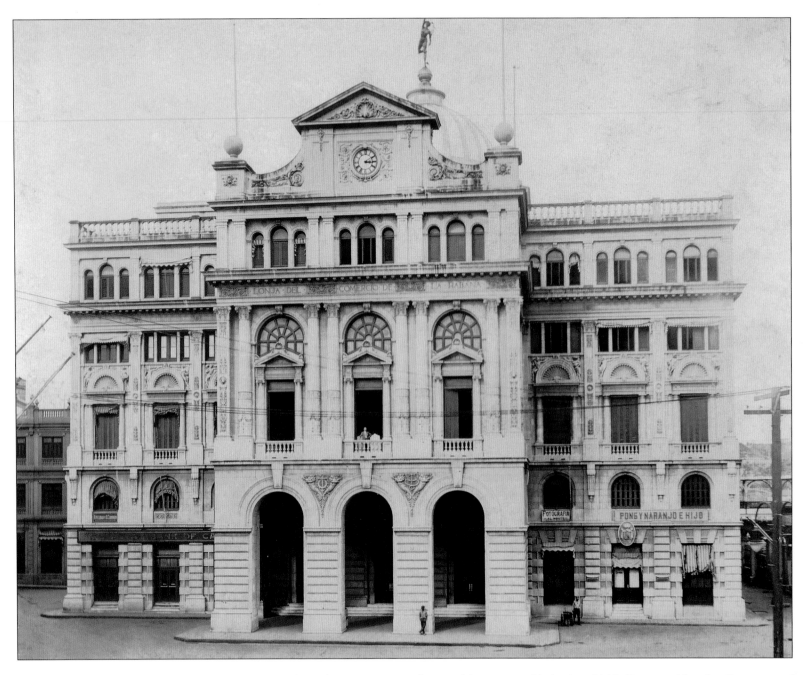

Built between 1908 and 1909 by the American company Purdy and Henderson, the Lonja del Comercio (Commercial Exchange Building) dominates one side of the Plaza de San Francisco. The customers of this building were Cuban and Spanish shareholders and it replaced the old Lonja de Víveres (Food Exchange) when it couldn't cope with the increasingly complex financial transactions during the period of economic growth when the republic was established in 1902. Designed by the German architect Thomas Mur in the Beaux Arts style of the period, it is much more discreet than his other buildings in the city. Originally it had five floors, with offices and exhibition halls looking onto a central, covered courtyard. This was covered by a dome topped with a figure of the winged Mercury.

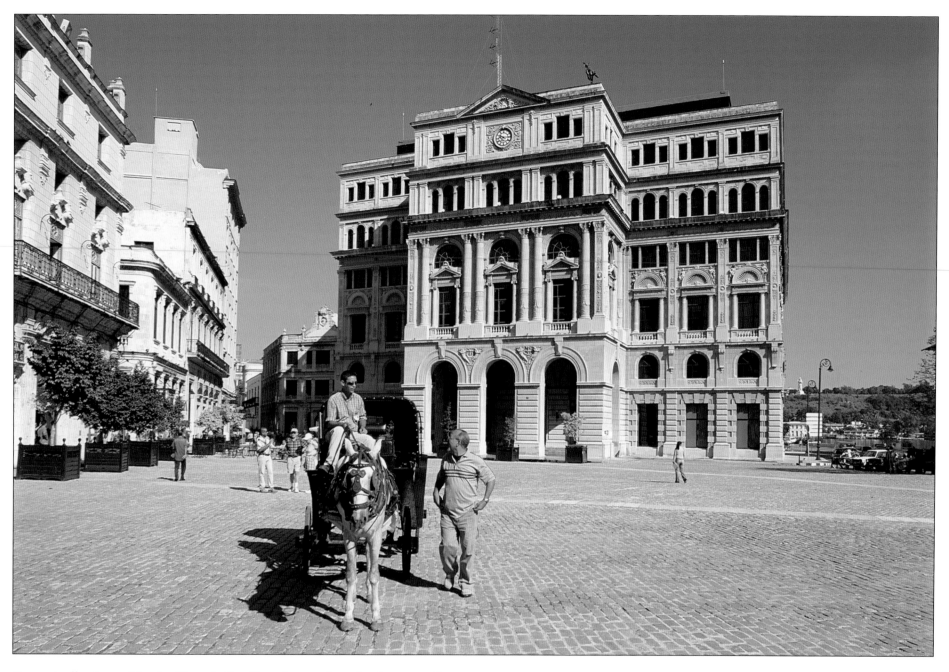

Strategically situated in the Plaza de San Francisco and on the doorstep of
Havana's port, the Lonja del Comercio played an integral role in Old Havana.
Recently restored by the City Historians' Office, it houses a number of businesses
and is the Cuban base for several foreign companies. A new floor was added
during the renovation and the work has restored the building's former impact.
It remains a landmark in Havanan architecture for many reasons: its size, its steel
and concrete construction, and the speed with which it was completed.

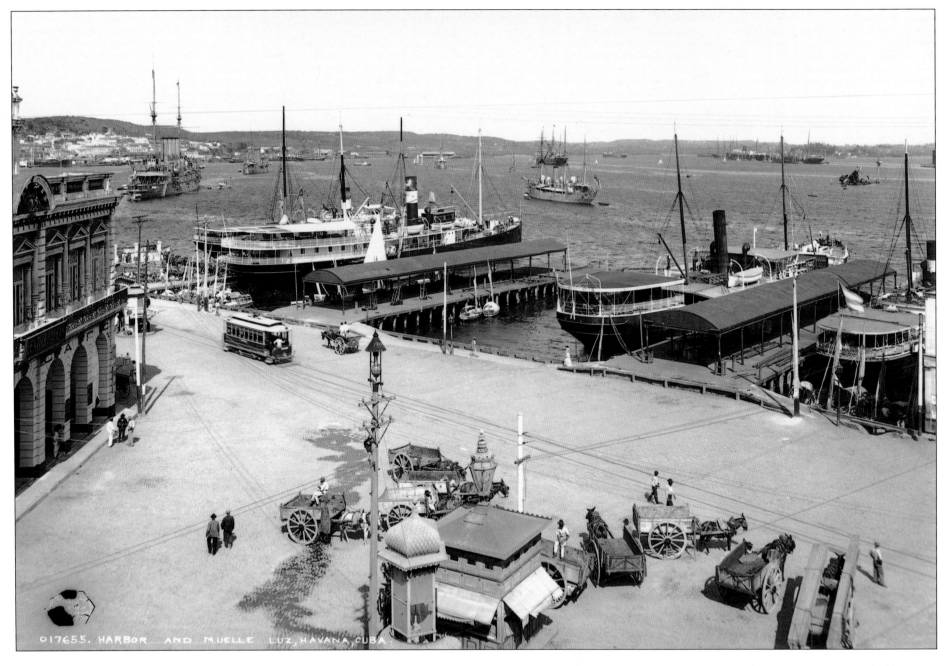

017655. HARBOR AND MUELLE LUZ, HAVANA, CUBA.

The Muelle de Luz (Luz Quay)—named for its owners—was one of a small number of wooden jetties that served the port for two centuries. It is said that it was used by the inhabitants of Regla, on the opposite side of the bay, as early as 1765. As a reflection of its importance, the jetty underwent various improvements over the years. This photograph, taken around 1900, shows the small square by the ferry port. The ferries would cross the port every half hour, carrying passengers and vehicles from one side of the bay to the other. Opposite the quay was a building containing the offices of a number of Spanish shipowners whose ships operated around the Caribbean and brought troops from Spain.

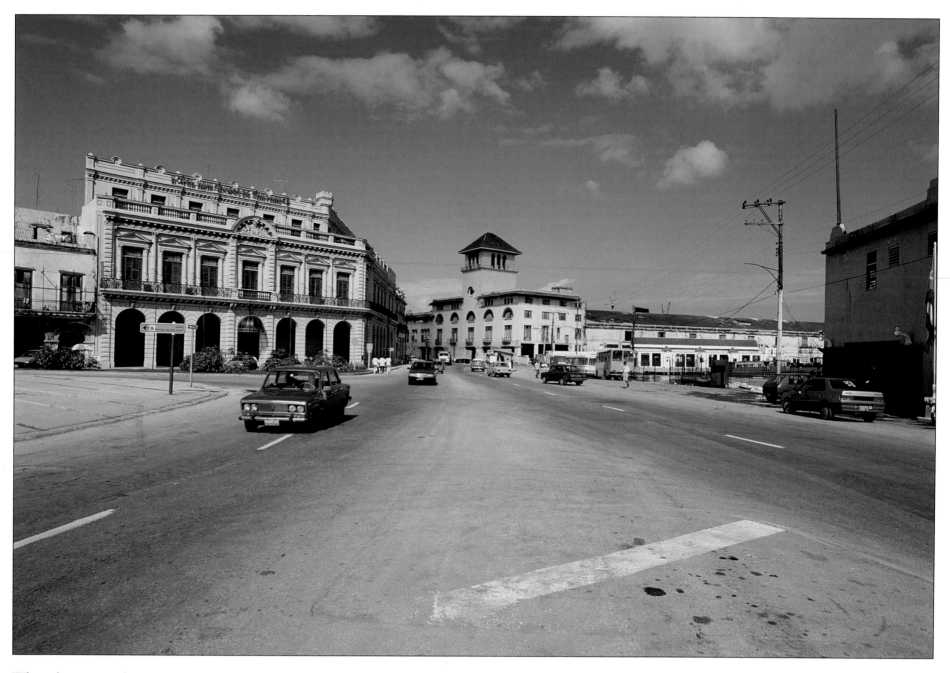

When the customs house was built in 1914, the Muelle de Luz changed completely. Today all that remains of the quay is the station from which the boats to Regla and Guanabacoa depart. These boats are occasionally hijacked by Cubans desperate to reach the United States coast. Today the old building by the quay is the Hotel Armadores de Santander (*left*).

Motifs typical of the architecture of that part of coastal Spain can be seen on the facade and interior of the hotel. The terrace on the top floor has been converted into a vantage point that commands the most spectacular views of the port. The initials of the builder and original nineteenth-century owner—José Cabrero Mier from Santander, Spain—can still be seen on the main door.

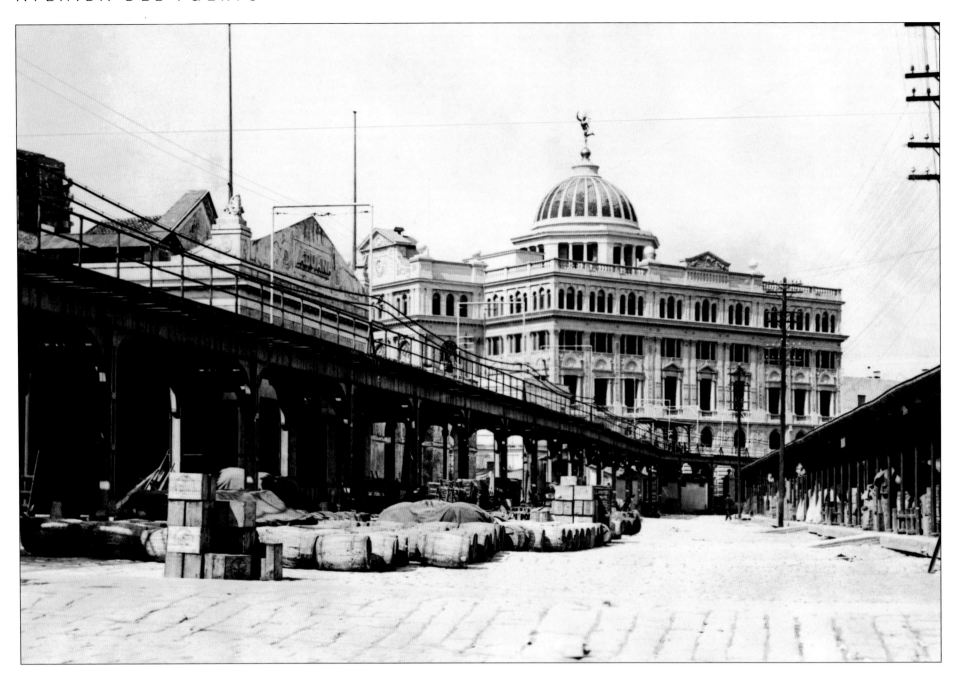

Numerous quays were built early on to service the port, including the famous San Francisco, Caballería, and La Machina quays, and later on the Luz and Paula quays. The area was very active at the beginning of the twentieth century with the constant movement of merchandise, and the number of warehouses around the main quays quickly multiplied. In that era, the section between the Plaza de San Francisco and the quay was always crammed with boxes, barrels, sacks, and carriages. When the new Estación de los Ferrocarriles (Train Station) was built, a track extended from the station to San Francisco quay opposite the recently constructed Lonja del Comercio, as seen in this photograph taken around 1912.

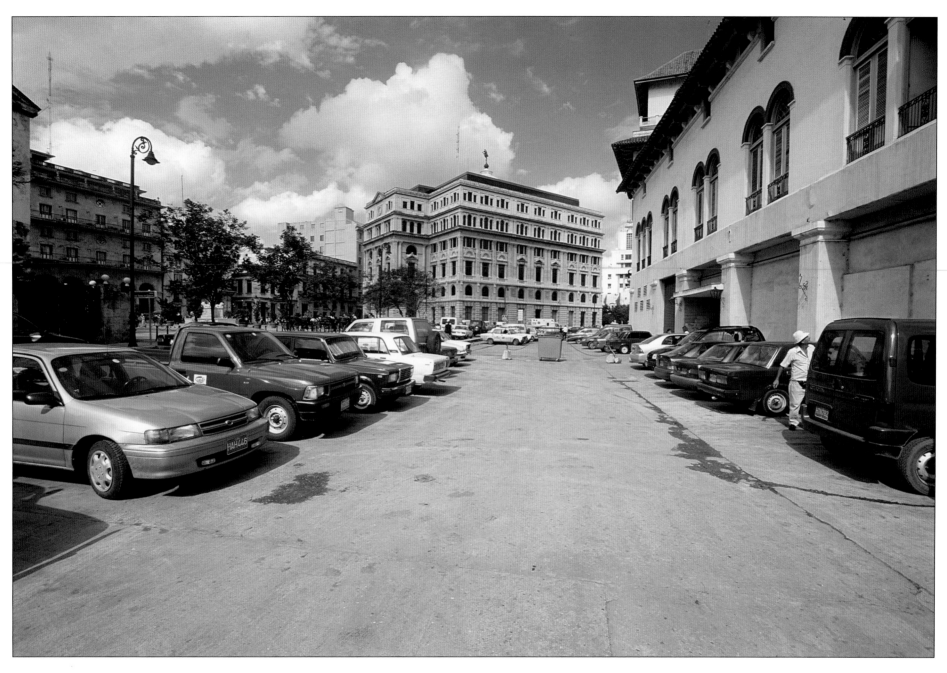

With the construction of the customs house, the roads that ran along the port from the Castillo de la Fuerza to the train station had to be improved. Additionally, the increase in the number of quays and warehouses in other parts of the bay helped to ease the congestion on the Avenida del Puerto until less and less merchandise was brought here. Eventually the raised train track disappeared, which has made the Lonja del Comercio look more impressive within the Plaza de San Francisco. The 1836 Fuente de los Leones fountain has also been returned to its original position in the square after being placed in various other locations around the city.

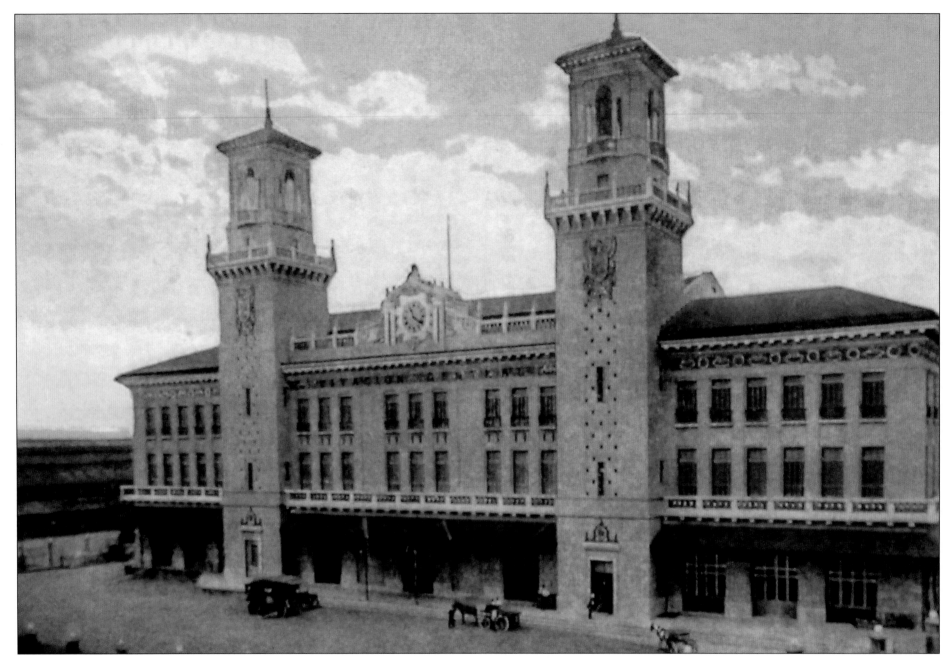

Trains were introduced to the island by the Creoles to transport sugar from the Bejucal valley to Havana's port. Cuba was only the fifth country in the world, and the first Spanish-speaking country, to use this mode of transportation. The work was overseen by American engineer Alfred Kruger between 1835 and 1845, and was paid for by a loan from the English. The first train station, called Villanueva, was next to Campo de Marte. This postcard shows the new Estación Terminal, which opened in 1912 on the site of the old town arsenal.

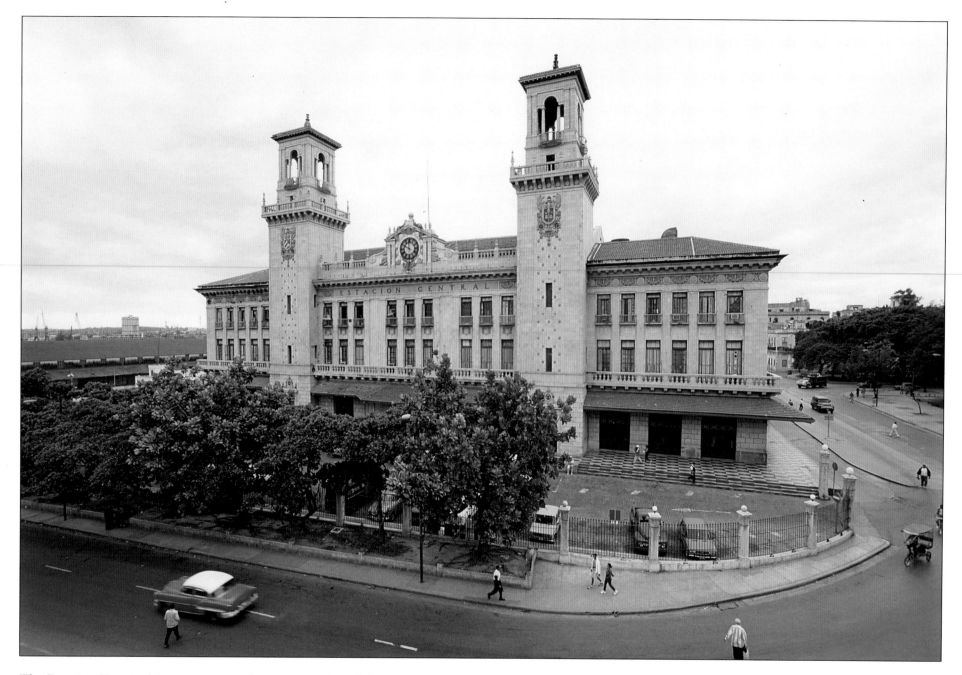

The Estación Terminal is now a national monument. It still functions as a terminal for trains traveling within the interior of the country, and it also houses various state rail companies. The building is a mixture of Spanish Renaissance style and other architectural features taken from similar buildings around the world. It is crowned by two tall towers, one bearing the shield of Cuba, the other that of Havana. This photo shows the terminal building today, dominating Calle Egido.

In around 1860, *guaguas* (buses) appeared in Havana; they were horse-drawn carriages that traveled along iron rails built into the main streets of the city. This mode of transportation was still widespread in 1900 and the stations, like this one at the junction of Calzada de 10 de Octobre and Agua Dulce, were similar to the small train stations found in the island's interior. Here one can see a neighborhood that was typical of those that sprang up on the roads into Havana when it spread beyond the old city walls. In 1901, the first electric tram system arrived with branch lines quickly extending throughout the city, changing the appearance of the capital with its posts and electric cables.

A century later this corner looks completely different, despite still being the crossroads for the main highways of the city. Its appearance changed greatly when the avenues were widened, but it altered most when the famous Vía Blanca was built in the 1950s to ease the flow of traffic on the main road. In the 1970s the so-called *ocho vías* (eight-lane) highway was built, which improved access to the provinces. Markets, warehouses, and manufacturing then emerged, making this an important working-class area in the republic.

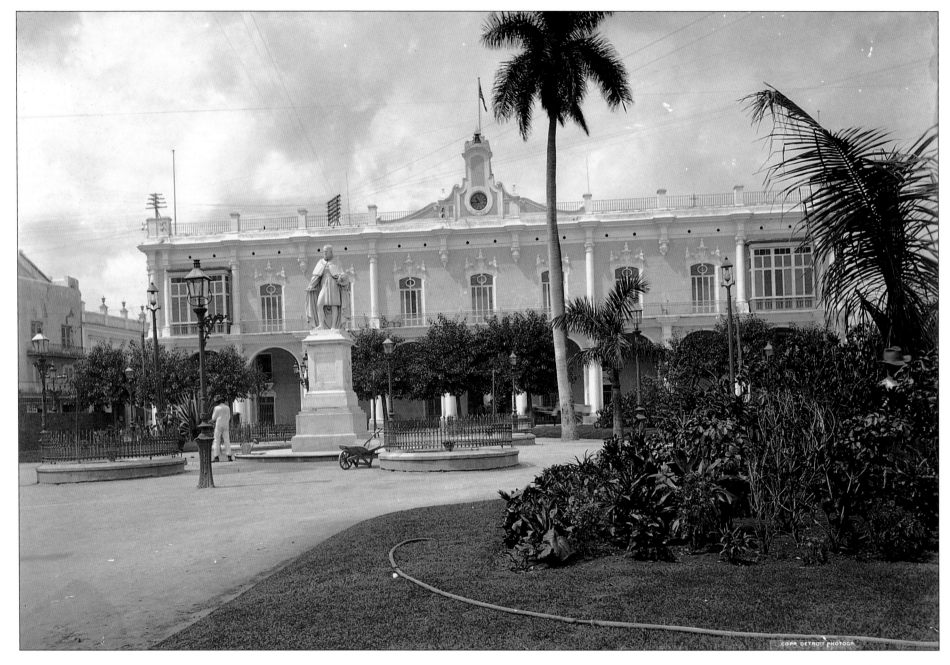

The Plaza de Armas, one of the most important areas in colonial Havana, really started to develop at the end of the eighteenth century when the Palacio de los Capitanes Generales and the Palacio del Segundo Cabo were built within the square. They exemplify the Andalusian Late Baroque style that became popular in this period. At the time, the square also contained gardens where, years later, a statue of Spain's King Fernando VII was erected. The square has witnessed many historically important events, as well as more bizarre occurrences, such as the flight by Englishman Eugene Robertson's hot-air balloon in 1828. The Palacio de los Capitanes Generales that overlooks the square was built between 1776 and 1791 for use as the headquarters of the Spanish authorities and colonial administration offices, and also contained the city's prison. During the first U.S. intervention in Cuba from 1898 to 1902, it was also the government's headquarters.

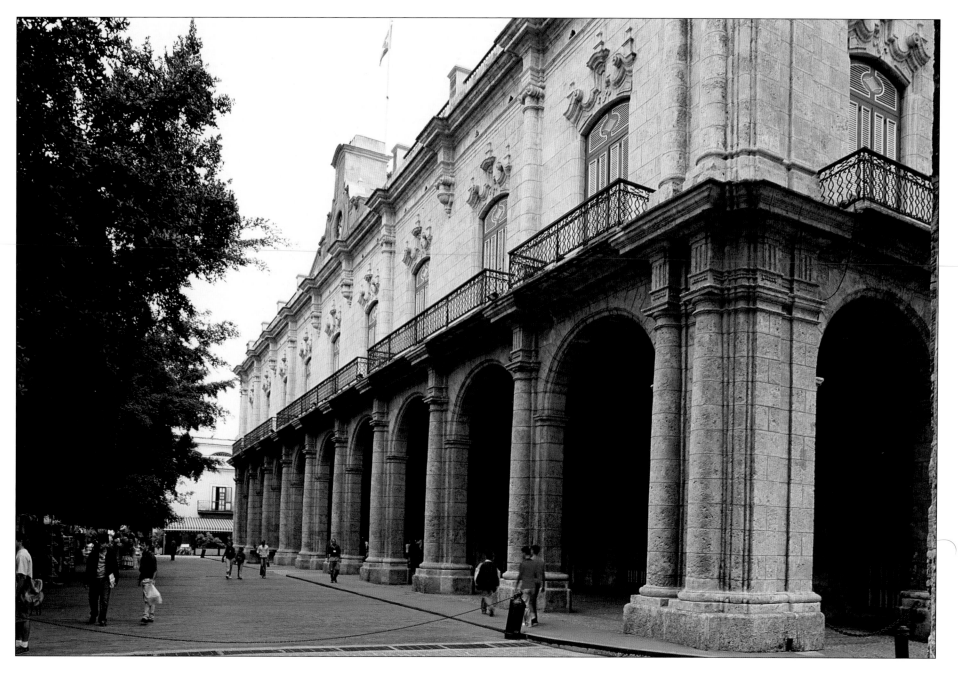

In 1902 the Palacio de los Capitanes Generales became the official residence
of the president of Cuba until the Presidential Palace was built in 1917. It
was restored by the Historians' Office and is now the Museo de la Ciudad
(City Museum), where historical and artistic treasures of the colonial era are
exhibited. The section of road that separates the palace from the park was
reconstructed following traditional methods using small wooden blocks.

El Templete was built in colonial times, forever marking the spot where Havana was founded. This was where the first mass and town assembly took place under the cover of a tree. Opened in 1828 during the rule of Governor Francisco Dionisio Vives, the temple contains three paintings by the Frenchman Jean-Baptiste Vermay representing the founding of the city. Situated on the Plaza de Armas, the temple was reduced in size when Calle O'Reilly was lengthened in 1851. By the beginning of the twentieth century, its grounds contained only a ceiba tree that had replaced the original, a pilaster erected by Governor Cajigal de la Vega in 1754 in honor of the founding, and the eponymous temple.

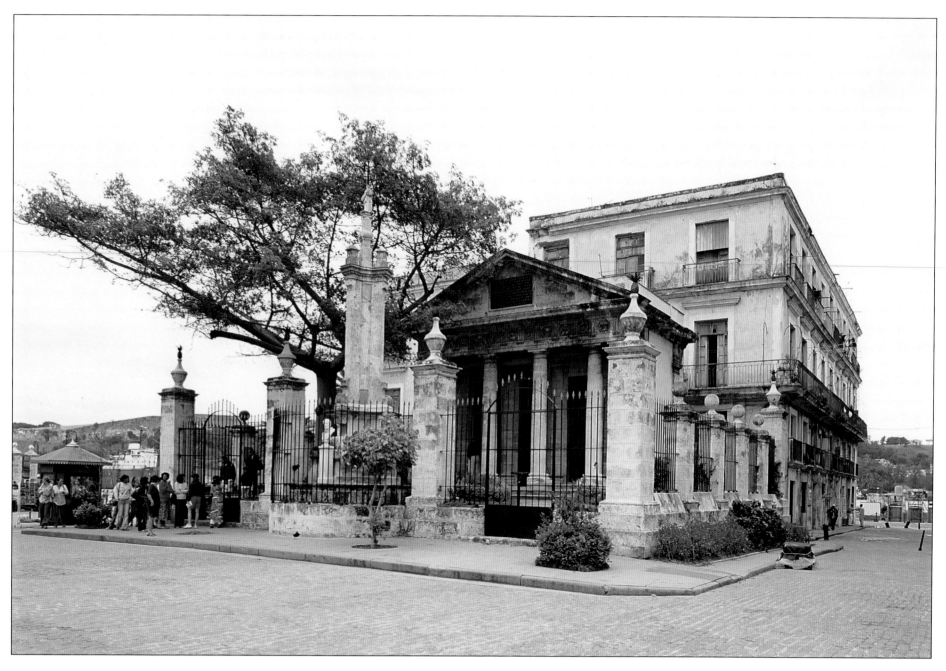

Recently the Vermay paintings were restored by the Historians' Office and were hung in their original place so they could be seen by the general public. The celebrations to commemorate the day Havana was founded start outside El Templete each November. In the traditional celebration, a line is formed outside the temple and hundreds of people take turns walking around the ceiba tree as they make a wish.

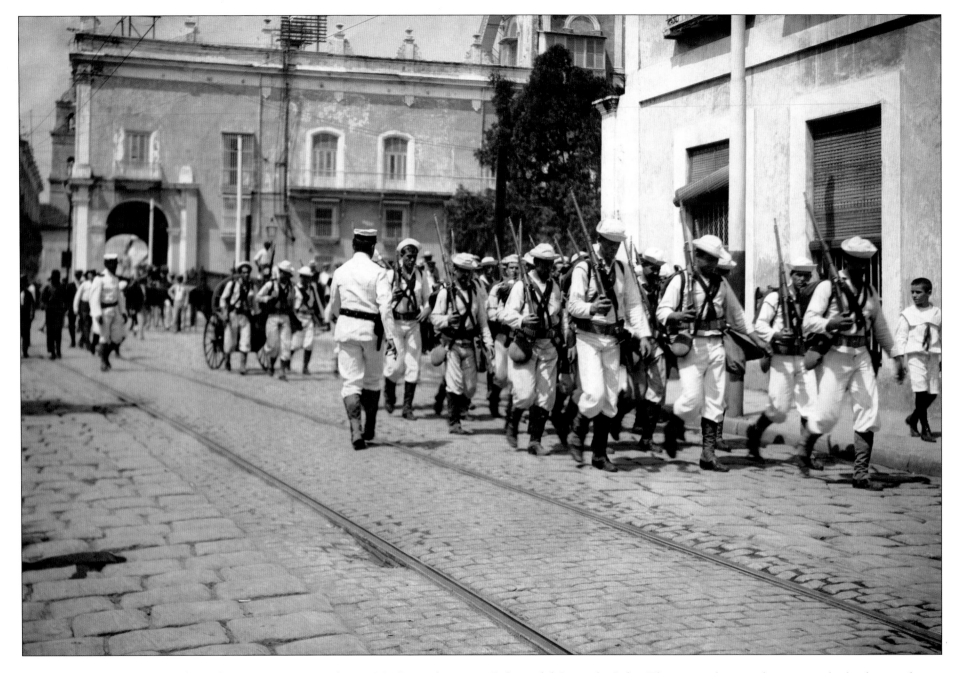

When the Cuban War of Independence came to an end in 1898, General
John R. Brooke took possession of the island and was replaced shortly
afterward by General Leonard Wood. At that time, American troops could be
seen doing their military exercises in the Plaza de Armas. This picture shows
a group of American soldiers marching down Calle O'Reilly alongside the

Palacio del Segundo Cabo. The tower that can be seen in the background
belonged to the Santo Domingo convent, once affiliated with Havana
University. The convent was knocked down in the 1950s to make way for
a helicopter pad. The streetcar lines that used to crisscross the city are seen
on the road.

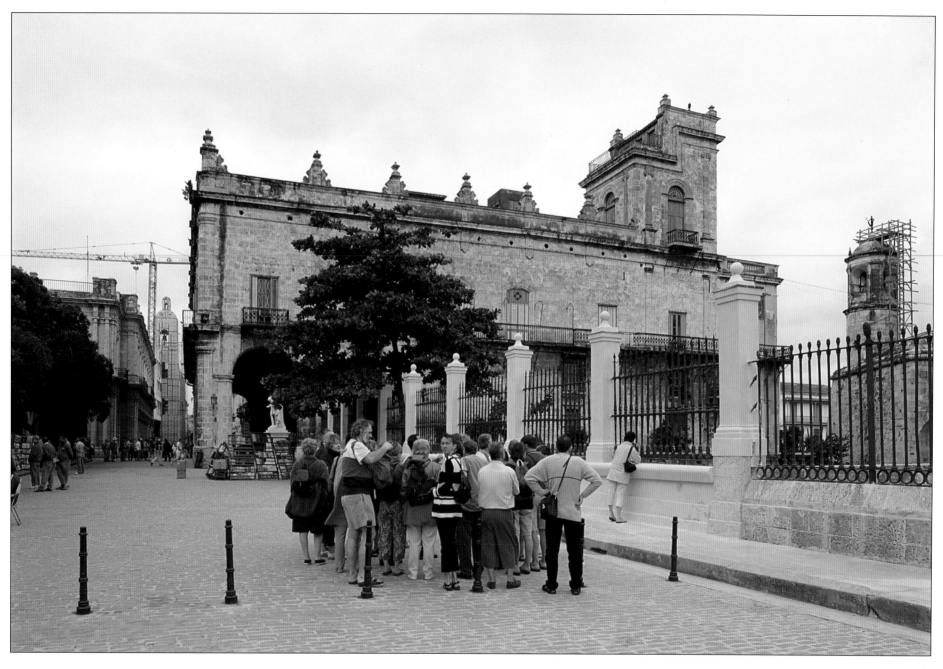

Today the Calle O'Reilly side of the Plaza de Armas is visited by a great number of tourists who come to experience Old Havana. One side is dominated by the building that was previously the Palacio del Segundo Cabo, housing the treasury department and main post office. During the time of the republic, it was used as the senate building until the construction of the Capitolio Nacional. It is regarded as the best example of Baroque architecture in Cuba. The street is now pedestrianized and hosts a regular used-book market. On the right are the railings around the moats belonging to the Castillo de la Real Fuerza, as well as the tower upon which the famous *La Giraldilla* statue (a small bronze weather vane in the shape of a woman) is perched.

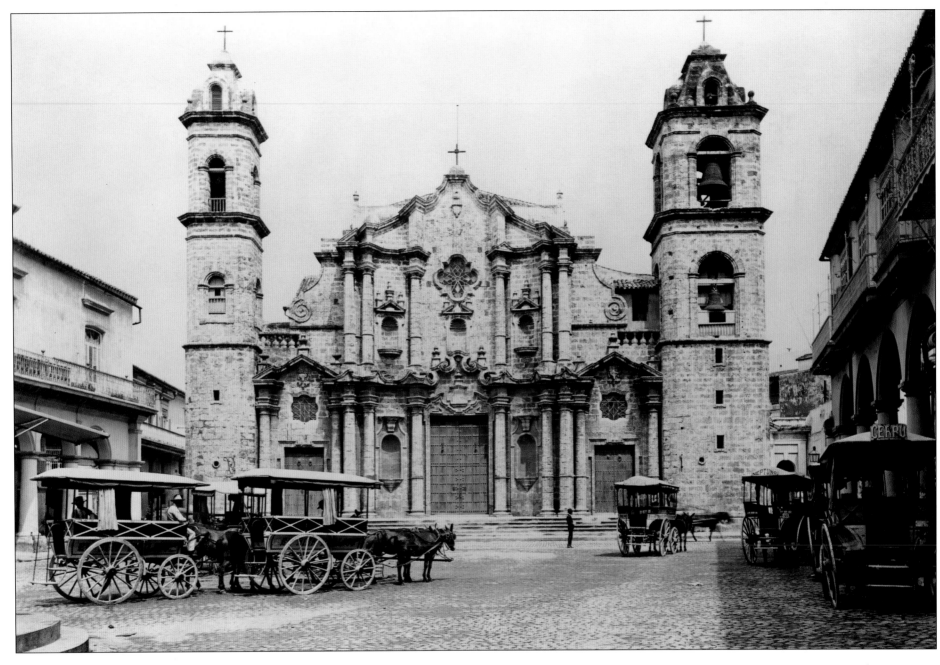

Dominated by the cathedral, whose facade is a classic example of Cuban Baroque style, the Plaza de la Catedral is today the most famous and popular square in Havana. It is one of the most interesting architectural constructions of eighteenth-century Cuba and contains some of the more noteworthy residences of that era. The wide colonnades reflect the style used in the aristocratic homes that graced the main squares at that time. Well into the twentieth century, horse-drawn carriages would wait for passengers in the narrow square. This picture from around 1900 shows the carriages that were a common mode of public transportation in Havana at the time.

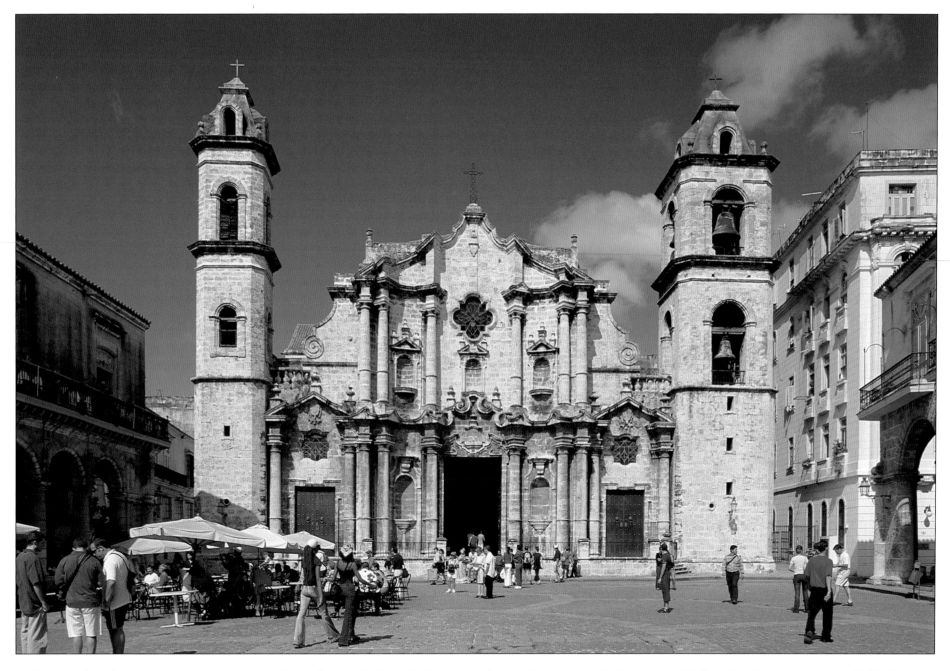

Today the Plaza de la Catedral is pedestrianized and the overlooking buildings have been renovated. With the exception of the cathedral where Pope John Paul II celebrated mass during his visit to Cuba in 1998, all the buildings on the square now have a different function. The Casa del Marqués de Aguas Claras—which can be seen on the left—is now the El Patio restaurant. Conde Lombillo's residence was until recently the Museum of Education but has been taken over by the Historians' Office. On the corner where Calle San Ignacio and Calle Empedrado meet, there is the Wilfredo Lam Center, which organizes the Bienal de la Habana, an arts festival. A few yards away on Calle Empedrado is the famous Le Bodeguita del Medio bar. The only eyesore in the square is the apartment building built next to the cathedral in the first half of the twentieth century.

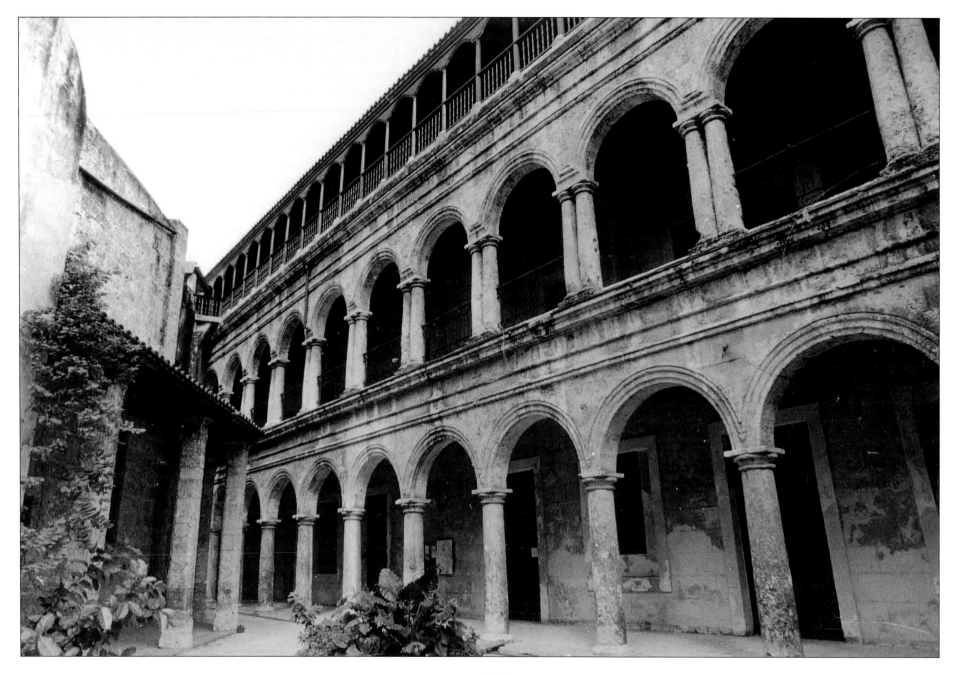

Founded in 1689 as a seat of learning, the college was promoted to the category of seminary in 1768 and became dedicated solely to ecclesiastical studies. Known as the Seminario de San Carlos y San Ambrosio, it was built by Jesuits in the eighteenth century as an annex to the old church that eventually became Havana Cathedral. Important figures of Cuban culture, such as the philosophers José Agustín Caballero and Félix Varela, lectured here. Its original structure can be seen in this picture from the beginning of the twentieth century.

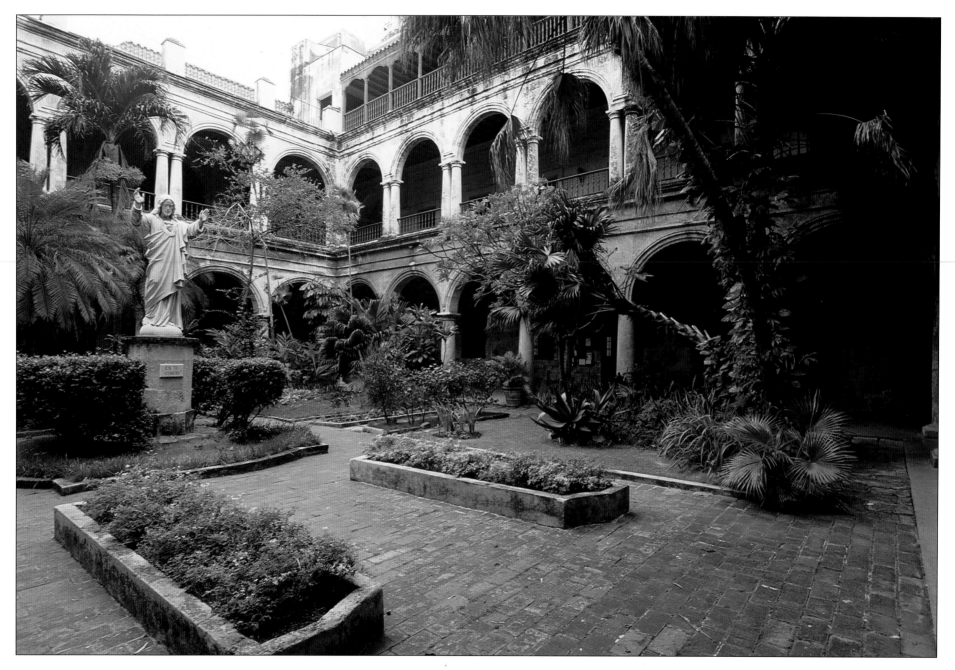

There are currently a number of students at the seminary who intend to follow careers in the church, as their predecessors would have done. The seminary centers around this cloister with colonnaded passages on the main floors, a design similar to that used in many of the great palaces of the eighteenth century. It has been very well preserved over the centuries, and visitors are welcome to see the building from this beautiful garden. The detailed carving of the wood on all doors and windows throughout the seminary is exceptional and, like the rest of the building, constitutes one of the best examples of Cuban colonial architecture.

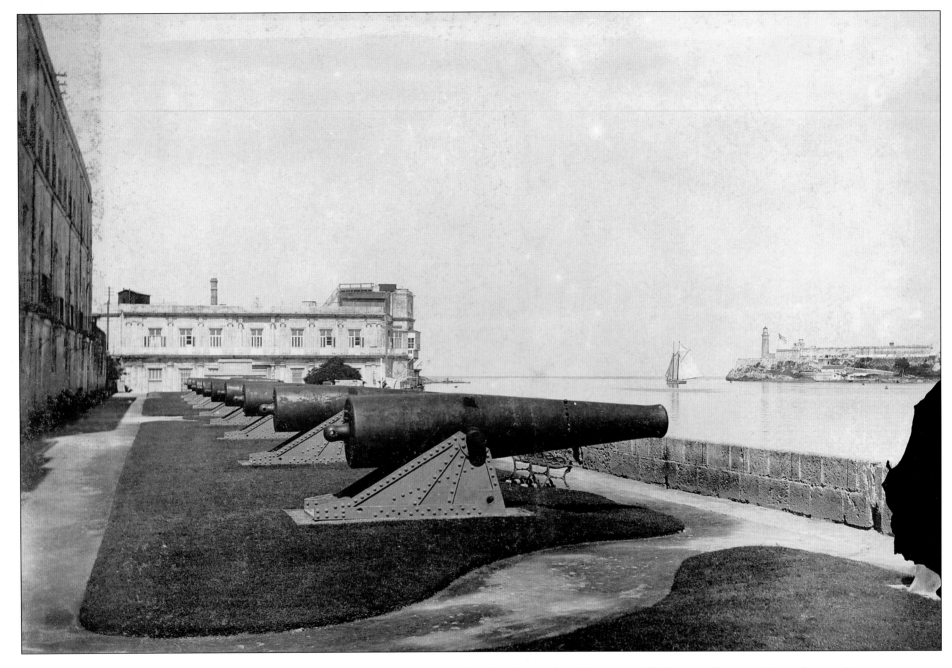

Under the short rule of Gerónimo Valdés, a walkway with gardens and seats was built between the back wall of the Seminario de San Carlos and the coast. It was a tree-lined avenue that was very popular with Havanans due to its beautiful view of the mouth of the harbor and its proximity to the city center. Opened in 1843, the Cortina de Valdés had a tiled pavement and was slightly elevated above the level of the surrounding streets. Nearby landmarks at the time were the naval dockyard, the fish market, and the ice warehouse.

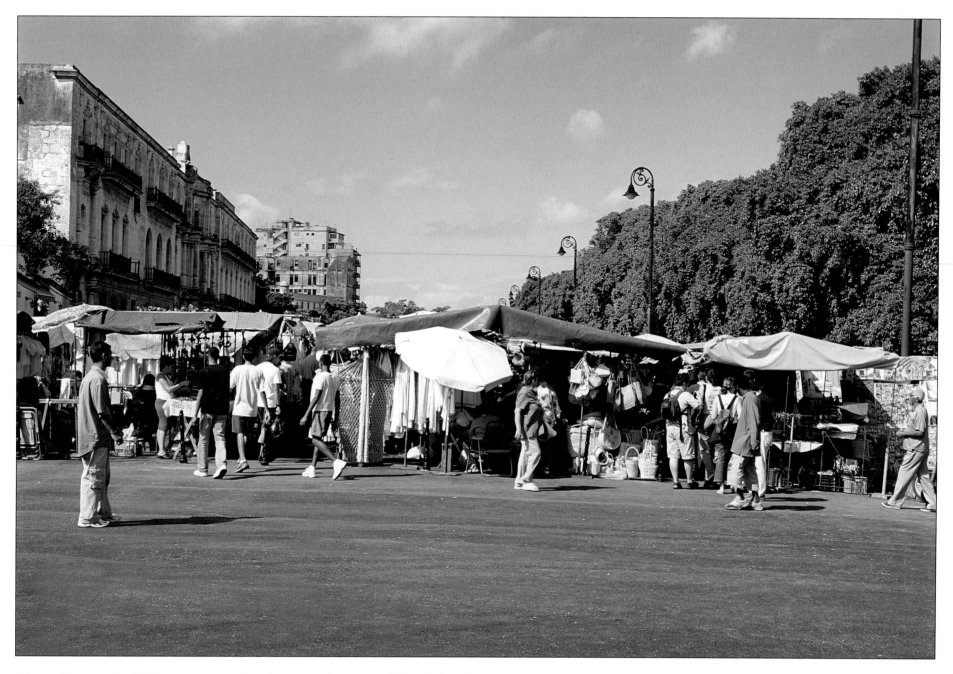

The walkway gradually lost its seats and gardens, and during the Cuban War of Independence a battery of cannons was put there instead. These were later removed to reinstate the walkway, but around 1929 a section of the coast was filled in to make room for the Malecón, and the Cortina was considerably reduced in size. Remains of the walkway have been preserved to the present day, but tourists now walk around the area looking for bargains at the flea market held on the site.

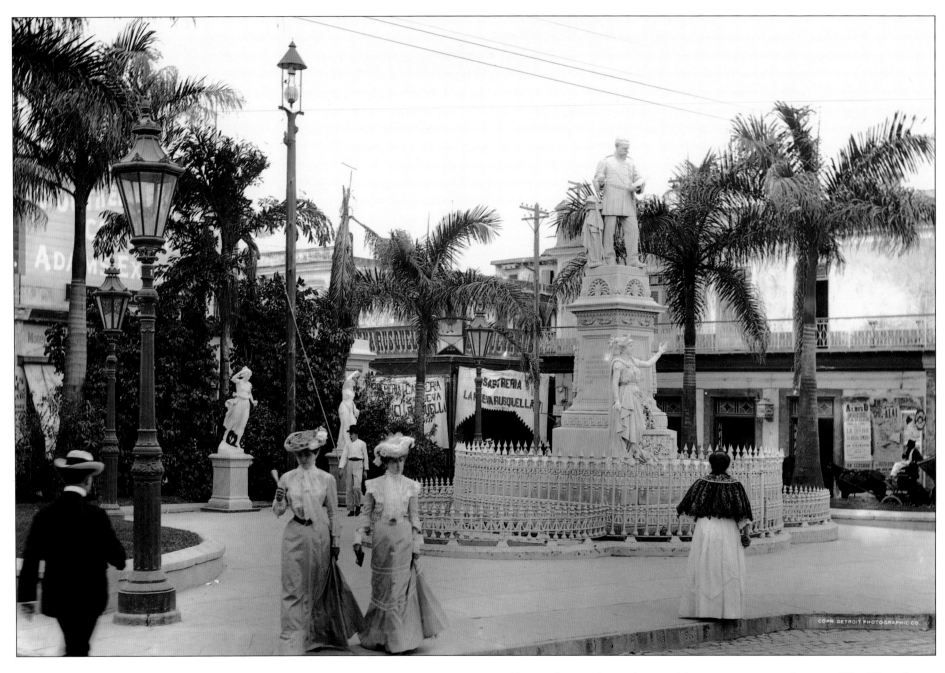

To the east of the Parque Central, where the old city walls once stood, is a statue of the famous engineer Francisco de Albear in a small square that now bears his name. Erected in 1895, it pays homage to the man who built the Havana aqueduct during the second half of the nineteenth century, thereby completing the old Zanja Real irrigation system that eventually proved insufficient for supplying the steadily growing city with water. The Plaza de Albear is found between the main commercial streets of the time—those of Monserrate, Bernaza, Obispo, and O'Reilly—and very near the Parque Central. In this picture, women in contemporary dress can be seen in the square following the custom that ladies should not go out walking alone.

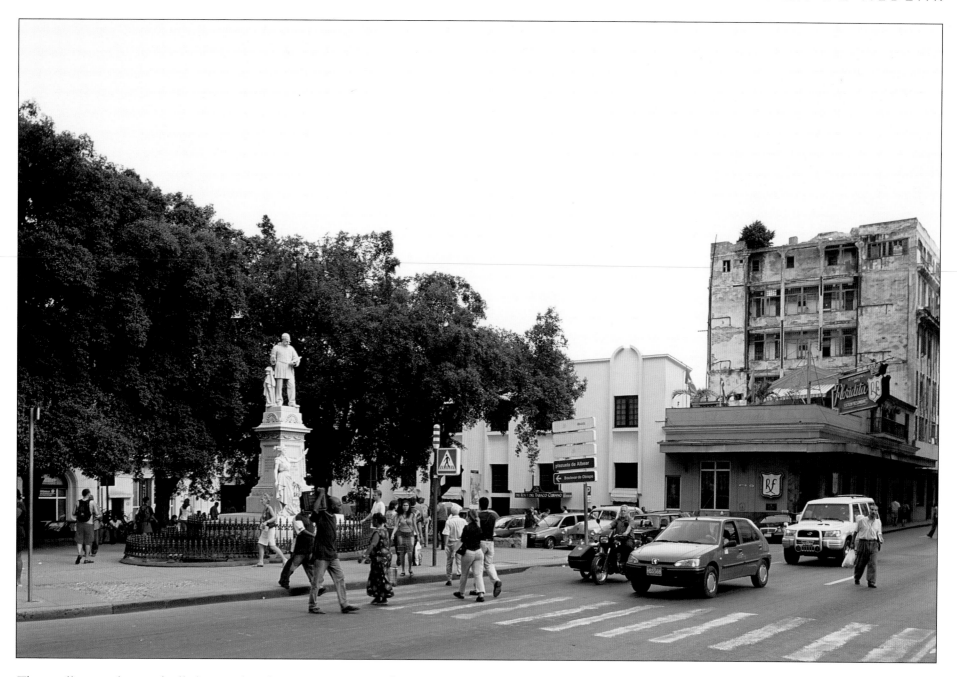

The small square has gradually been reduced in size over time and today there is barely room for the statue of the famous engineer. The square is located at the top of Calle Obispo, which leads into the historic center of Havana, and so it is still very busy. There are other landmarks nearby, such as the La Moderna Poesía bookshop and the El Floridita restaurant, which was made famous by Ernest Hemingway, who declared when he lived in Cuba, "My mojito in La Bodeguita, my daiquiri in El Floridita."

The story goes that Bishop Morell de Santa Cruz was expelled from Havana during the English occupation, and on his return in 1770 he lived on Calle Oficios. He would take his evening walk down this next street, which came to be known as Calle Obispo. Over time, the number of buildings with commercial premises on the ground floor and living quarters above—a style typical of the premises that sprang up inside the old city walls—multiplied. At the start of the twentieth century, Obispo was one of the busiest streets in Havana and was at the forefront of fashion. Here one could find anything from cafés to elegant boutiques, and it was one of the favorite haunts for Havanans who were out shopping or strolling.

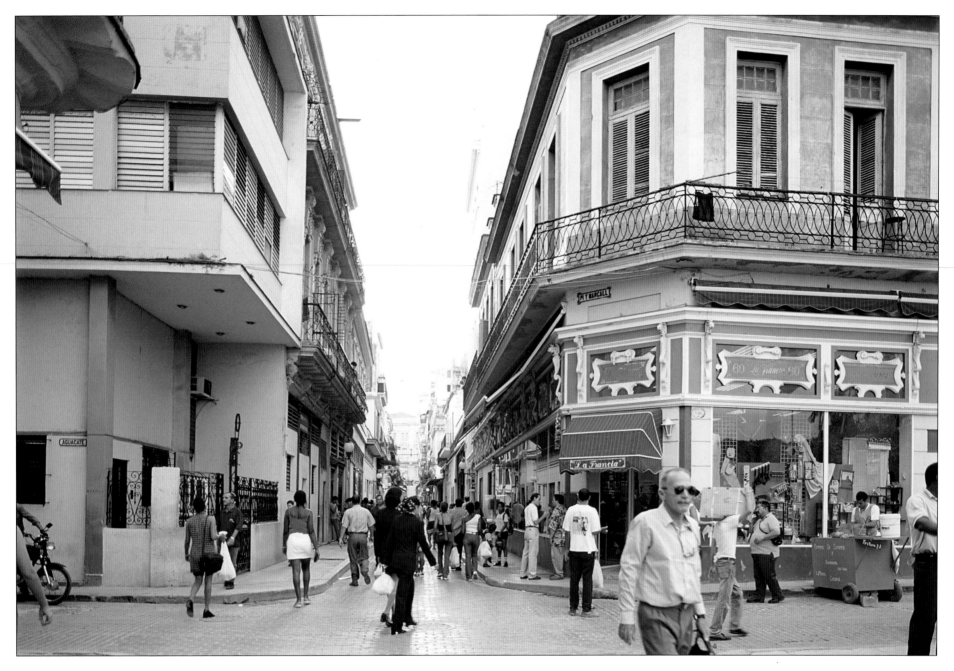

Today, Calle Obispo no longer has the awnings that store owners would throw across the street to shelter the public on hot summer days, which gave it the appearance of an indoor gallery. The narrow street has changed over time with the appearance of modern housing and offices with more stories than those permitted by the old building regulations. Little by little, it has lost its status as the center of fashion, as well as its colonial charm. Cars were excluded some years ago and it is again very busy, not so much due to its elegant stores but more a result of its strategic location between the Plaza de Armas and the Parque Central.

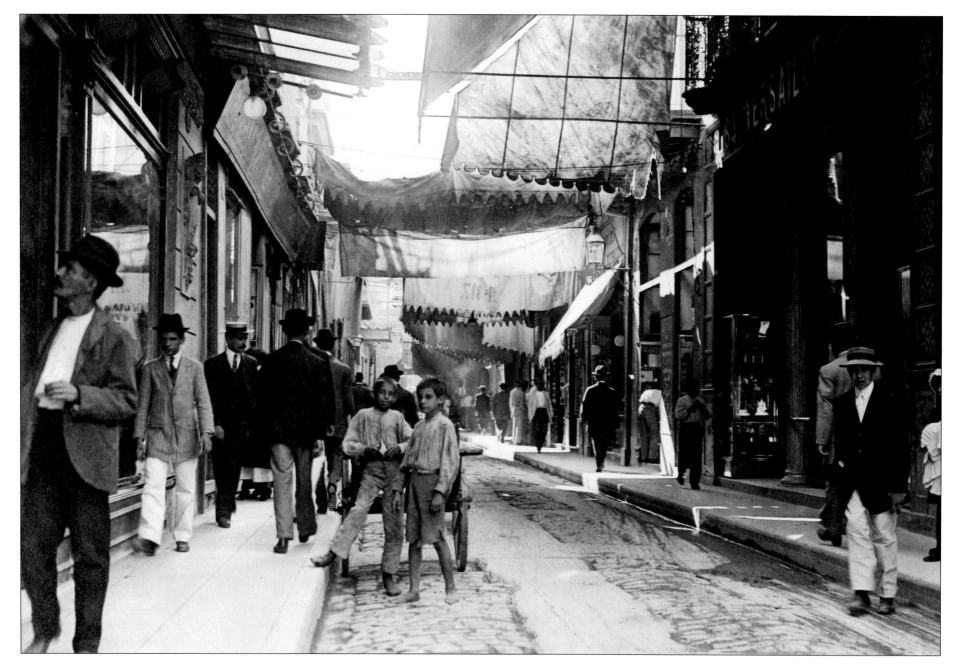

When the English handed Havana back to the Spanish in 1762, General Alejandro O'Reilly was sent from Spain to take possession of the city, entering the capital by what became known as Calle O'Reilly. Running parallel to the coast, the narrow street crossed the city from the Plaza de Armas to the street now known as Calle Monserrate, where the Plaza de Albear would later be built. Until well into this century, O'Reilly was one of Havana's main commercial streets, containing elegant, upscale boutiques whose products were displayed in modern store windows similar to those on neighboring Calle Obispo.

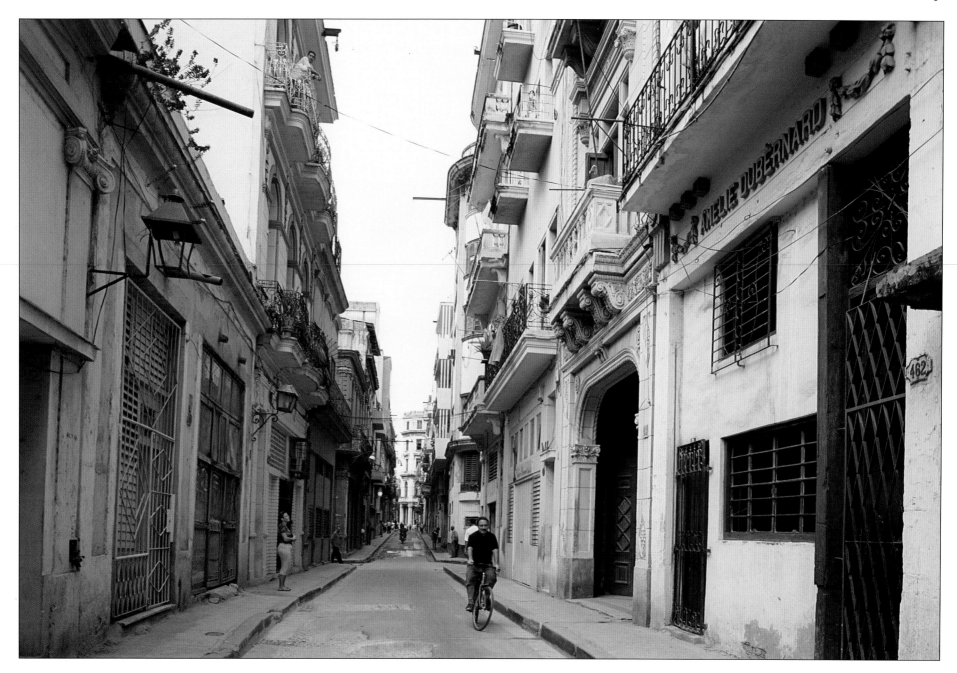

Calle O'Reilly has gradually changed; like nearby Calle Obispo, the elegant fashion boutiques were replaced by new office buildings and hotels. However, it did become well known for the bookstores that sprang up; some specialized in Cuban authors, others in foreign literature, but the most popular were those that imported the latest books and magazines from France. In the second half of the twentieth century, it lost its commercial prestige and the old buildings deteriorated quickly, but it is still used frequently for getting around Old Havana.

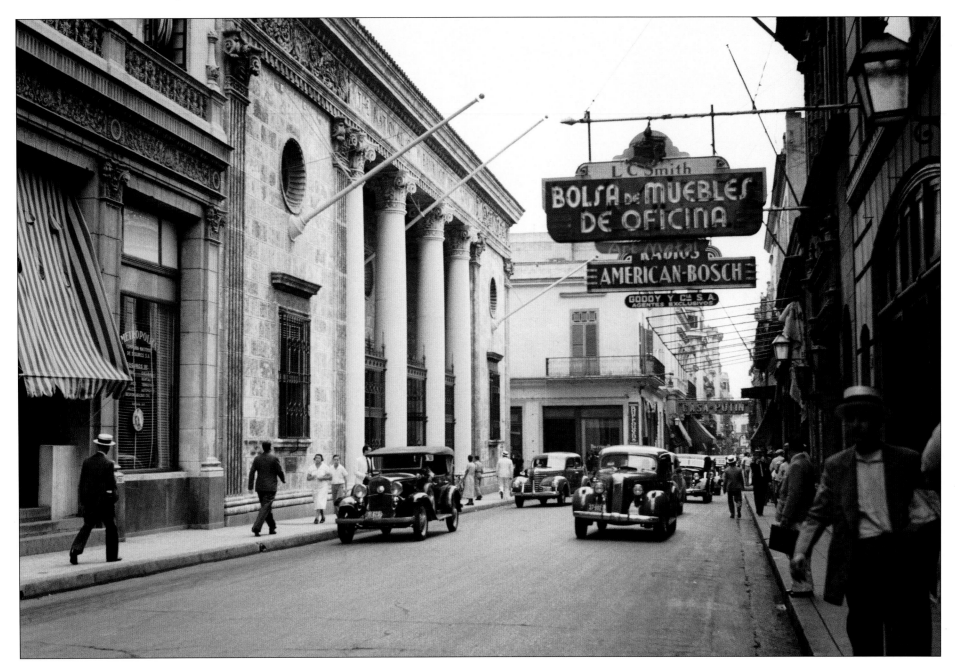

In 1925 the National City Bank of New York opened its Havana headquarters on Calle O'Reilly, on the corner of Compostela. The work of the American company Walker and Gillette, this was one of the last banks to be built in Old Havana, an area that had seen the addition of a great number of banks and offices during the previous decade. To increase its profile and to ease the flow of traffic through the area, the bank's facade was built a few feet back from the street.

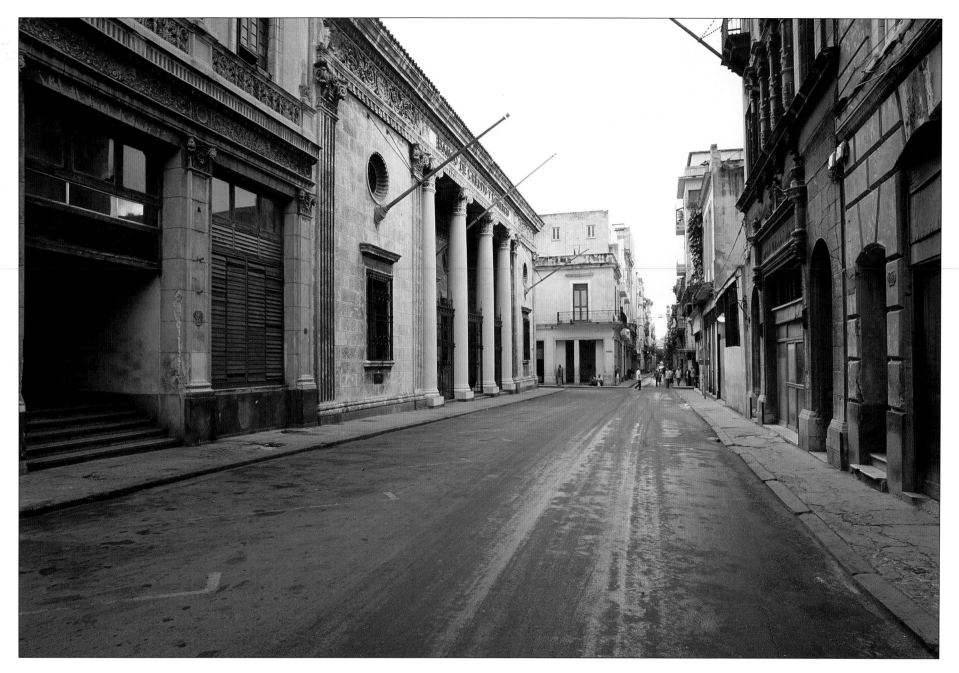

The National City Bank of New York stopped trading in Cuba when relations with the United States broke down after the revolution, and the building is now a branch of the Banco Nacional de Cuba. It retains its original grand appearance behind the simple yet elegant facade. As the bank is not located on a main thoroughfare in Old Havana and the popularity of Calle O'Reilly has waned, the building does not receive the recognition it deserves as an important commercial building of that era.

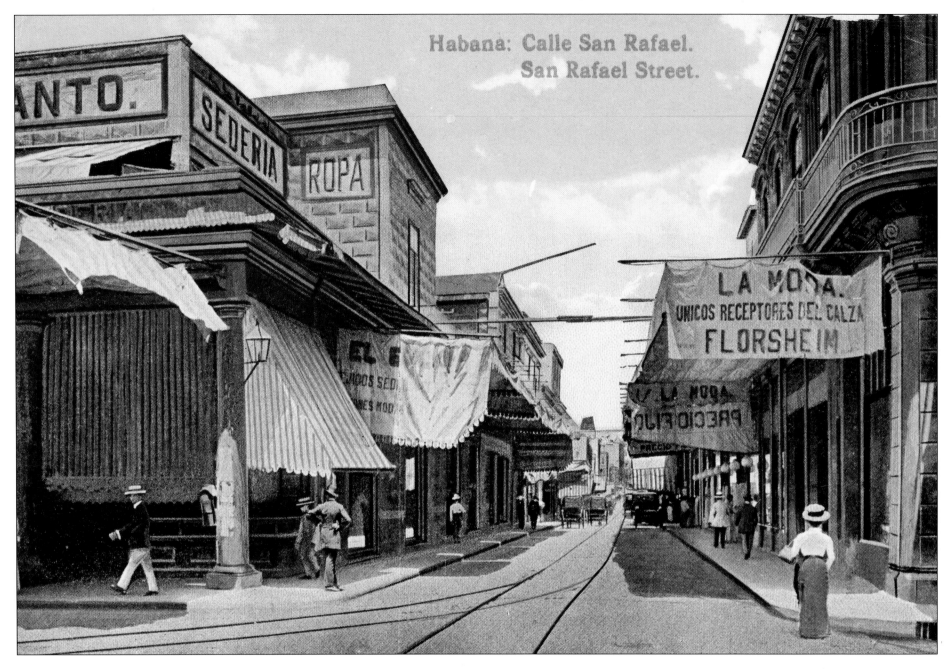

Habana: Calle San Rafael.
San Rafael Street.

In 1900, when most of the elegant stores were concentrated around Obispo and O'Reilly, clothing and shoe stores started to open on Galiano and San Rafael. Over the years the area would attract more and more Havanans. There was good access to San Rafael from even the most remote parts of town, as the tram line passed directly through the area. For this reason Galiano and San Rafael typified nineteenth-century Havanan street design. This postcard from c. 1910 shows the masses of storefronts that were on San Rafael at this time, including the famous Florsheim shoe store.

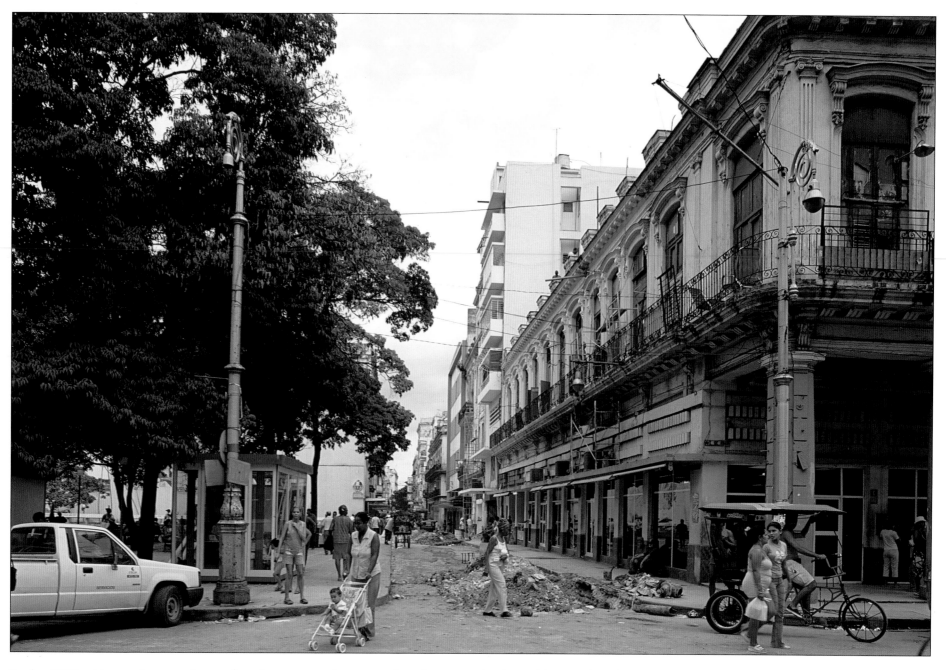

In the 1950s, this area became the most exclusive part of town, and modern buildings appeared among the turn-of-the-century surroundings. On this corner, the old El Encanto premises were replaced by a new building that was to be the height of Cuban fashion for many years. Seen as a symbol of quality and good taste, upper-middle-class women came from all over the country to be dressed here. After the revolution, it was destroyed in a fire started by counterrevolutionaries in which a store assistant, Fe del Valle, died. The park on the site of the old store is named for her. Despite the scarcity of products, these streets are still very popular with the capital's shoppers.

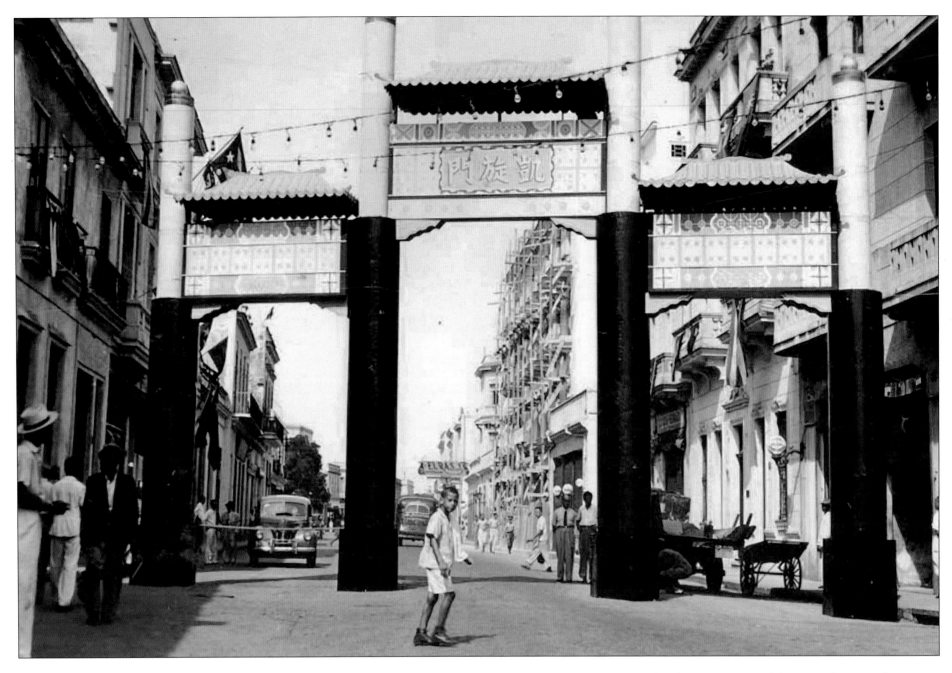

Chinese immigrants settled in Havana near the Tacón Market, in an area bordered by the streets of Zanja, Reina, Galiano, and Belascoaín. Around 1920, Havana's Chinatown was one of the most prosperous in Latin America, and on days of celebration a traditional decorative gateway was erected at its entrance on Calle Zanja. The area boasted some extremely rich merchants who would try and attract the public to their street festivals or to functions at

the Shanghai Theater. In its heyday, it was one of the most famous Chinese theaters in Latin America and, according to Alejo Carpentier, comparable only to those of San Francisco and Lima. Despite being marginalized by certain factions of Cuban society, the Chinese gained a reputation as an honorable segment of society, and it was often said that their men were "excellent husbands and even better fathers."

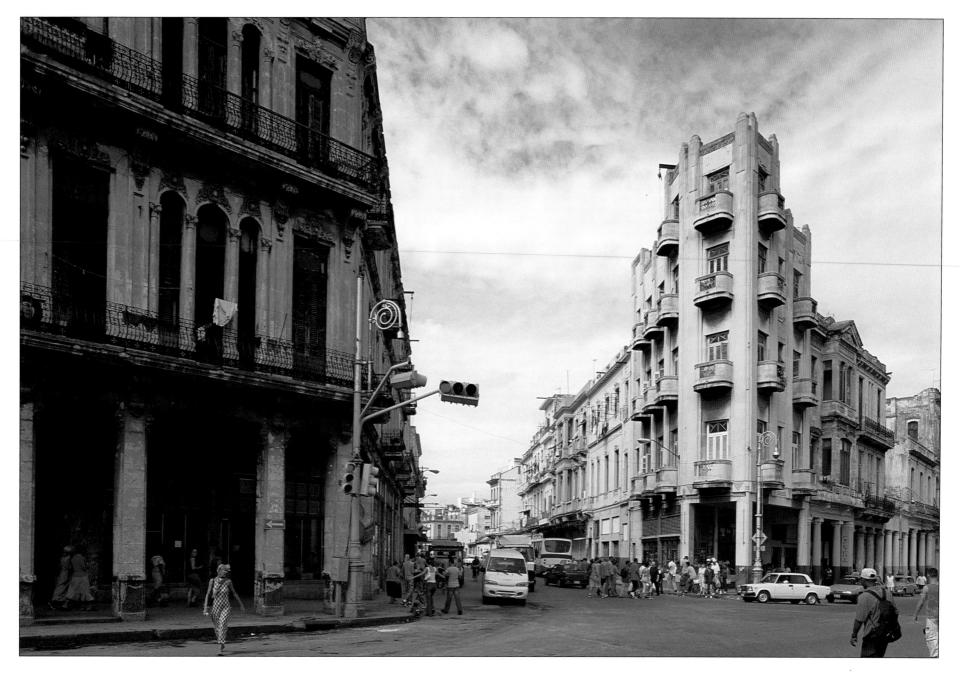

Until a few years ago there was hardly any evidence of Chinatown on Calle Zanja. This historical quarter had all but disappeared, along with the merchants who sat in their stores' doorways selling china, silks, perfume, traditional ointments, and natural remedies. But recently the descendants of this community revived Chinatown's traditional activities and opened restaurants and stores selling fresh produce on one of the nearby streets. One building, designed in the elaborate style typical of 1940s Havana, stands out on this narrow corner where Calle Zanja meets Calle Galiano.

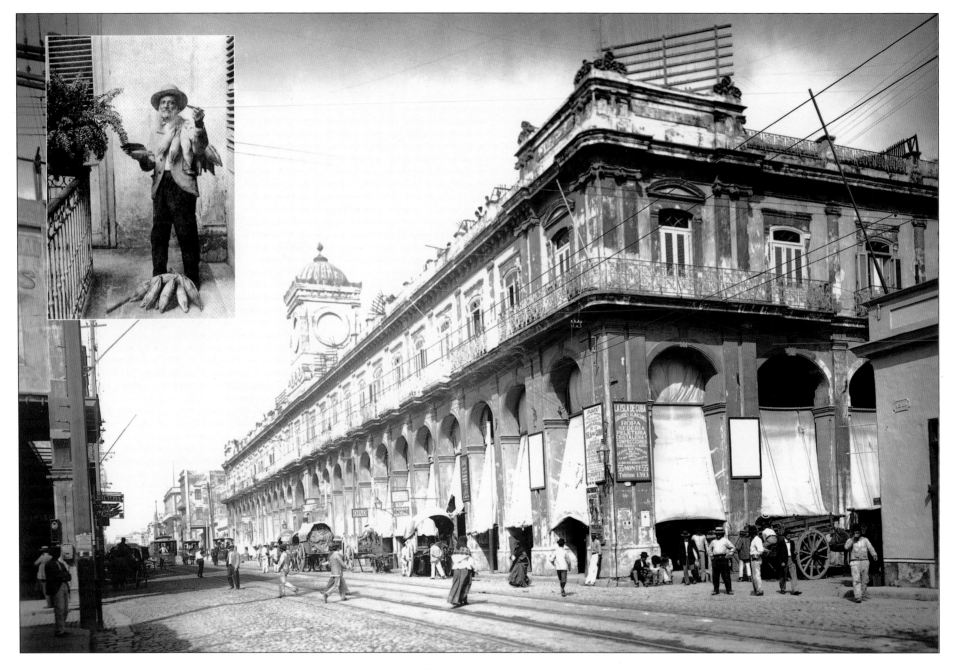

The buildings on the Plaza del Vapor were destroyed in a fire, and in 1876 the Tacón Market was built on the site. As this 1916 photograph shows, the market took up a whole block. Tobacco, an important crop grown on the island since colonial times, was traded here. The best-quality tobacco was grown in the area called Pinar del Río, especially in Vuelta Abajo—this area is famous for the quality of its smooth, aromatic tobacco leaves (inset).

Immigrants from the Canary Islands came over en masse to cultivate tobacco. Many historical figures have been partial to a Havana cigar, but the most famous has to be Winston Churchill, for whom the company Romeo y Julieta would prepare cigars to his personal specifications. This led to the popularity of Churchills, long Havana cigars celebrated the world over.

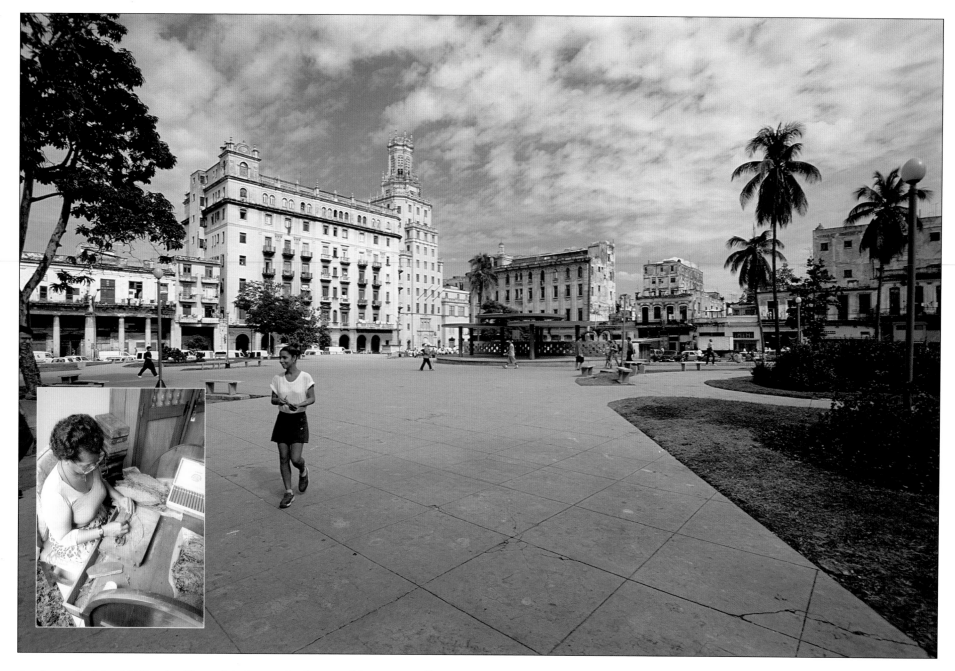

At the end of the 1950s, the Tacón Market—which some Havanans still called the Plaza del Vapor—fell gradually into disuse. The market no longer fitted in with the elegant boutiques on Calle Galiano or with other distinguished buildings going up in the area, such as that of the telephone company. After the revolution, the building was demolished to make way for a high-rise. However, this project never came to fruition; the land was simply leveled out for a park and parking spaces. The cigar business still thrives though. It takes years to master the art of rolling the perfect cigars that allow air and smoke to circulate to the correct degree inside. Today tobacco rolling (inset) is recognized as a great skill, one that is passed down from generation to generation.

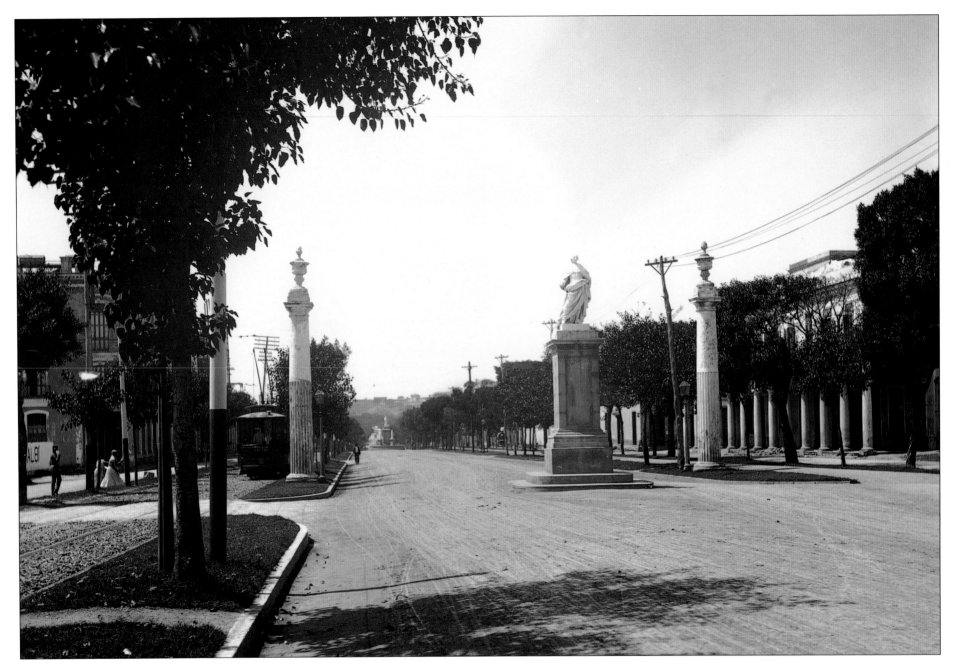

Built between 1834 and 1838 for military parades, the Avenida de Carlos III was originally known as the Paseo de Tacón for the field marshal who built it. At one time it took over from the Paseo del Prado as the center of fashionable society, and it extended from the foot of the hill upon which the Castillo del Principe still sits, as far as the railway station for trains to Marianao. The statue of King Carlos III, who championed reform in Spain, can be seen in this picture taken at the beginning of the twentieth century from the direction of Calle Belascoaín.

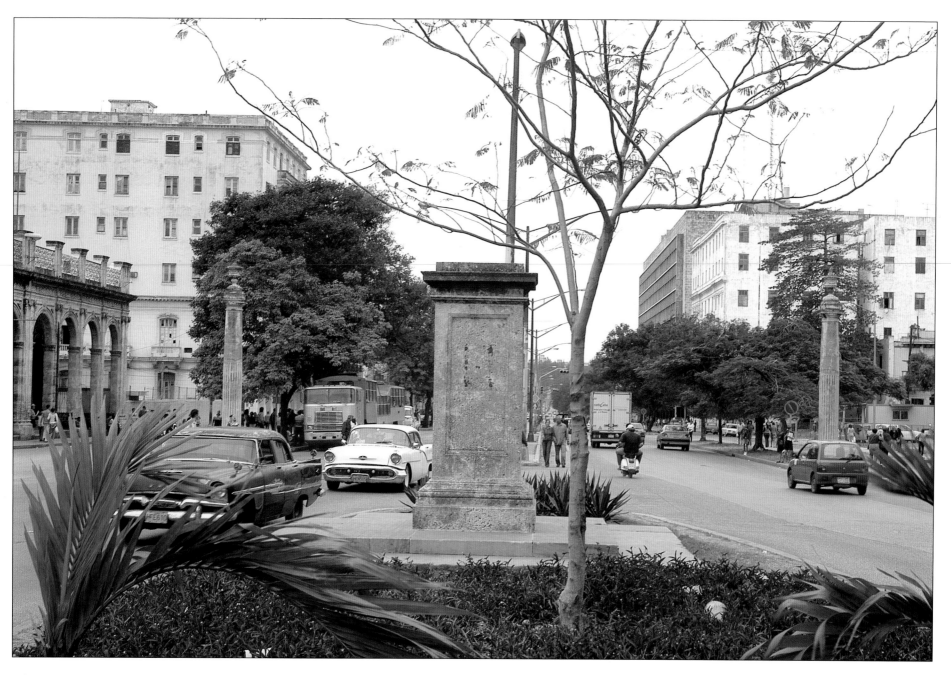

The avenue was renamed for a former president of Chile, Salvador Allende,
although locally it is still known as Carlos III. It is flanked by a succession of
architecturally eclectic buildings, most of which were built at the beginning
of the twentieth century. The marble statue by the Italian sculptor Antonio
Canova that once overlooked the avenue can now be seen in the Palacio de
los Capitanes Generales under the protection of the City Historians' Office.

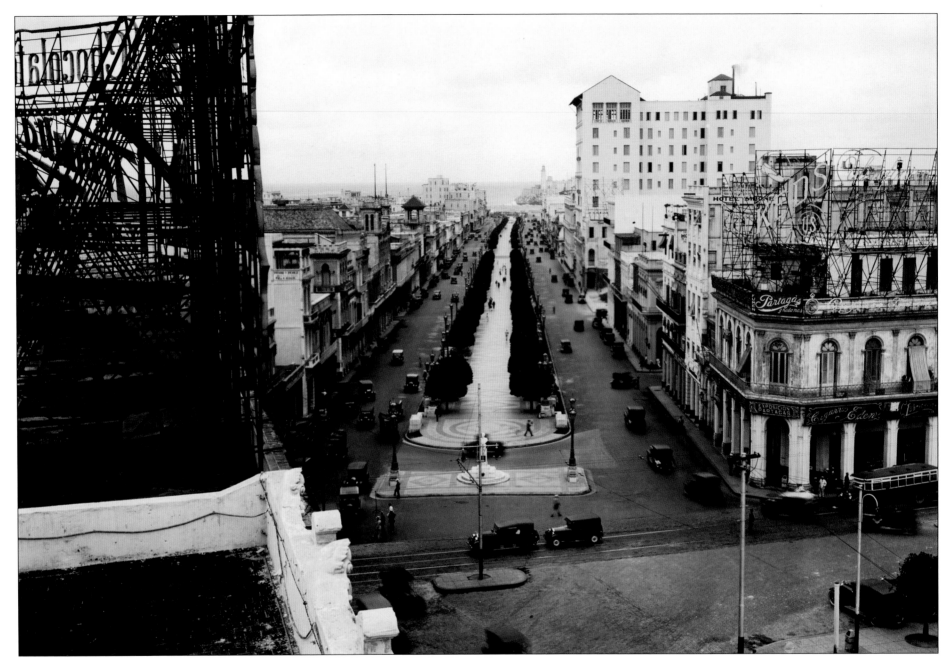

Conceived during the rule of Marquis de la Torre between 1771 and 1776, this promenade was originally known as the Alameda de Extramuros (the Avenue Outside the City Walls). It ran parallel to the city walls and ran from the coast to the Campo de Marte, near the Calzada de Jesús del Monte. After it was established, it quickly became the favorite promenade of polite society. Young men and women would come here to parade on foot, on horseback, or in one of the many carriages that were becoming popular in colonial Havana.

Eventually the pedestrian section would be limited to a wide pavement down the center of El Prado featuring benches and laurel trees. The side sections were widened at the beginning of the century to enhance the flow of traffic around the park and the Malecón, as this photograph taken in about 1930 illustrates. High above the buildings facing the Parque Central, the first neon advertisements in Havana can be seen.

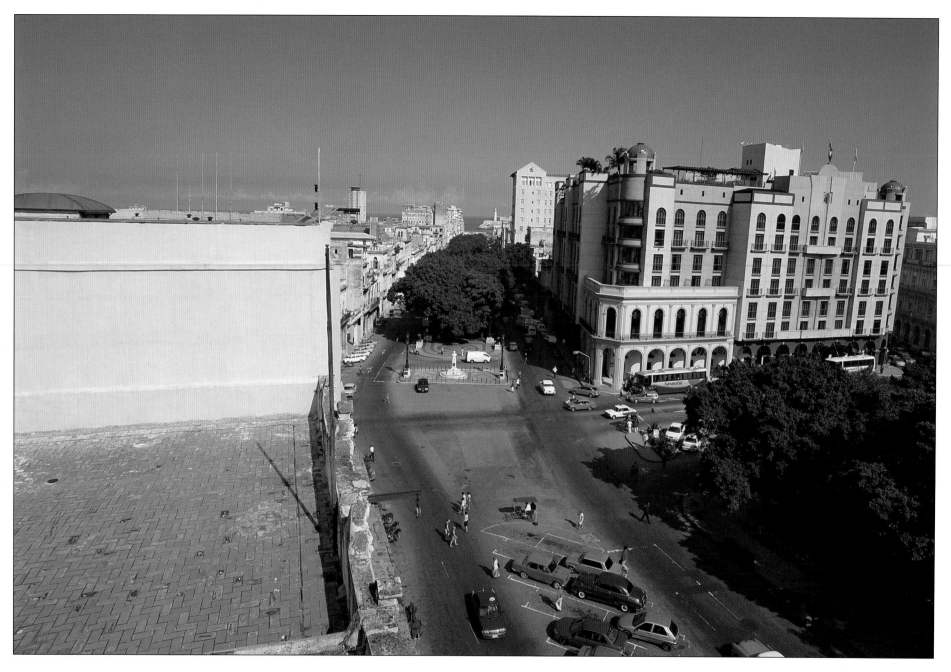

Today on the corner of El Prado and Neptuno is the Hotel Parque Central, whose style took advantage of the freedom of its postmodern surroundings. Previously, various stores and restaurants with apartments on the upper floors could be found here. Of the original building, only a part of the facade and one floor of the colonnade remain, but the signs of two of the original establishments—the Bar Partagás and the Hotel Siboney—can still be seen. Opened in 1998, this hotel is one of the most luxurious in Havana and is the most popular choice of American and European visitors. This photograph also shows the section of El Prado that runs past the Parque Central.

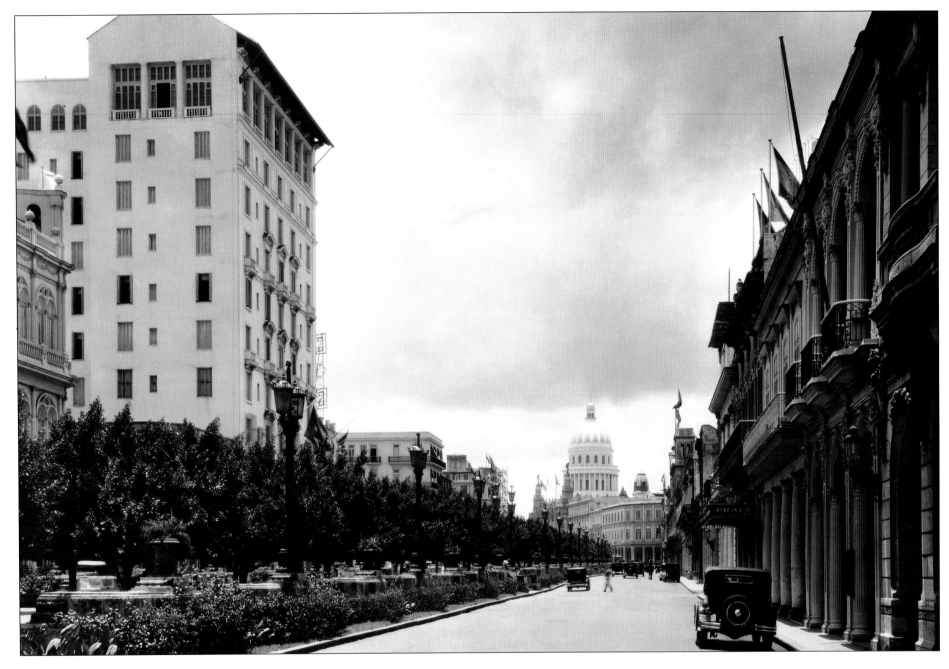

This view of El Prado dates back to the 1930s and shows the changes to the street at the beginning of the twentieth century, when major redevelopment of houses, social clubs, and hotels took place. Most of the buildings date from the first two decades of the century. They left behind the neoclassical simplicity typical of the nineteenth century and favored an excessive regard for past styles, which was then popular with Havana's nouveau riche. These buildings are characteristic of the eclecticism that pervaded Cuban architecture at the turn of the twentieth century. The Hotel Sevilla dominates the left side of the picture, while the Capitolio Nacional can be seen in the background.

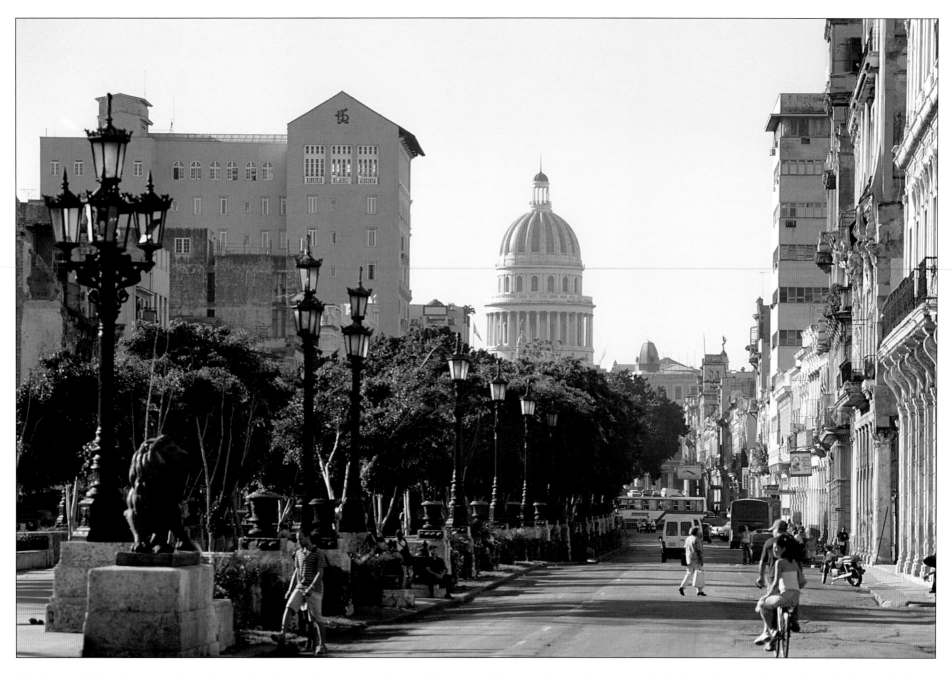

The Paseo del Prado was to be influential in the city's expansion beyond the city walls and established a style that was to be copied on other avenues within central Havana, such as Galiano and Belascoaín. This picture shows the changes made at the end of the 1920s, when the lions for which it is now famous were introduced. The Hotel Sevilla can be seen on the left of the picture, with the extension added in 1917 when it became the Hotel Sevilla Biltmore. Recently renovated, the hotel retains the roof garden from which a beautiful view of El Prado can be glimpsed. When it opened in 1908, it was one of the most luxurious hotels of the time and was the first choice for American tourists who expected modern luxuries like private bathrooms, electric lighting, and telephones. It was the first tall building in the area, and it is said that jazz was played for the first time here in Cuba around 1919.

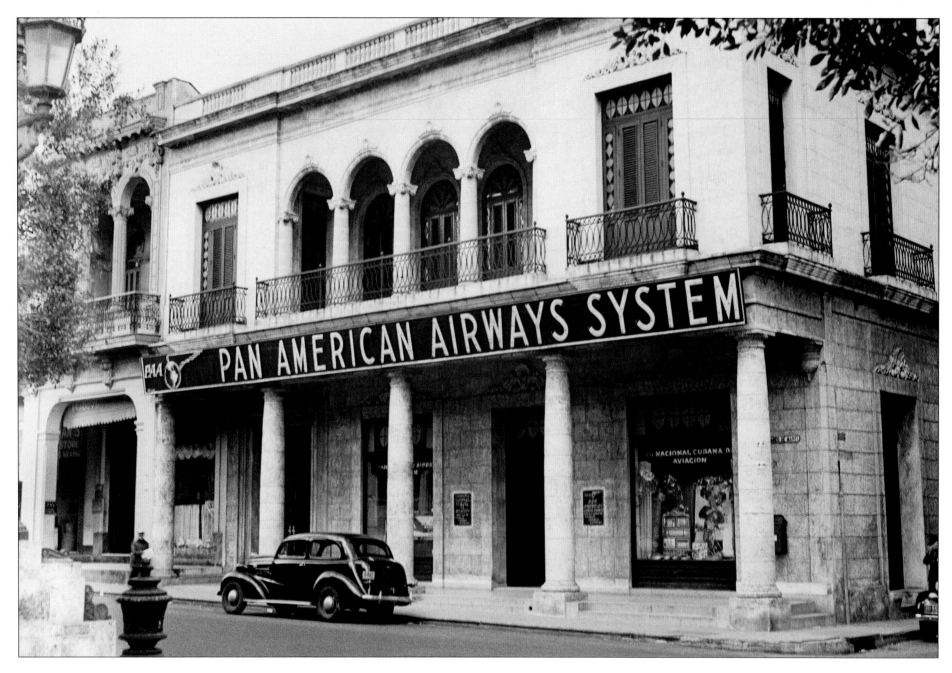

El Prado was a fashionable residential area for politicians, as well as for Cuban and American businessmen. Many buildings of different styles were constructed, all with colonnades and balconies characteristic of the nineteenth-century aristocratic mansions once fashionable in the city. When regular flights to Havana began in 1928, Pan American Airways moved into such a building. The airline was created in 1927 with the aim of developing international flights from the United States, using Florida as a base. On October 28, 1927, Pan American began the world's first scheduled international air service with a ninety-mile mail run from Key West to Havana.

The Pan Am branch remained in Havana until relations with the United States deteriorated. The office had long since disappeared by the time the company went out of business in 1991. Today there is a school on the premises. Some *bicitaxis* can be seen parked in front of the school. These rickshaw-style tricycles have become a popular mode of transportation in Havana, especially in Old Havana. To get the most out of them, some owners customize the tricycles in an attempt to carry more passengers.

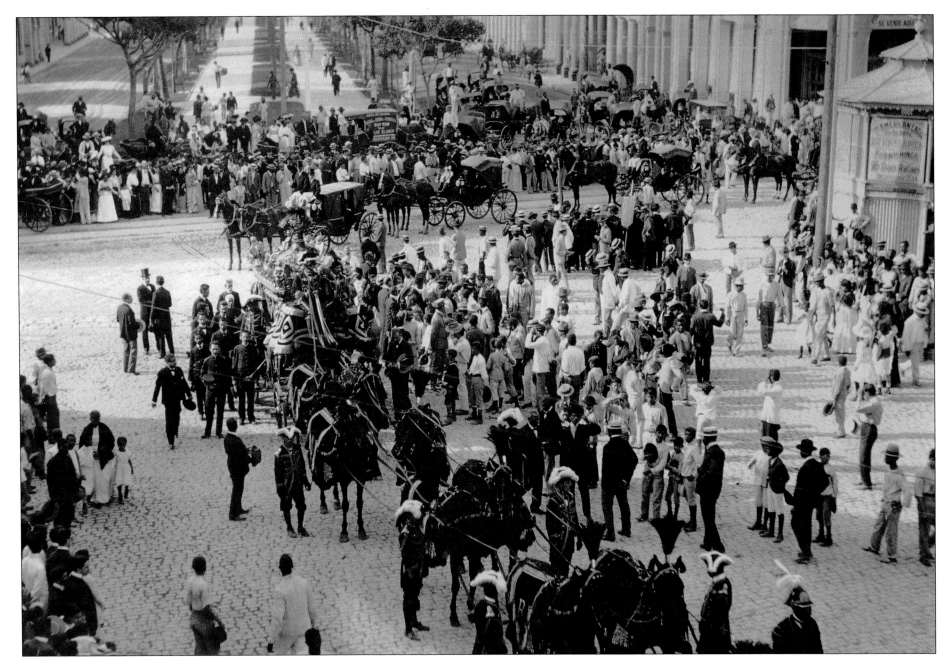

At the time of the republic, the corner of El Prado and Neptuno was one of the city's big meeting points and was the scene of many events, including the Havana Carnival. Havanans have always been known for celebrating, and they would come from all parts of the city, pass in front of the Capitolio, cross the Parque Central, and head down El Prado toward the Malecón. The corner was known as a place to meet people from all walks of life, and became famous when the creator of the cha-cha, Enrique Jorrín, wrote in his song "La Engañadora": "*En Prado y Neptuno, iba una chiquita que todos los hombres la tenían que mirar*" (On the corner of Prado and Neptuno there was a girl that all the men looked at).

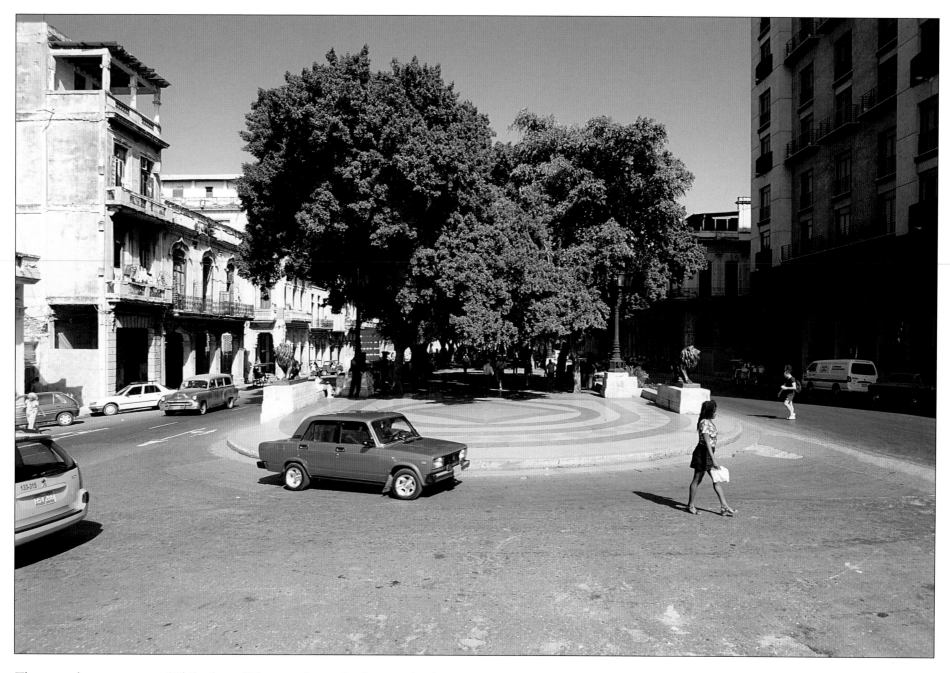

The once-famous corner of El Prado and Neptuno has today lost much of its charm. It is a gathering point for tourists to the island throughout the year and a crossroads for vehicles. Outside the Hotel Parque Central, a bus waits to ferry tourists from one side of the island to the other. Additionally, examples of the old American cars that have survived the years, thanks to the efforts of their owners, can be seen in this photograph. They are known locally as *almendrones* (big almonds), and can be seen daily picking up passengers throughout the city.

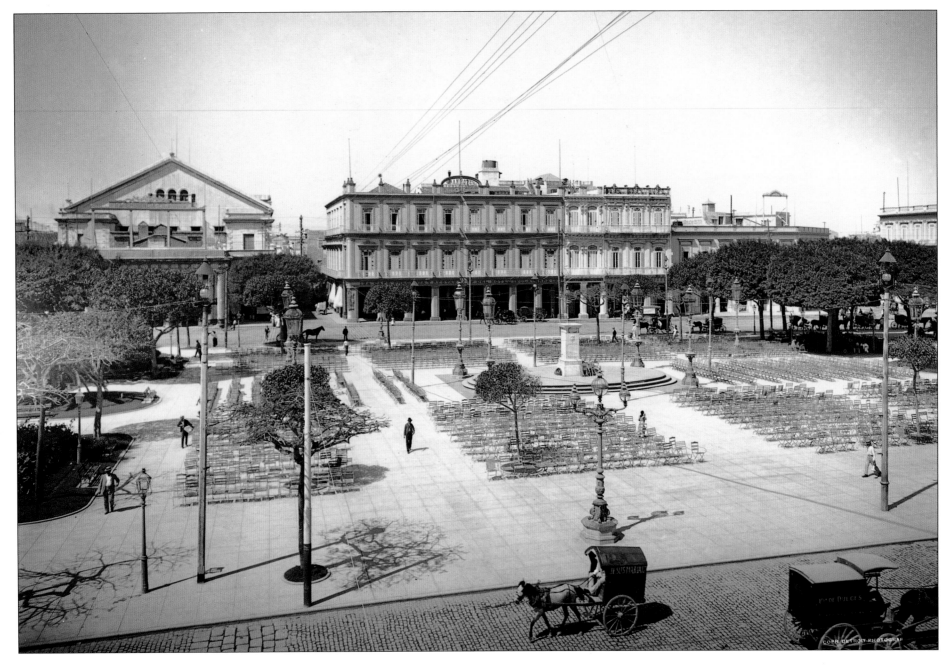

From 1836, the Parque Central—situated on the old Paseo de Isabel II (now known as El Prado)—became a favorite haunt in Havana. In that year the Teatro Tacón, the biggest and most luxurious theater of the era, was built alongside it. A number of famous international stars, such as Marie Taglioni, made appearances there. The importance of the park determined the development of what would become the city center in the second half of the nineteenth century. It was completed in 1877 when streetlights and railings were added in an attempt to reproduce an American style. In this picture taken around 1900, the old building of the Teatro Tacón and the younger Hotel Inglaterra can still be seen side by side, with horse-drawn carriages in the foreground.

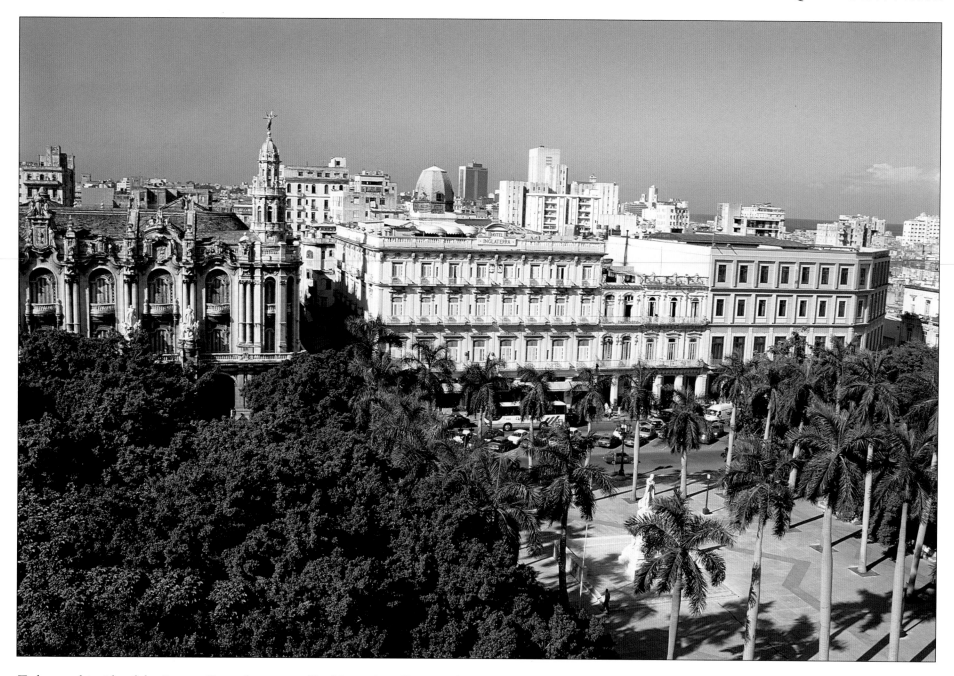

Today on this side of the Parque Central is a row of buildings that illustrate the various stages of Cuban architecture. On the left is the Centro Gallego, built at the turn of the century. Next to it is the Hotel Inglaterra, which dates from the nineteenth century, and at the right is the recently-opened Hotel Telégrafo. All that remained of this building was a facade hiding derelict land until it was redesigned in accordance with the needs of the modern tourist. In the distance the tall buildings of Centro Habana and El Vedado can be seen.

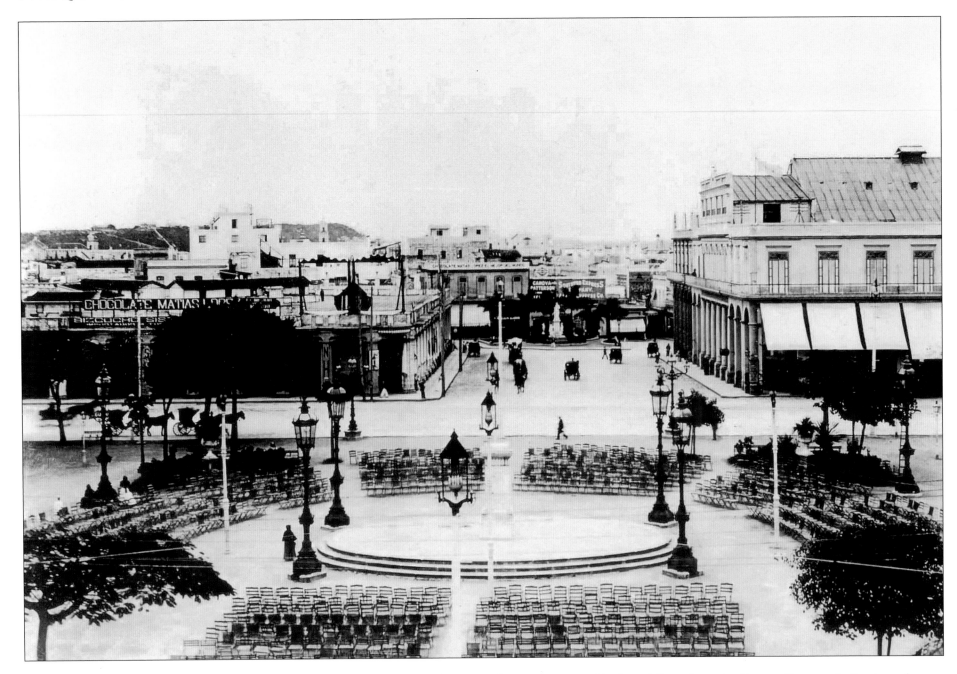

This photograph, taken from the opposite side of the park at the turn of the twentieth century, shows the Parque Central from the Hotel Inglaterra toward Old Havana. Seats have been placed around the bandstand in preparation for an open-air concert. In the background is the Plaza de Albear and on its right, the building that housed the Centro Asturiano and the Albisu Theater. The theater was owned by José Albisu from the Basque Country in Spain and was devoted to the genre of Chinese theater, which was popular in Spain at the time. During the Cuban War of Independence, it was where the Spanish would gather to celebrate the colonial army's victories over the rebels. To the left of the picture is the old Manzana de Gómez building.

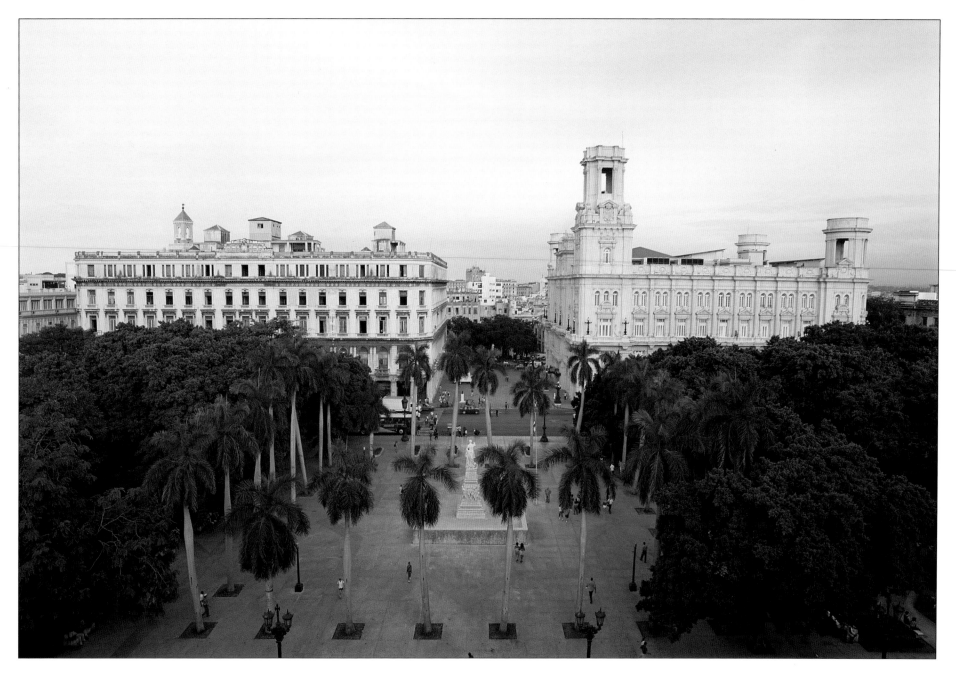

Today the Parque Central is one of the city's few green spaces, and its original charm has been enhanced by the restoration of what was the Centro Asturiano in the 1930s. Much like the Centro Gallego, it was built as a meeting place and named for a region in northwest Spain. It was designed by the Spanish architect Manuel del Busto and combines the Spanish Baroque and Plateresque styles. It is testimony to the varied tastes of the Spanish who remained in Havana at the end of the War of Independence. It is now the National Museum of Fine Art, which houses the Joaquín Sorollas paintings, a selection of eighteenth-century English portraits, a number of Greek urns donated to the museum by the Conde de Lagunillas in the 1950s, and other treasures from across the years. To the left of the picture is the new Manzana de Gómez building. The statue of José Martí that has dominated the Parque Central since the beginning of the republic can be seen in the center.

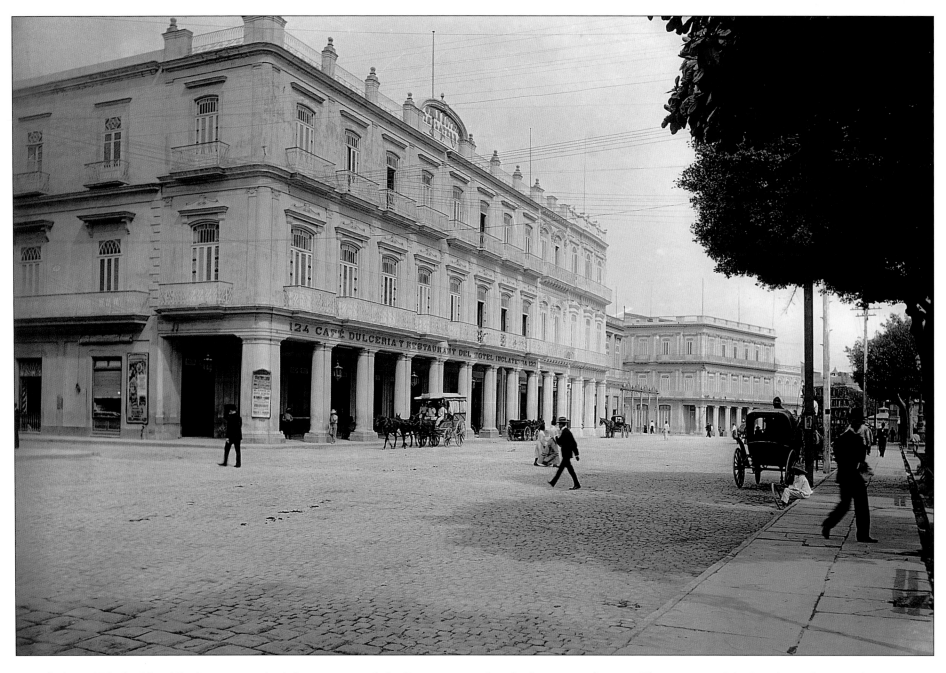

Founded in 1875, the Hotel Inglaterra enriched the area around the Parque Central, especially since its expansion when it took over the adjoining buildings in 1890. The hotel was built on part of what used to be the famous Acera del Louvre, where the youths who rebelled against Spanish rule would gather. The third floor was added in 1890, resulting in the neoclassical facade for which it is now known. The interior of the hotel was decorated in a Mozarabic style reminiscent of southern Spain. Being so close to the Parque Central, it was a fashionable venue for the youth of Havana well into the twentieth century.

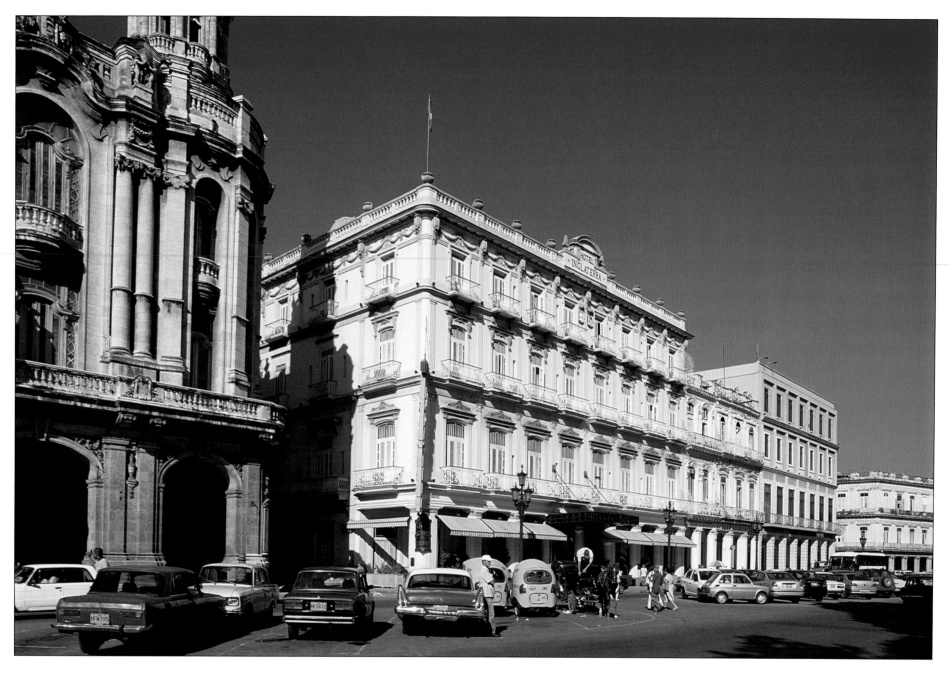

The current hotel management is trying to keep the hotel's traditions alive. Many of the city's famous visitors from the world of entertainment have stayed here, including Sarah Bernhardt, Anna Pavlova, the bullfighter Luis Mazzantini, and the singer Imperio Argentina. Due to its location and its ambience, the U.S. war correspondents who helped foster the first American intervention preferred to stay in this hotel. During the last few years there has been a drive to attract tourists to Cuba and this has brought about some much-needed restoration work. Today the building is totally restored and is busy both day and night.

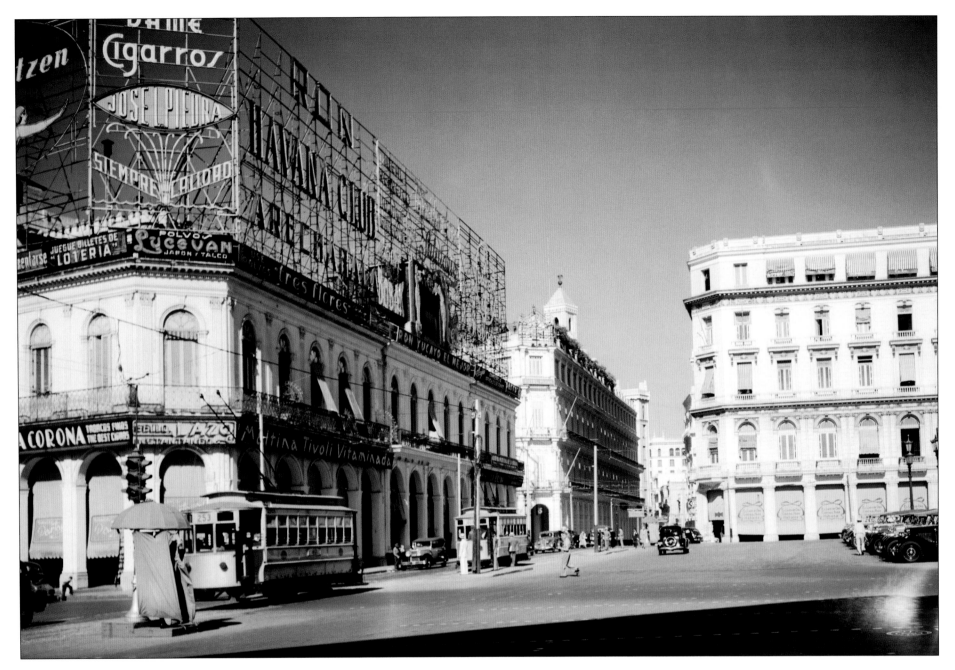

This picture of a corner of the Parque Central shows the new Manzana de Gómez building (*right*) that opened in 1919 and which, during the first half of the twentieth century, was the most popular commercial center in Havana and one of the first places to be built with a department store in mind. It was five stories high and took up a whole block bordered by the streets of Obrapía, Monserrate, Neptuno, and Zulueta. It was a type of exchange where shares of any type could be bought, and was owned by the Gómez Mena family. It is said

that in its heyday it supported twenty-five thousand people. On top of the building to its left, some popular 1920s advertisements can be seen. The author Graziella Pogolotti said that a neon advertisement appeared here that "flickered in the night showing the swimmer Jantzen dive off a diving-board, swim a few energetic strokes, and return to the starting point in a flourish of color and movement that didn't stop until dawn." Electric trams—the main form of public transportation at the time—can be seen in the foreground.

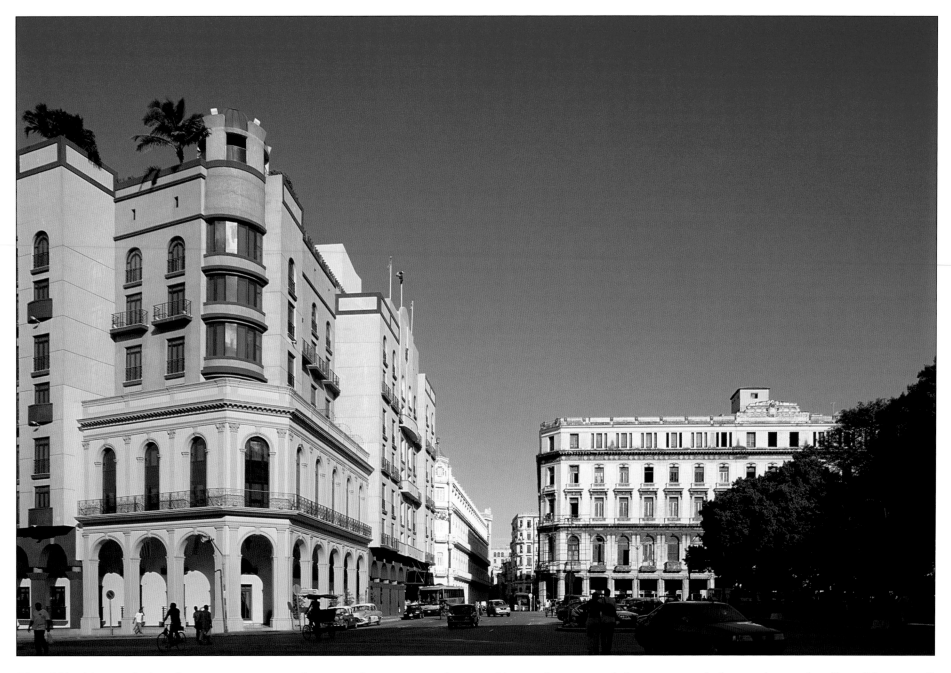

The old building with the advertisements on top disappeared years ago, and in its place is the Hotel Parque Central. The Manzana de Gómez has lost its original splendor but it is still very busy, partly as a result of its location and also because it allows access from one side of the block to the other along passages that cross through the interior of the building. Inside, some of the old stores have recently been reopened; they are known locally as "shoppings," as is any businesses where products can only be bought with foreign currency. Despite its wear and tear, the building's structure is still solid and the discreet design of its four facades still evident. The angles of the building are beveled, as was customary with corner buildings of that era.

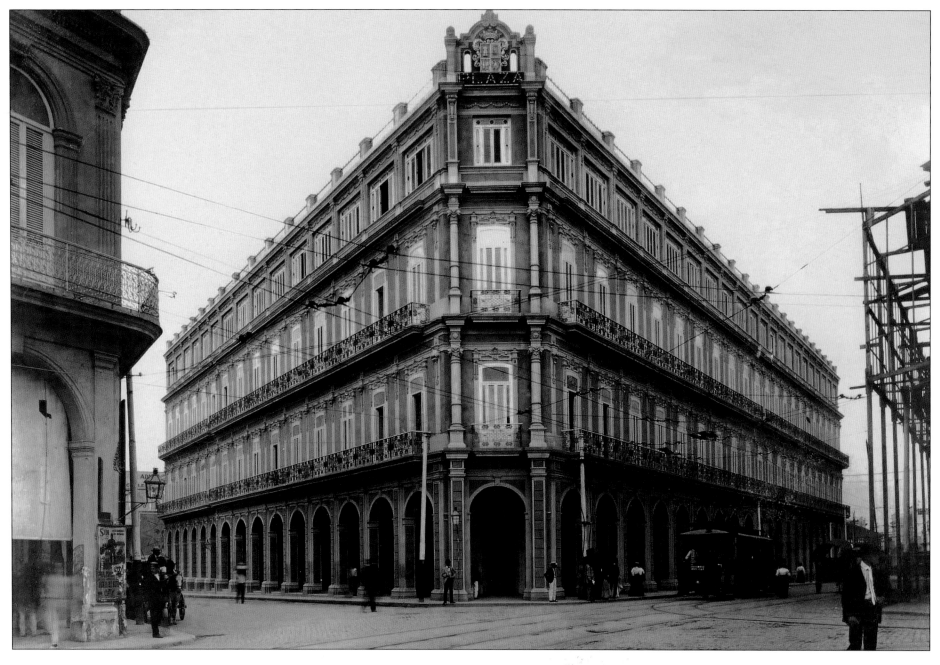

Until 1902 this building was the headquarters of the *Diario de la Marina,* a newspaper with ties to Spanish concerns on the island. When the newspaper moved to new premises, this building was bought by W. Fletcher Smith, a captain in the U.S. Army who came to Cuba with the occupying government. When the occupation ended he decided to remain on the island and become a businessman. After completely remodeling its interior, he opened the Hotel Plaza in 1906. In 1919 a roof garden with a restaurant and ballroom was added, and the locals were said to be very pleased to finally have "a corner of New York or Paris in the capital."

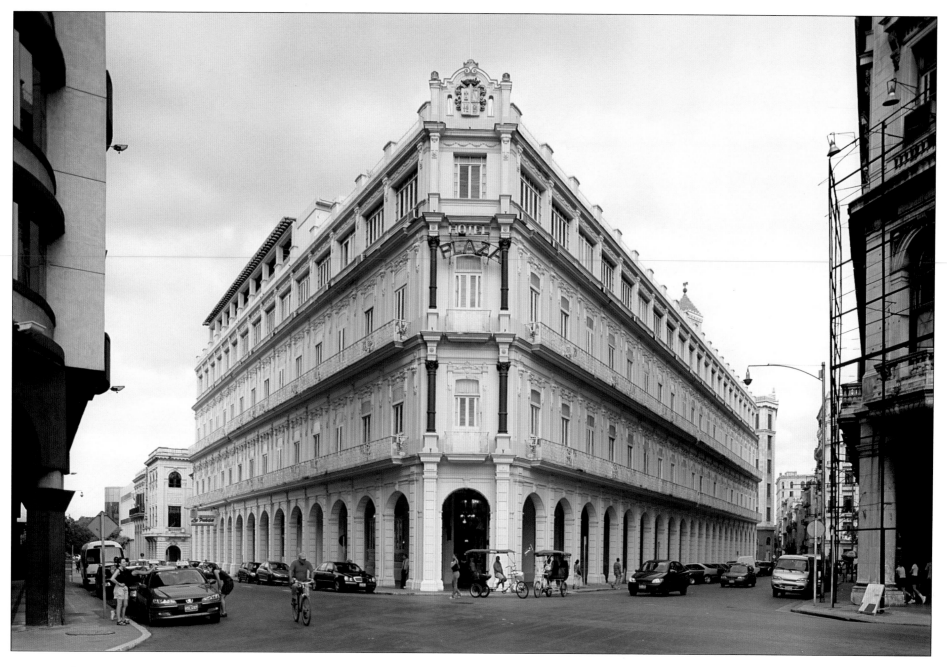

Renovated in the 1980s, the elegance of the Hotel Plaza can be seen down the length of its facades on both Neptuno and Zulueta. It is a typical nineteenth-century building, boasting colonnades and balconies with intricate ironwork; it does, however, have its original features, such as the corner entrance that takes advantage of the view over the park. It has changed very little throughout the last century, as the only alterations that were made to the building during its renovation were to update the guest rooms. Behind the hotel down Calle Zulueta, the fire station and the National Museum of Fine Art can be seen.

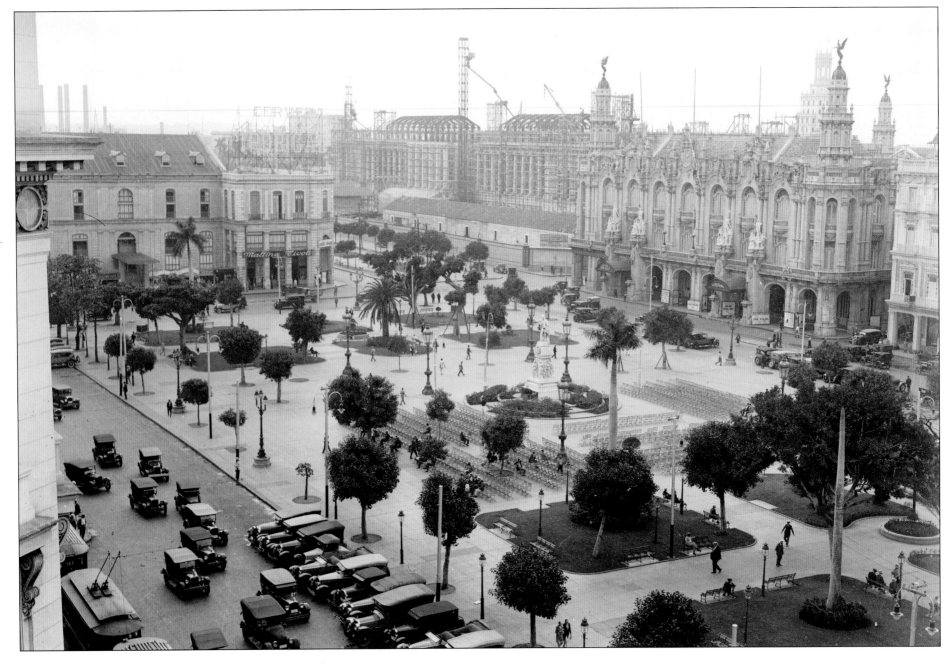

This view right across the Parque Central shows its appearance at the end of the 1920s. In the center rises the statue of José Martí, erected in 1905, and beyond that is the impressive Centro Gallego. Due to open in 1929, the Capitolio Nacional was under construction at that time, and the small square it would fill can still be seen. In the street below, the electric trams and cars of the era can be seen passing the park down Calle Zulueta.

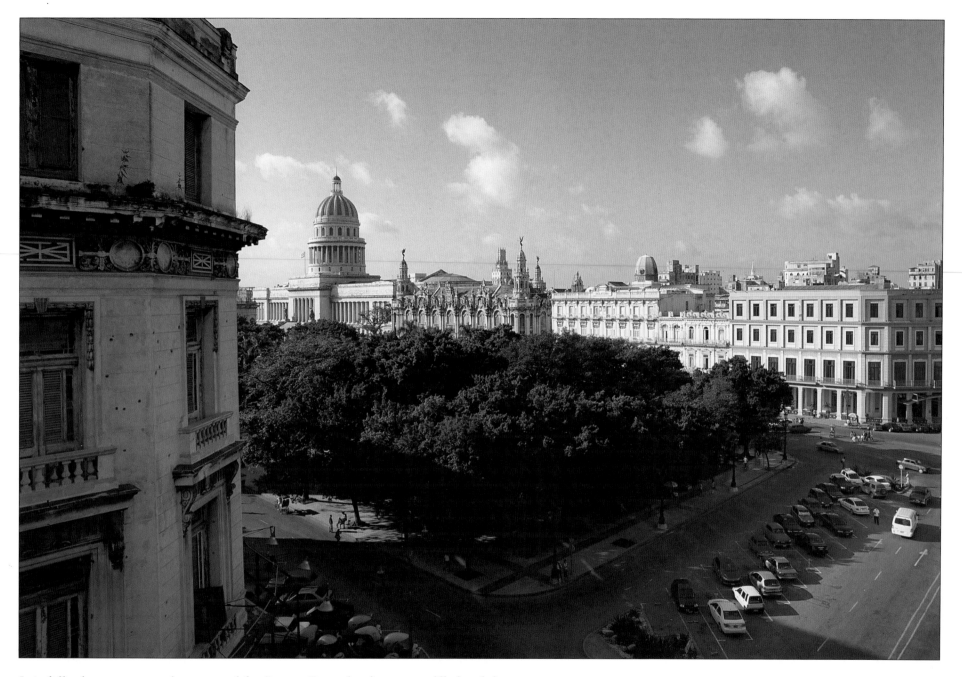

It is difficult to get a complete view of the Parque Central today, as it is filled with huge trees that protect passersby and those who stop to rest on the benches from the heat of the sun. In the background is the recently constructed Hotel Telégrafo; the efforts that have been made to retain the original nineteenth-century facade and have it blend in with the surroundings can be appreciated from this side view. In the foreground of the picture are some *cocotaxis*; they are a reasonably priced mode of transportation owned by the state, and are made from a combination of motorcycles and cabs shaped like coconuts.

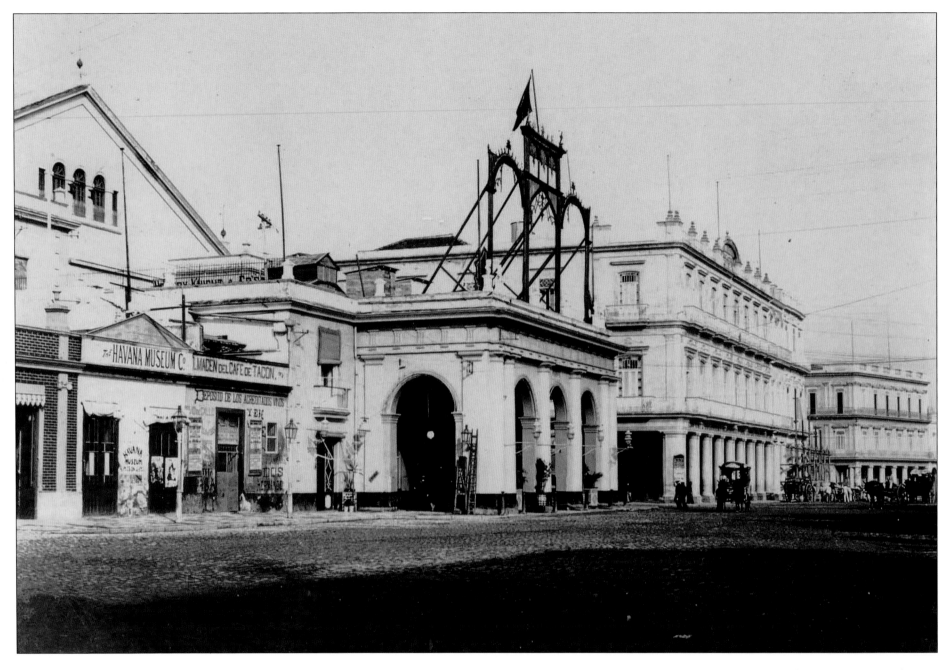

This theater near the Parque Central was named for the Spanish governor-general Miguel Tacón. During his rule from 1834 to 1838, Tacón did many good things for Cuba, as well as many acts of aggression—he started the construction of sewers in Havana, paved the streets of the city, built a great prison, and encouraged the construction of this theater. The theater held around 3,000 people and had events such as bullfighting, as well as plays and musicals. The great Austrian dancer Fanny Essler performed here in 1841 in the ballet *Sylph*.

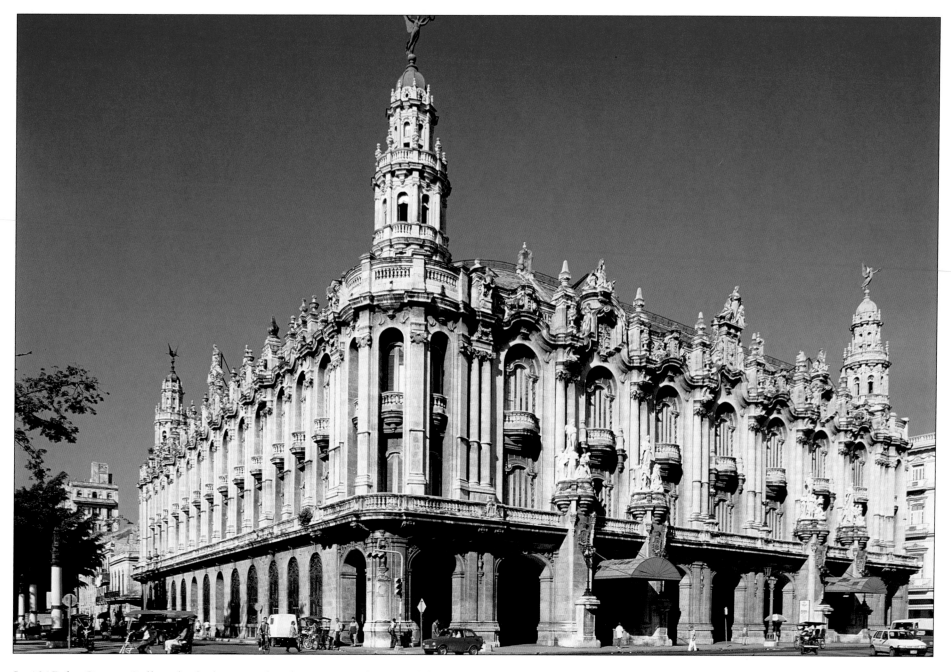

In 1917 the Centro Gallego built their new headquarters on the site of the old Teatro Tacón. Thought at that time to be the most expensive building ever constructed in Cuba, it has a neo-Baroque design with decorative elements on the balconies, windows, cornices, and even on the towers. Today the former Centro Gallego is the Gran Teatro de la Habana, the headquarters of the Cuban National Ballet. As well as holding regular performances, the company also organizes the annual Havana Ballet Festival. Many famous ballet dancers have performed at the festival on the invitation of Alicia Alonso, Cuba's most important prima ballerina. Every famous Cuban ballet dancer of the last fifty years has danced at the Gran Teatro, some of whom are regularly invited to dance with other prestigious European and American companies.

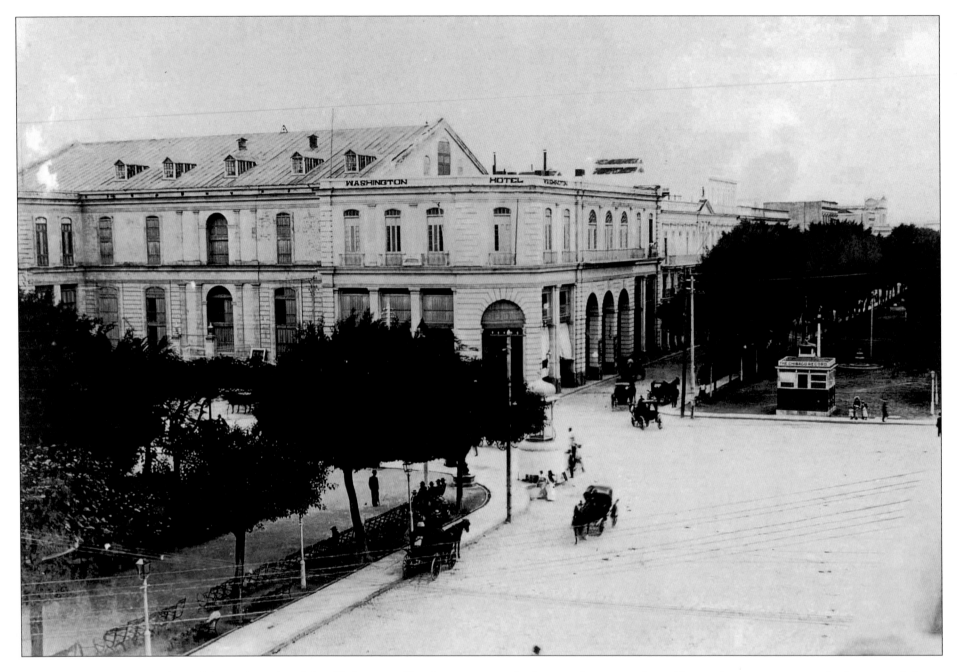

The Teatro Payret opened in 1877, to the right of the Washington Hotel on the corner where Calle San José met the section of El Prado. It came to symbolize Spain and, after the signing of the Treaty of Zanjón in 1878, was renamed the Teatro de la Paz (Theater of Peace). Its owner, the Catalan Joaquín Payret, entrusted the construction to Fidel Luna, who had previously worked on the urban expansion of Barcelona. The theater covered five stories: on the bottom floor were the stalls, on the next two were the boxes, and the top two contained the circle. It could house more than two thousand people. As fires were so common in the city's buildings, the owner had an iron frame specially imported from Belgium. Payret, who wanted his theater to rival the Tacón, dedicated it to opera and other highbrow forms of entertainment.

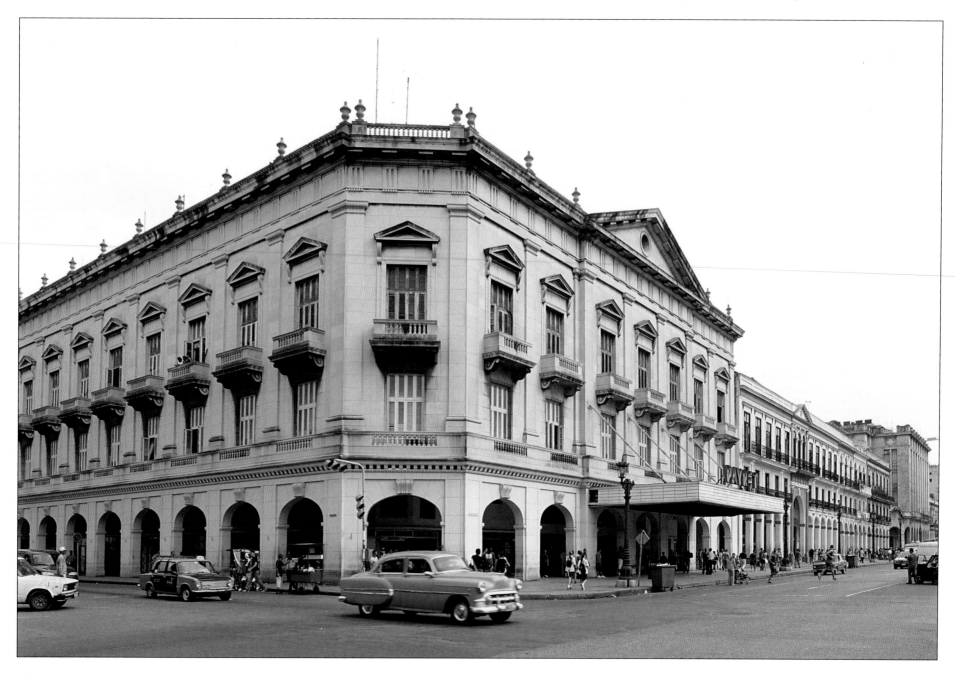

The Teatro Payret was closed in 1882 for many years. The building had already lost
some of its original elegance, and it wasn't until 1940, when it was bought by Falla
Gutiérrez, a well-known Cuban landowner and industrialist, that it was completely
rebuilt and became one of the greatest cinemas in Cuba. The refurbishment was
overseen by Cuban architect Eugenio Batista, who entrusted the sculptress Rita Longa
with all of the interior design. She had several famous sculptures in Havana, including
that of St. Rita in the church of the same name in Miramar.

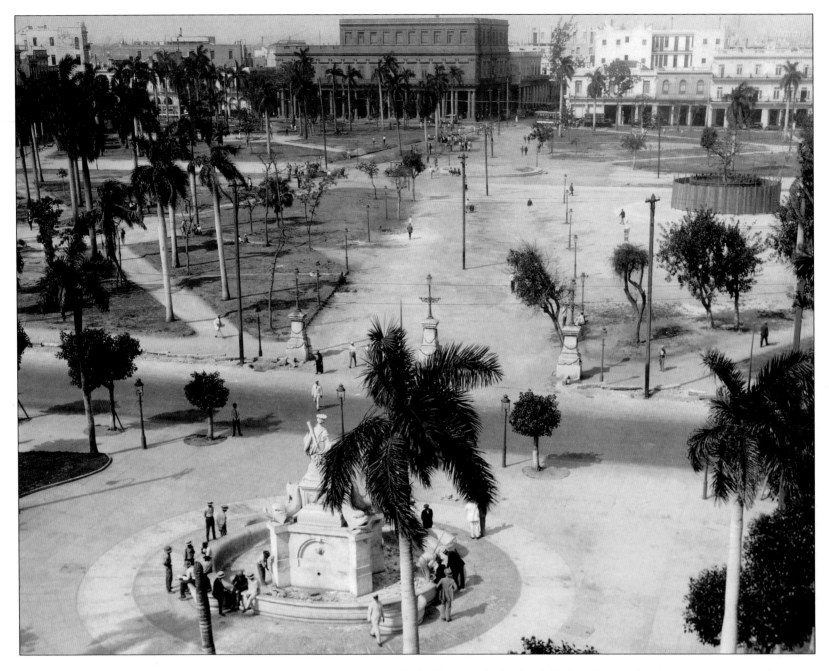

Opened during Marquis de la Torre's rule (1771–76), the Campo de Marte was conceived as a drill square where Spanish troops could do their military exercises and was located near the end of the Paseo del Prado. It was the starting point of both the Calzada de Jesús del Monte and the Calzada de Reina, which would form the bases of the city's expansion in the nineteenth century. It was also a place of leisure, being where hot-air balloon flights took off from during the nineteenth century. In this photograph, taken around 1920, the Palacio Aldama can be seen in the center, on Calle Reina. Until 1840, this was the most impressive building in Havana.

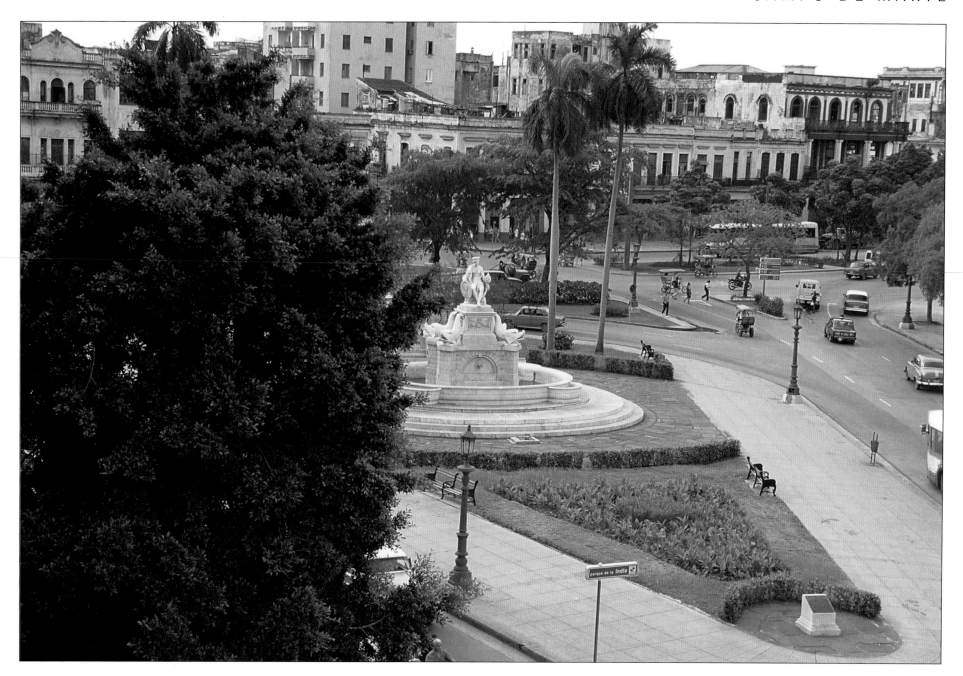

Over the years, the Campo de Marte has gradually been reduced in size. At
the end of the nineteenth century, it was no more than a garden containing
fountains, plants, and caged animals, and was known at the time as Parque
Colón. Then in 1929, as part of J. C. N. Forestier's remodeling of the city,
it was swallowed up by the Capitolio and surrounding buildings. Today it is
hard to pinpoint the site of what was once one of Havana's most beautiful
recreation areas.

FUENTE DE LA INDIA

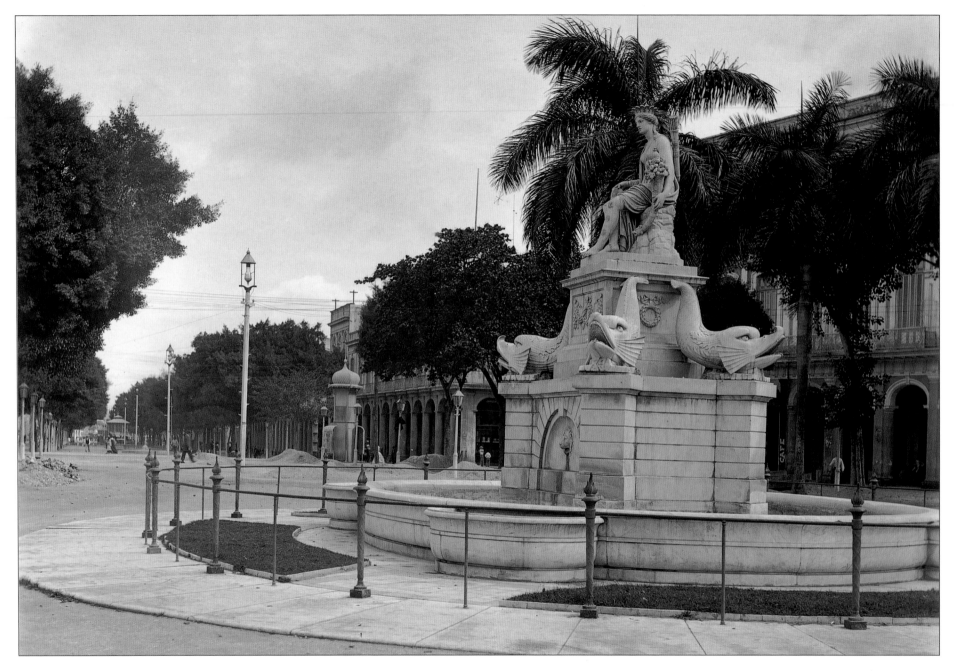

To challenge the arrogance that Miguel Tacón showed toward the native population, the Havanan landowner Conde de Villanueva—a prominent member of the Creole ministers with a certain amount of influence in Spanish circles—decided to draw up building plans mimicking those of the colonial governor. Tacón commissioned a fountain of Neptune from Genoa for one of the city's squares, so Villanueva did likewise but ordered a fountain depicting an Indian girl that he called "La Noble Habana." It was placed near the Campo de Marte but with its back to the door of the military barracks that was named for the governor, a symbolic gesture of disdain.

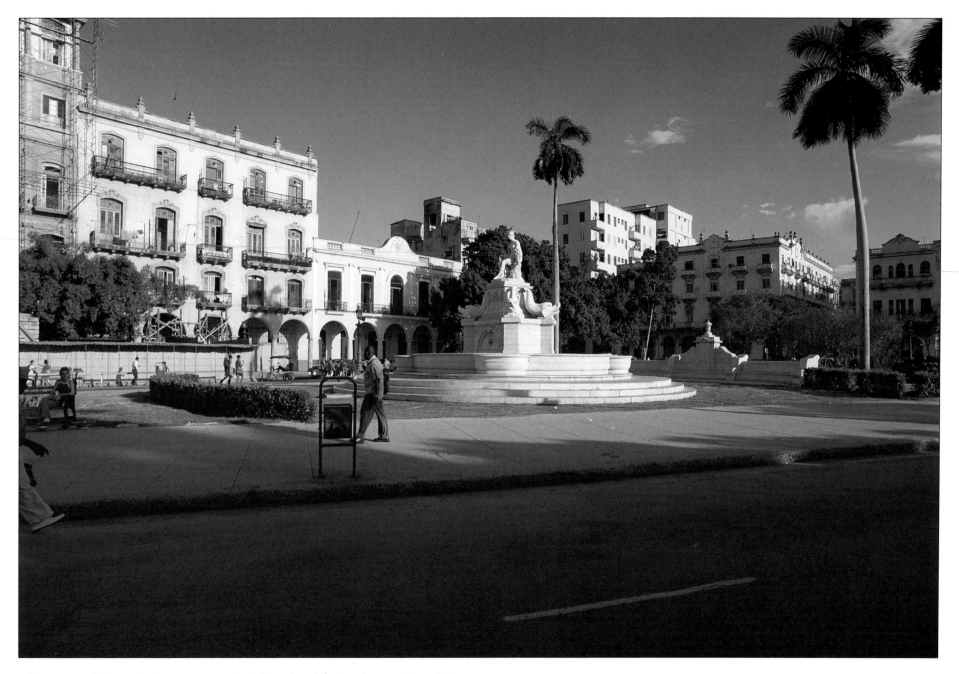

The Fuente de la India has not moved, although it has faced a number of directions over the years. Conceived as an allegory of the city, the fountain is carved from white marble and portrays a woman with indigenous features. Her serenity and elegance were understood to characterize the spirit of the new city and the independent temperament of the Creoles. The most popular symbol of nineteenth-century Havana, the locals still hold it dear to their hearts and recognize the sentiment behind it to this day. It is now hemmed in on all sides by apartments and hotels built in various architectural styles.

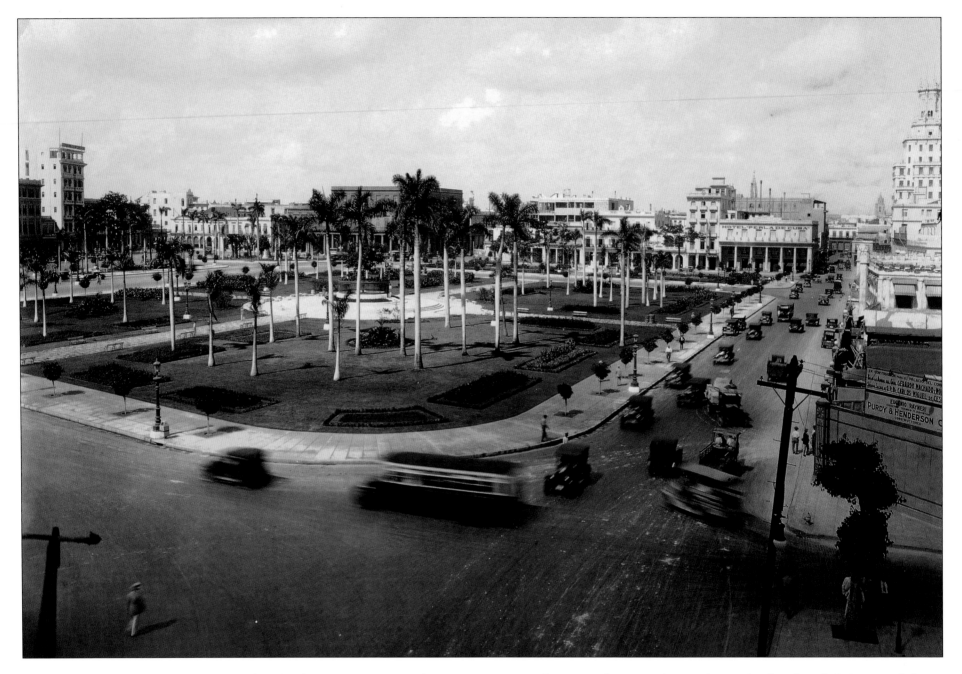

In 1925, President Gerardo Machado's plans for the city were executed to great acclaim by one of his ministers, Carlos Miguel de Céspedes. These plans involved redesigning a number of urban sites, for which the town planner J. C. N. Forestier was brought over from France. One of his tasks was to give the Capitolio (*out of picture on right*) more scenic surroundings, which would involve transforming every side of this square. Consequently, the Campo de Marte, adjacent to the Capitolio, made way for the Plaza de la Fraternidad Americana, which contained trees that wouldn't grow so tall as to obstruct views of the magnificent building. This 1929 photograph was taken in its inaugural year. To the right is Centro Habana, dominated by the tower of the Cuban Telephone Company.

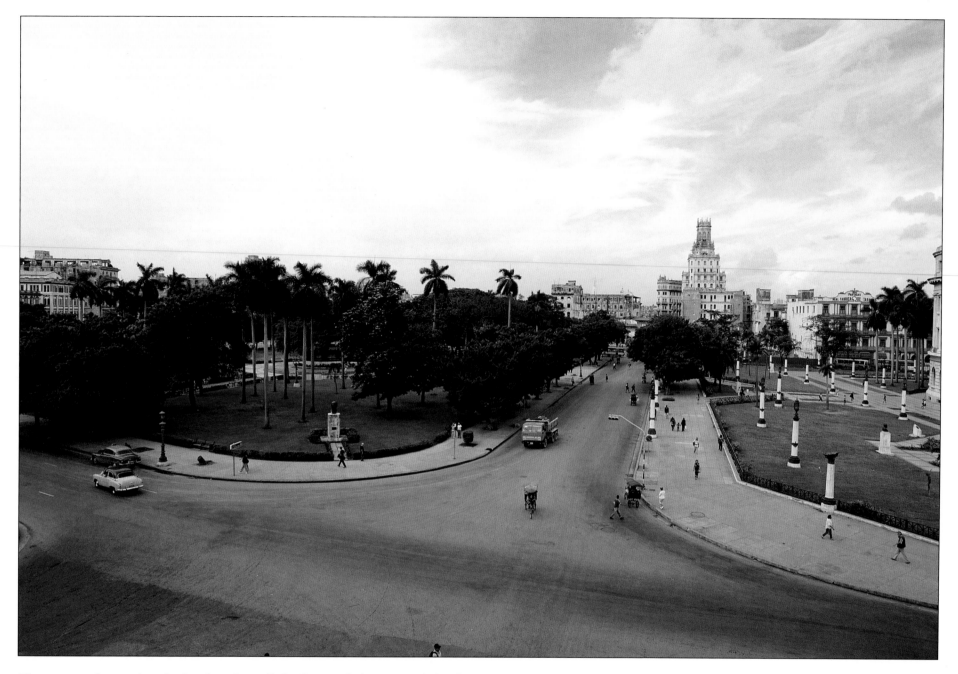

This picture shows what the locals today call the Parque de la Fraternidad, taken from Calle Dragones. On the right is the parkland that surrounds the Capitolio Nacional. In the distance is the main building of the Compañía Cubana de Teléfonos, formerly the Cuban Telephone Company. It was designed and built by Leonardo Morales, who was famous for reproducing elements of traditional Cuban architecture. The tower of this building could once be seen from all over the city, and it exemplifies the neo-Baroque eclecticism that was so popular here until the 1930s.

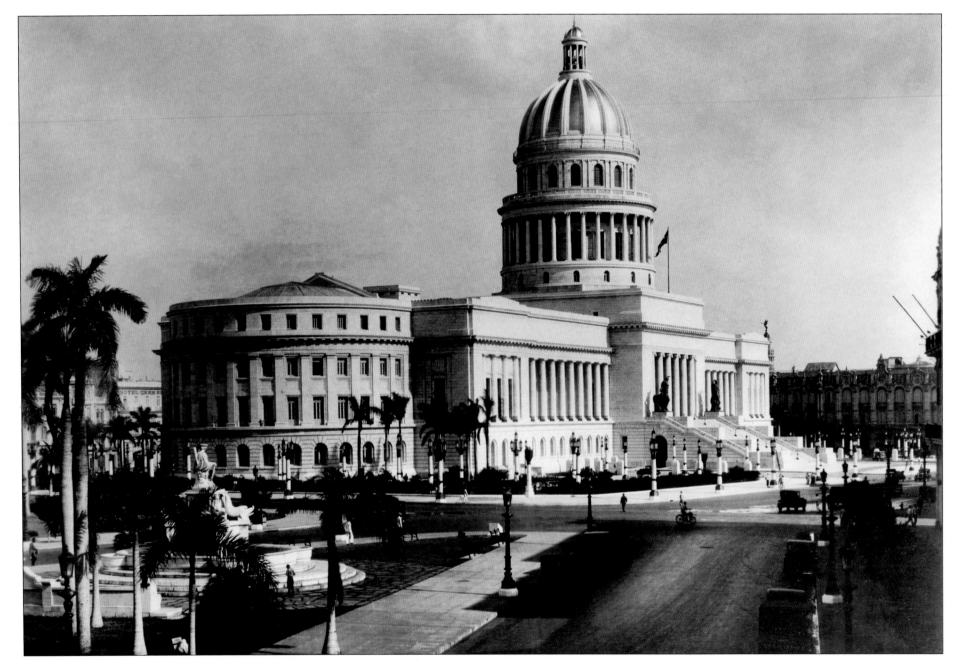

Located on the site of the former Estación de Villanueva, the Capitolio was opened in 1929 to house the senate. Its completion marked the culmination of the city's makeover. Various Cuban architects worked on its design, although it was almost an exact replica of its counterpart in Washington, D.C. The Capitolio quickly became a symbol of Havana, and photographers could always be seen in front of the building, offering people from the provinces a record of their visit to the capital.

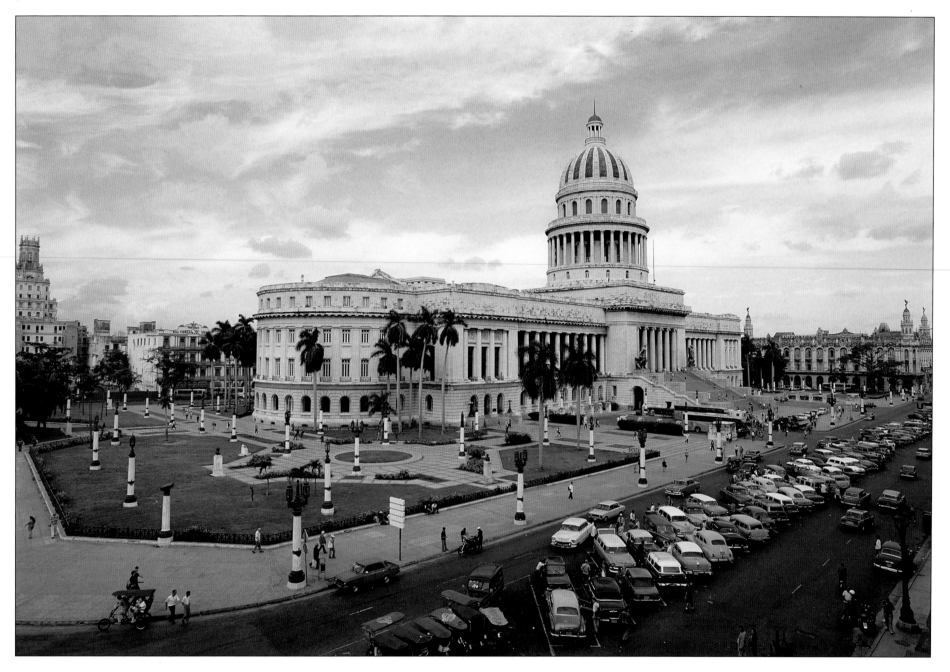

In 1962 the Cuban Academy of Science was created to replace the Royal Academy of Medical, Physical, and Natural Sciences founded in 1861. After the revolution in 1959, the Capitolio no longer served its purpose and so became the new headquarters of the academy. Its first president was the well-known Cuban geographer Antonio Núñez Jiménez. The building also contained the Museum of Natural History, which was recently relocated to Old Havana. The Capitolio has been preserved magnificently and is a monument that should be on most tourists' itineraries.

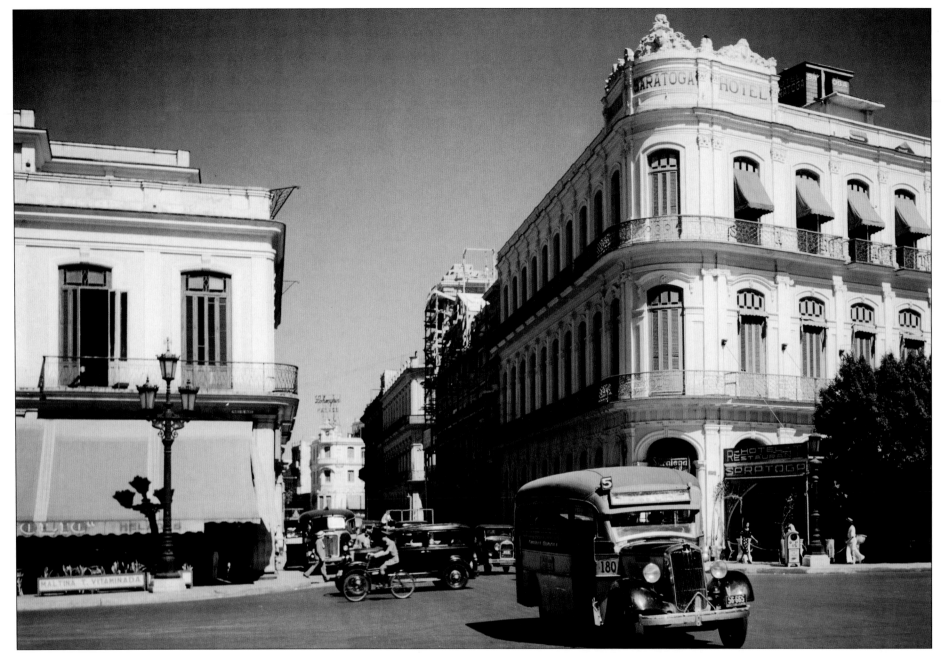

This three-story building was constructed by the Spanish trader Gregorio Palacios between 1879 and 1880 in the former Paseo de Martí, a stone's throw from the Fuente de la India. As was customary at the time, the ground floor was taken up by boutiques, one of which was a tobacco store. Also on the ground floor were the entrance halls of the four first-floor apartments. On the second floor there was a hotel with forty bedrooms and a dining room. The building's two facades met on a curved corner topped with a crest. Around 1933, this building was remodeled and became the Hotel Saratoga.

Some of the old hotels in central Havana are being restored to their former glory as part of the revival of tourism that Cuba has seen in the last decade. This photograph shows the restoration and upward expansion in progress at the Hotel Saratoga. The intention is to increase the number of beds available to tourists who prefer to stay close to the old part of town. Investors in this enterprise also made donations toward the restoration of the building across the street, which now houses a primary school for local children.

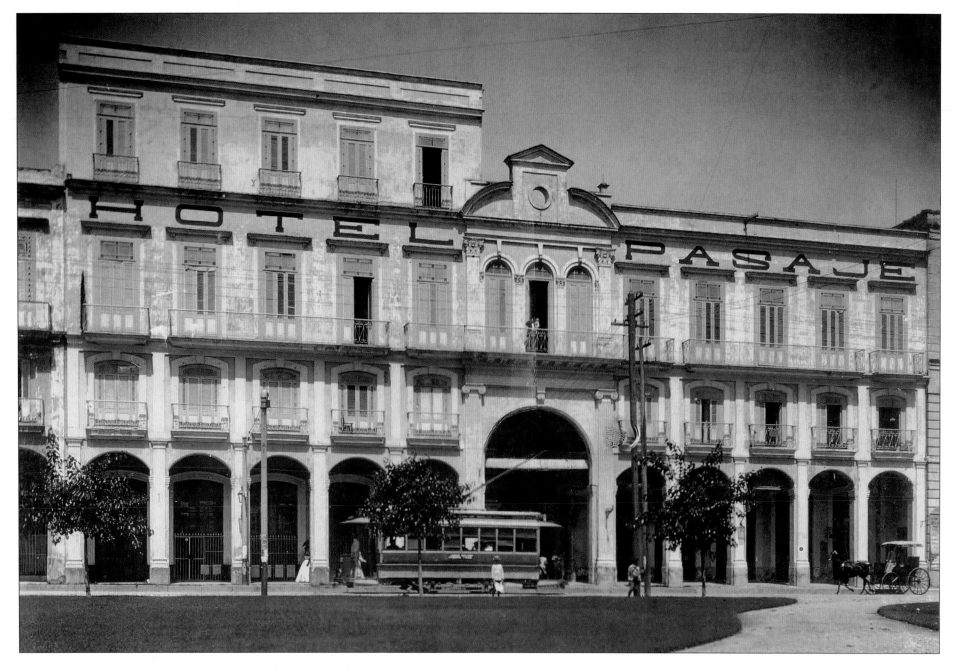

Owned by the Zequeira y Zequeira family and thought to be the oldest hotel in Havana, the Hotel Pasaje was built in 1876 on the Paseo de Martí. Paradoxically, for a long time it was also the most modern in design, as it incorporated a gallery constructed of iron and glass that traversed the ground floor and could be accessed from both sides of the building. Its two facades, decorated with monumental arches and pediments, were easily the most distinguished on the street. The building was also famed for having the first hydraulic elevator in Cuba. In this photograph, taken at the beginning of the twentieth century, an electric tram is seen passing by; for many years trams shared the streets with horse-drawn carriages.

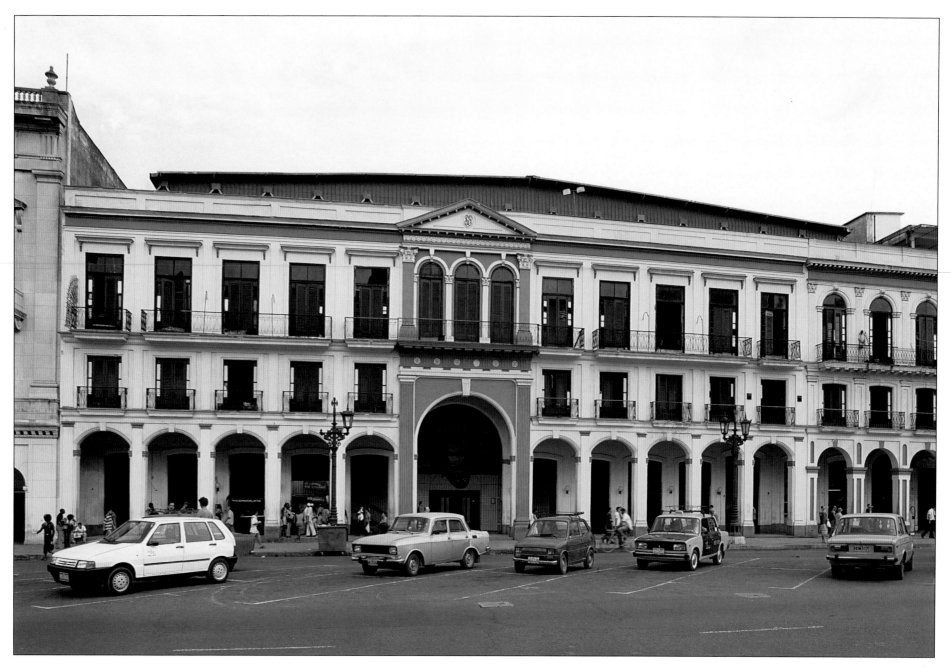

The Hotel Pasaje was converted into apartments many decades ago. In the 1980s, the building collapsed during one of the fierce storms that frequently batter the island and which many other old buildings did not survive. Today the only original part of the structure is the facade that was used in the attempt to restore the building to its former glory. This enabled it to blend in perfectly with the row of neoclassical frontages that face the Capitolio Nacional on the Paseo. The interior space was redesigned to accommodate the Sala Kid Chocolate, a hall named after one of the greatest boxers Cuba has ever seen. The hall was originally used just for boxing matches but now also hosts a number of cultural events.

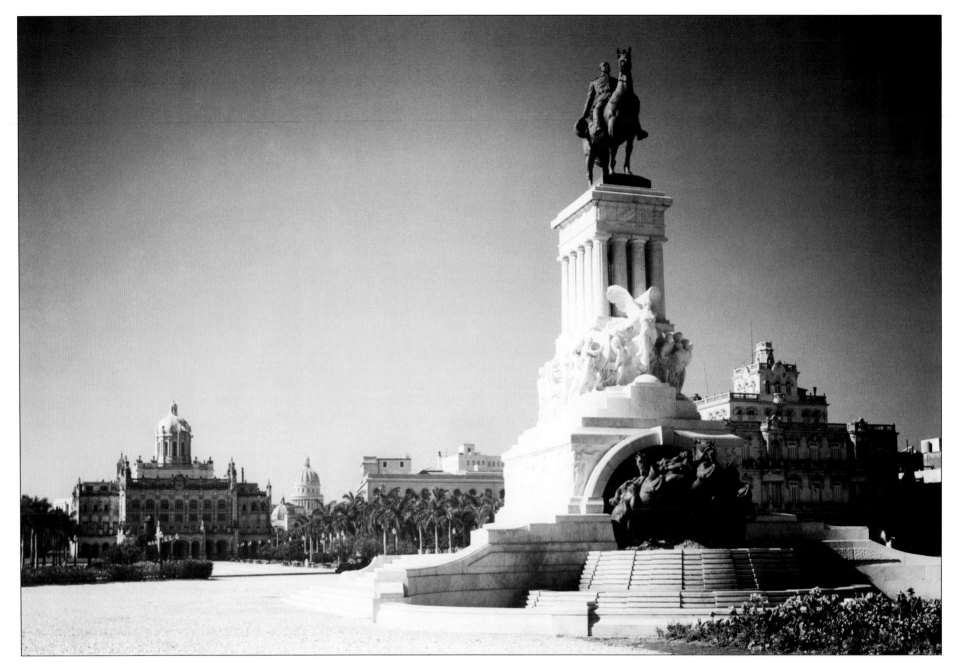

As part of Forestier's urban project in the 1920s, he opened up the Avenida de las Misiones with the idea of creating a setting that would frame both the Presidential Palace and the entrance to Havana from the bay. To achieve this, he knocked down the last colonial buildings in the vicinity, which immediately gave the area a more modern look. The buildings most typical of the architecture and urban planning of the first thirty years of the republic were concentrated here. In this photograph from the end of the 1930s, the Presidential Palace can be seen to the left and in the distance is the dome of the Capitolio. They were built in different decades and illustrate the evolution in style. At the head of the avenue is the statue in honor of the celebrated Dominican who, during the War of Independence, was the commander-in-chief of the liberation army, and whom the Cubans call "el Generalísimo" in recognition of his military expertise.

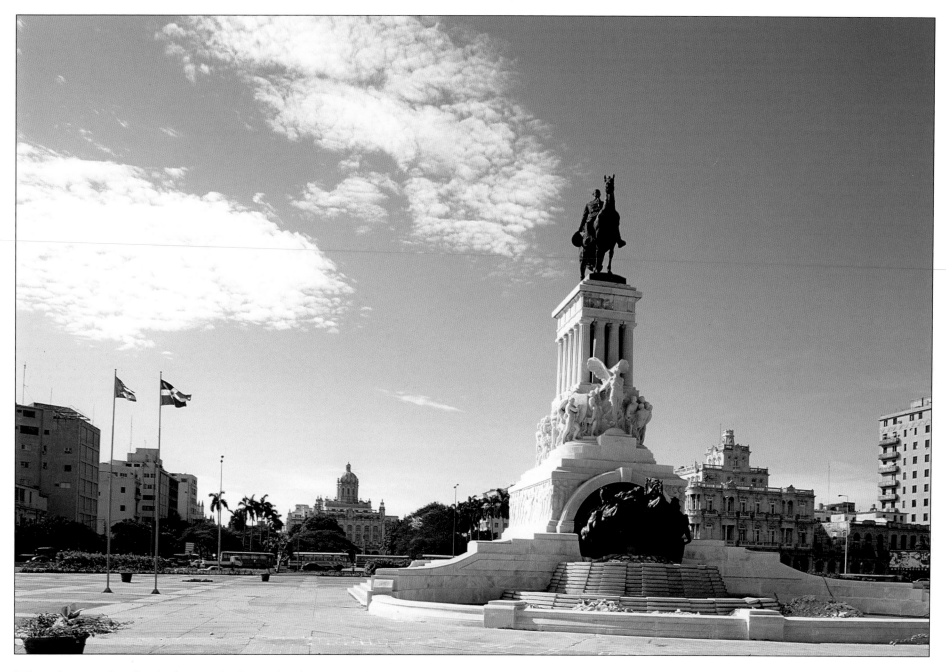

When the tunnel under the bay was built nearby, the area underwent many changes. However, the park featuring the monument to Máximo Gómez was preserved. Despite its proximity to the coast, it is still in perfect condition. Designed by sculptor Aldo Gamba, the monument has a marble and granite pedestal supporting the figure of el Generalísimo in battle dress looking proud, holding the horse's bridle in one hand. Symbolically, the flags of his two fatherlands—Cuba and the Dominican Republic—have been raised nearby. On the left side of the Avenida de las Misiones are some 1950s multistory buildings, one of which is now the Gobierno Provincial (Local Government Building) and another the headquarters of the Unión de Jóvenes Comunistas (Union of Young Communists).

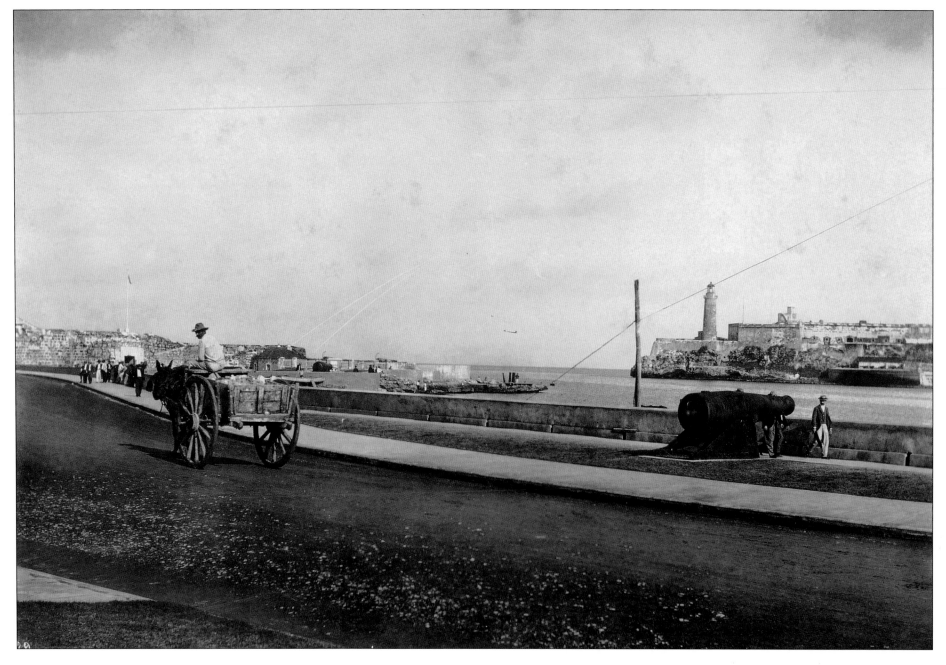

In about 1930, the east section of the Malecón was completed. This part, between the Castillo de la Punta and the port, had not been considered important before. This work was undertaken as part of the plan to create a fitting first impression of Havana from the bay, as most visitors to the city arrived by boat. It also improved the general flow of traffic in the area. The avenue was widened to enhance the views of the Castillo de la Punta, as were the sidewalks on both sides of the road as far as the Castillo de la Real Fuerza.

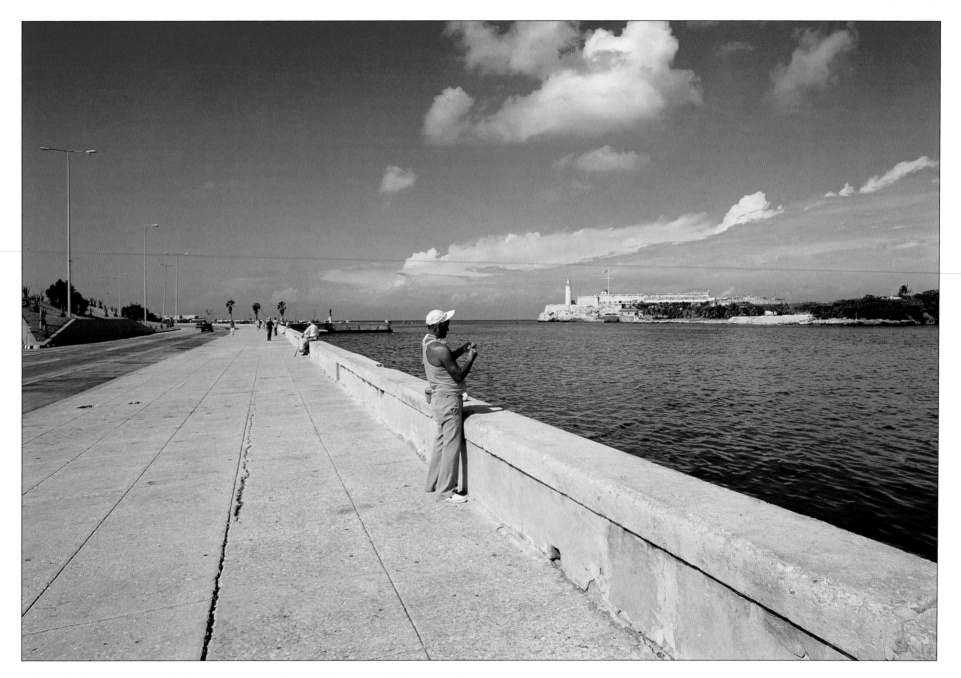

When the bay tunnel was built, its entrance obscured the view of the city and consequently this section of the Malecón fell in popularity. The area is only used by a few fishing enthusiasts and tourists taking this road to Old Havana. The government has recently become more concerned about contamination in the bay after centuries of pollution, and has sought the help of international experts to salvage the local ecosystem and clean up the waters.

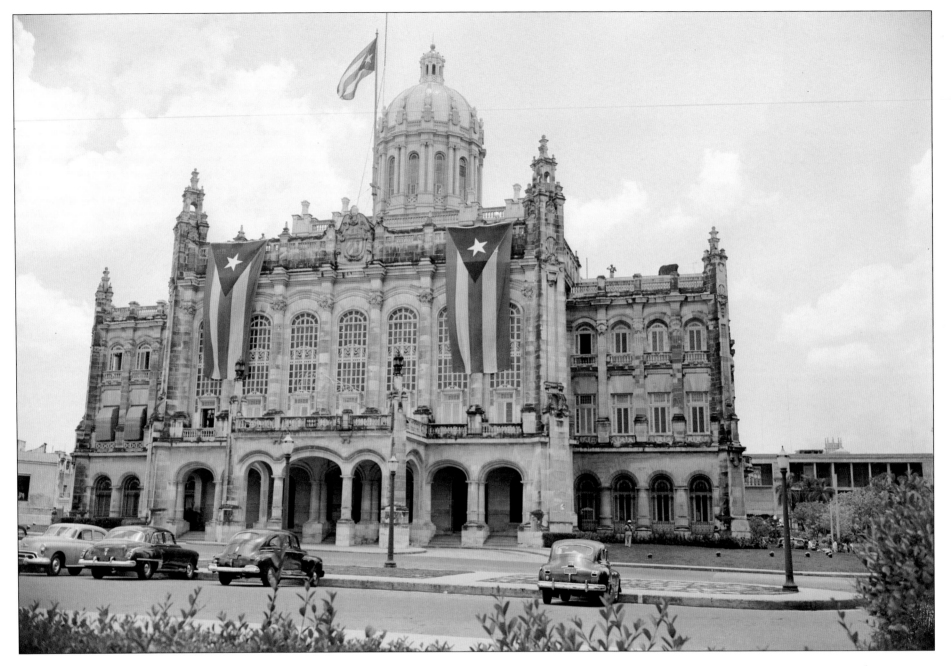

Built in a ditch that was left after the city walls were demolished, the Presidential Palace was one of the most significant buildings at the start of the republic. Originally conceived as a local government building, its plans were changed over the years until the palace was finally opened in 1920. Between then and 1959 it was the official residence of successive Cuban presidents. Designed by the Belgian architect Paul Belau, it mixes elements of both the Spanish renaissance and neo-Baroque styles, as well as being slightly Germanic in its ornamentation. The interior decoration was entrusted to Tiffany's of New York, which took care of every detail, including the curtains.

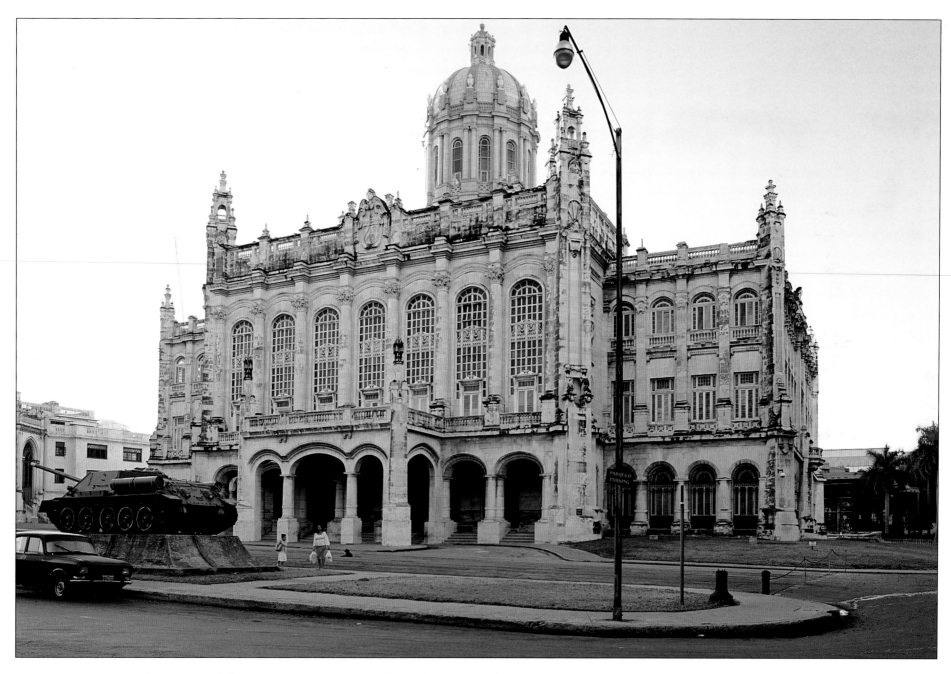

In 1957 a group of students stormed the palace in an attempt to bring the dictator Fulgencio Batista to justice. From 1959, it was the seat of the new government headed by Fidel Castro. Now the Museo de la Revolución (Museum of the Revolution), it houses significant documents and objects from Cuba's recent history. Behind the palace, in what used to be the gardens, the yacht *Granma* is exhibited. In 1956, a group of youths—including Castro—sailed from Mexico in this yacht to fight against President Batista. Next to the yacht are the vehicles used in 1957 by the members of the Movimiento 13 de Marzo to attack the palace where Batista was then living.

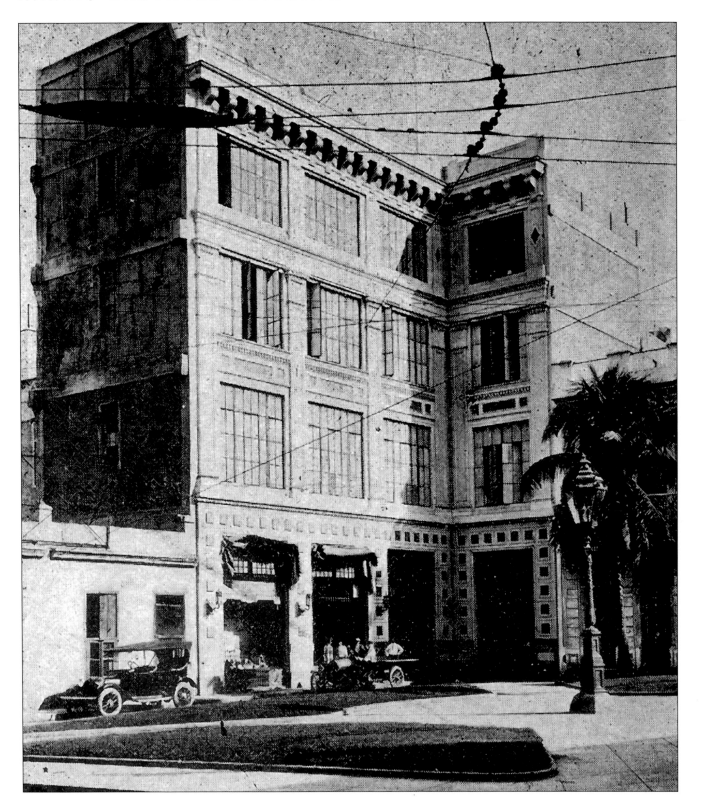

Opened in 1914, this building housed the warehouse, offices, and showrooms of the American firm Harris Brothers Co., which sold stationery and office furniture. This four-story building was erected quickly, thanks to its steel structure; its design was a far cry from the eclecticism in vogue at the time. Although the front of the building was on Calle O'Reilly, this street was so narrow that the company could easily be missed. For this reason they would put advertising on the back of the building on Calle Monserrate, which was much wider and had enough room for a small square, enabling a better view of the establishment from the street.

The building that once sold the latest office furniture is now a department store. After standing empty for many years and falling into disrepair, it was included in the recent renovation taking place in Cuba. The front of the building—characterized by its wide windows and simple geometric design—has been returned to its original state. The interior has also been modernized and adapted.

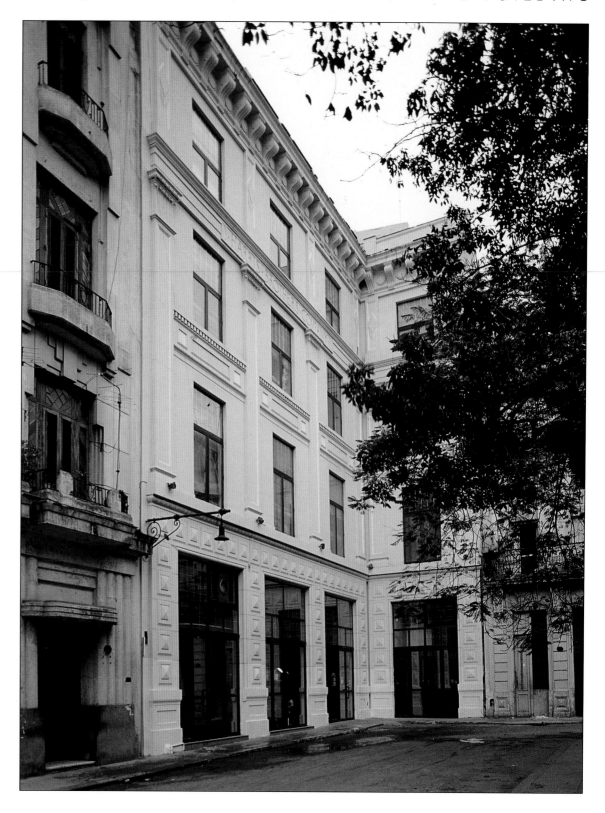

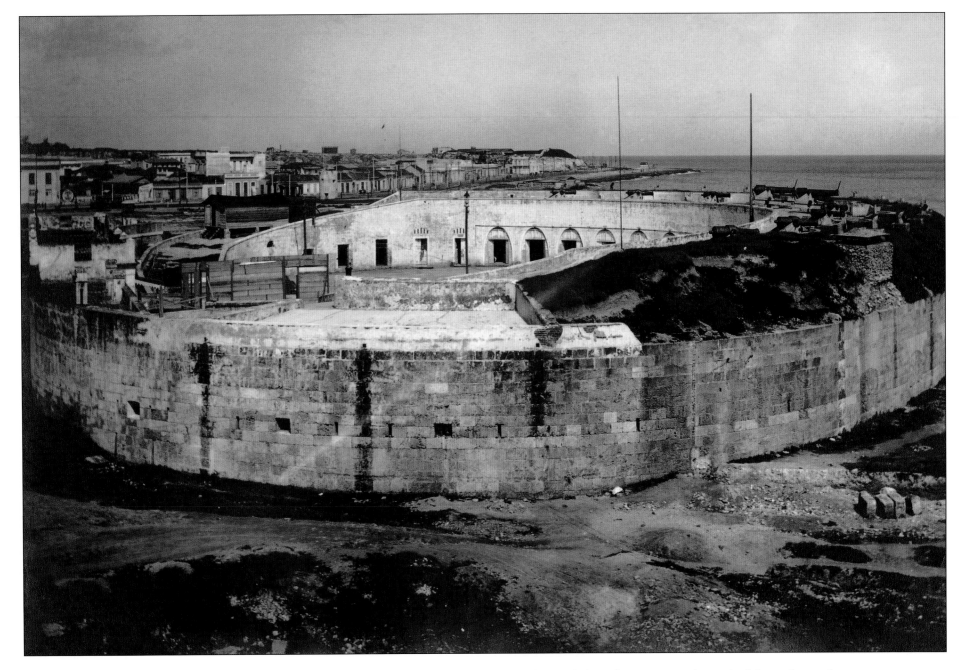

After the English took Havana at the end of the eighteenth century, a new defense system appeared in addition to the castles that already existed. It involved a series of military enclaves positioned along the coast. The battery in this photograph is situated at the edge of the beach near San Lázaro cove and dates from around 1770. It contained forty-four cannons and would have housed a garrison of some 250 soldiers. It was still standing at the start of the twentieth century but succumbed to the expansion of the Malecón.

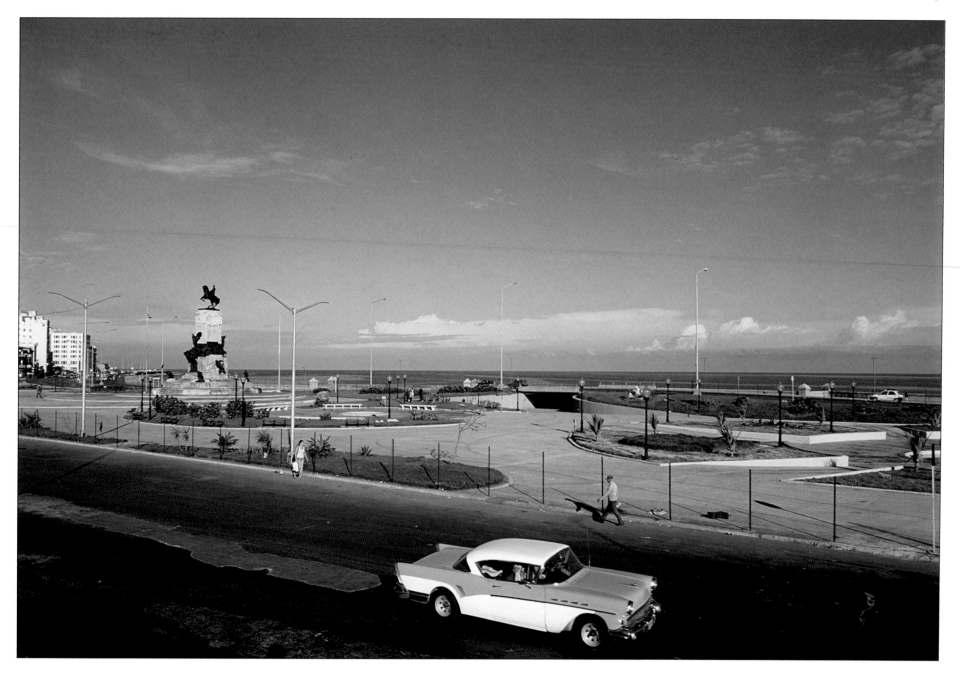

During Mario García Menocal's second term of office, improvements to the
stretch of the Malecón from the Parque Maceo were undertaken. When it
came to enhancing the area near San Lázaro cove, both the battery and a
nearby children's home were sacrificed. In their place the Parque Maceo was
built, and the area next to it was the wide avenue of the Malecón. This led to
the construction of a tunnel underneath the Malecón that allowed pedestrian
access to the coast. A fence was recently installed around the park.

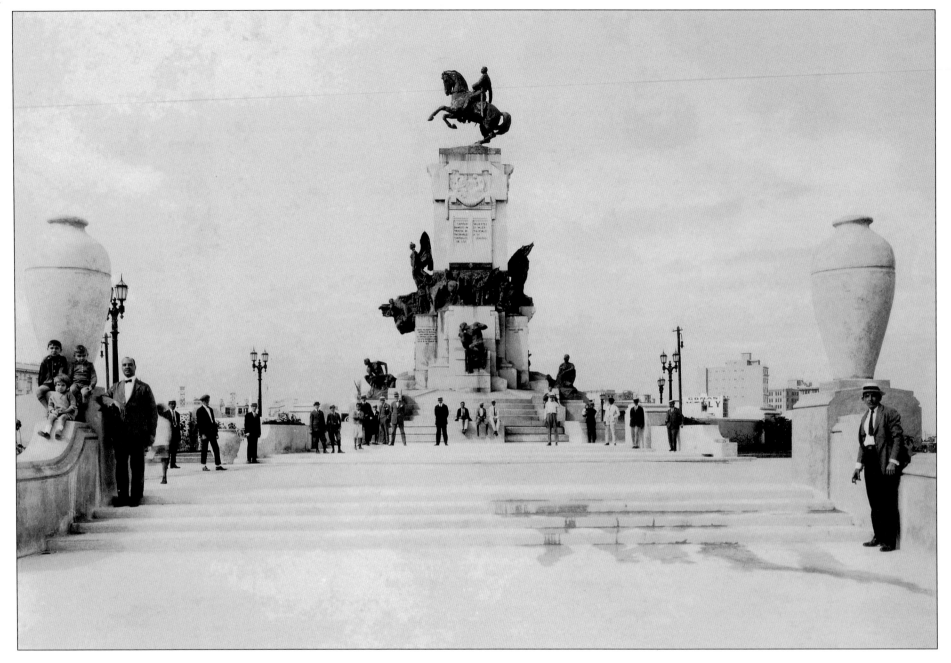

The Parque Maceo was established on the area surrounding San Lázaro cove and took the place of the battery and other colonial redoubts. Built between 1916 and 1919, the park paid homage to Antonio Maceo, the man the Cubans call the "Bronze Titan." He was one of the greatest generals of the Cuban War of Independence and the only one to refuse to sign the Treaty of Zanjón, which ended the Ten Years' War in 1878. The work of the Italian sculptor Domenico Boni, this picture shows the monument dedicated to the hero, with the original steps.

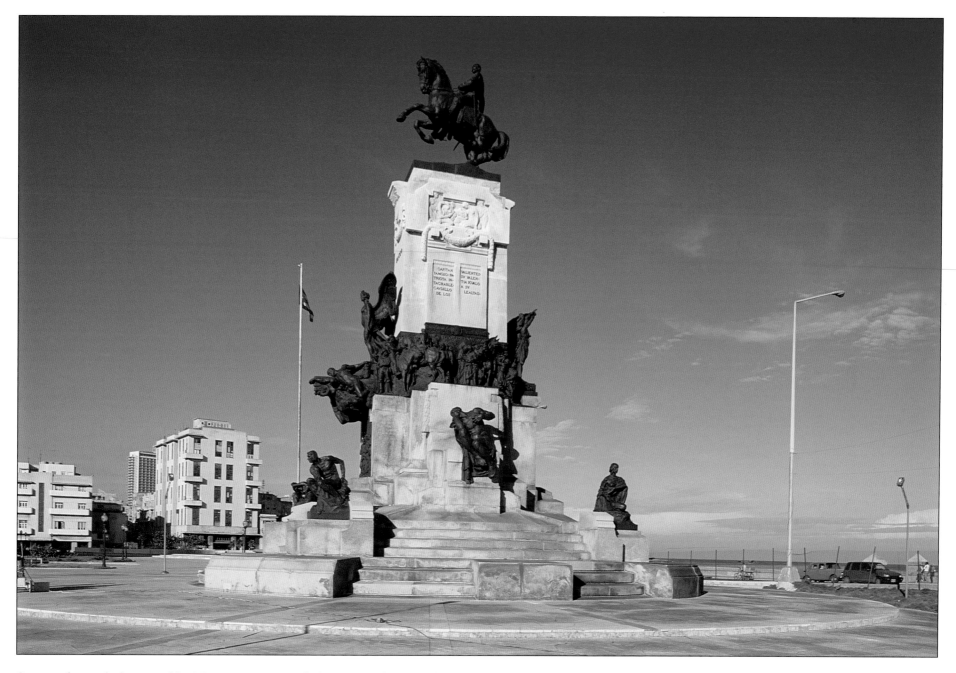

Set on a base of white marble, Maceo is seen astride his rearing horse. Below are a series of sculptures depicting the general's most famous battles. Today the monument is being cleaned and restored, and lights have been fitted to illuminate it at night. Gardens have been added to the park to make it a more pleasant environment for enjoying the fresh breeze coming in off the sea.

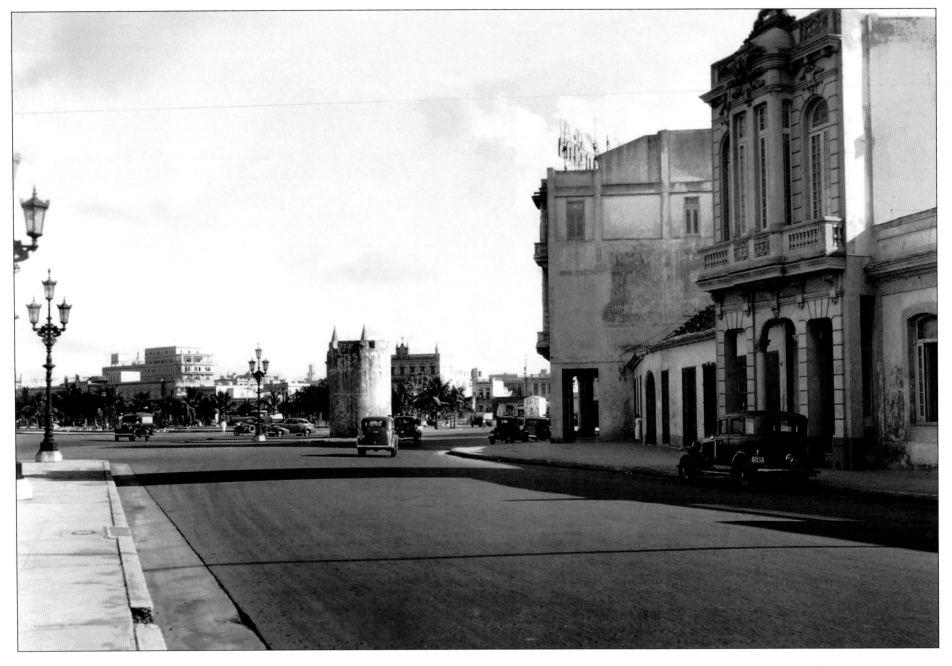

This photograph taken in the 1930s shows a section of the Malecón, seen from the direction of El Vedado toward the Parque Maceo. In the center is the seventeenth-century monument known as the Torreón de San Lázaro. It was a watchtower from which the inhabitants of Havana were alerted by the banging of a drum whenever a suspicious-looking boat came near the coast. It was preserved when the Malecón was built.

This area has changed considerably over the years. The surrounding buildings have been updated to reflect changes in taste—for example, the building on the right has had its facade replaced with a huge window for displaying Fiat cars—but the Torreón still stands next to the Parque Maceo. The most important change to the area to date has to be the completion of the building seen behind the Torreón. Construction on this building was started in the 1950s but ground to a halt after the revolution. The work resumed in the 1970s, and the interior and access routes were updated in the process as the building became the Hospital Hermanos Amejeiras. Opened in 1982, this twenty-four-story building illustrates the rationalist stage of Havanan architecture that developed in the 1950s.

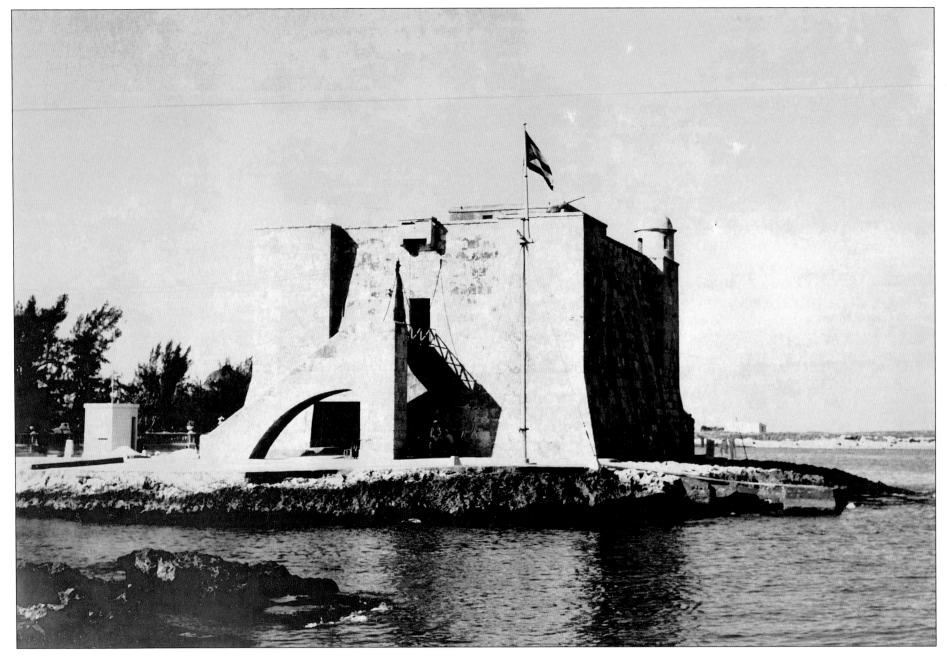

This fortress was built at the mouth of the Río Almendares in about 1646 to keep pirates from entering the river in search of fresh water. The river was then known as the Chorrera, hence the name of the fortress, and it is said that those living in the area actually funded its construction. The river is now named for Bishop Armendáriz, who came to Havana suffering from rheumatism and was cured at this spot. In 1762 the original tower was all but destroyed by the English and when rebuilt, it became a rectangular, two-story structure with bastions. That is how it looked when this photograph was taken in the 1920s.

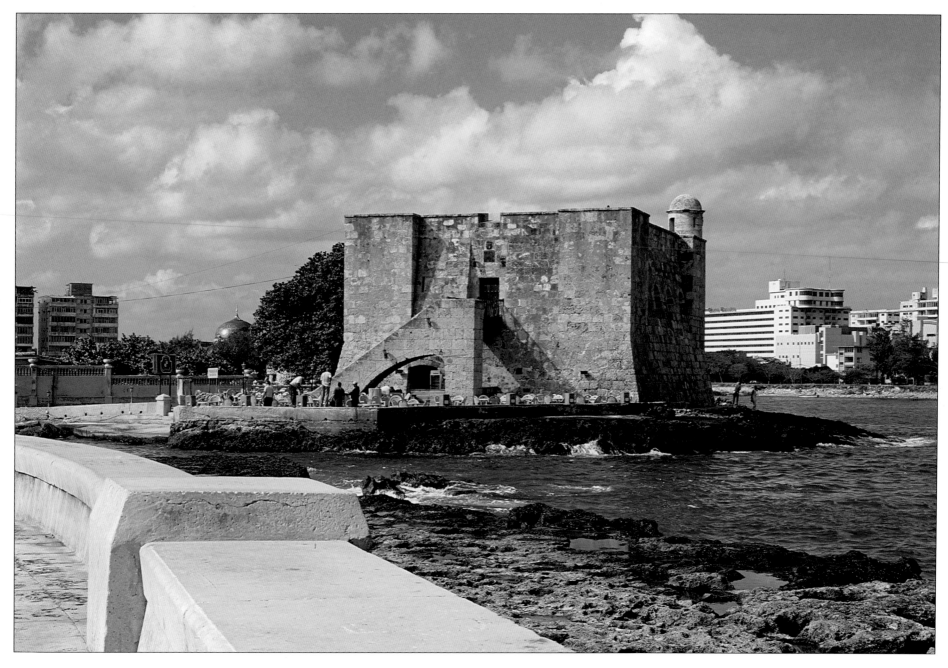

Havana expanded across the river estuary and into Playa de Marianao, and the suburb of Miramar developed. The part of that suburb called La Puntilla can be seen behind the Torreón. In the 1950s, one- and two-story buildings were constructed here, but more recently they have been replaced by taller buildings that house offices or state-run supermarkets. Today the Torreón de la Chorrera is a café. This is the second time the fortress has been used as such: at the turn of the twentieth century, a restaurant was opened here that became famous for its chicken and rice "à la chorrera."

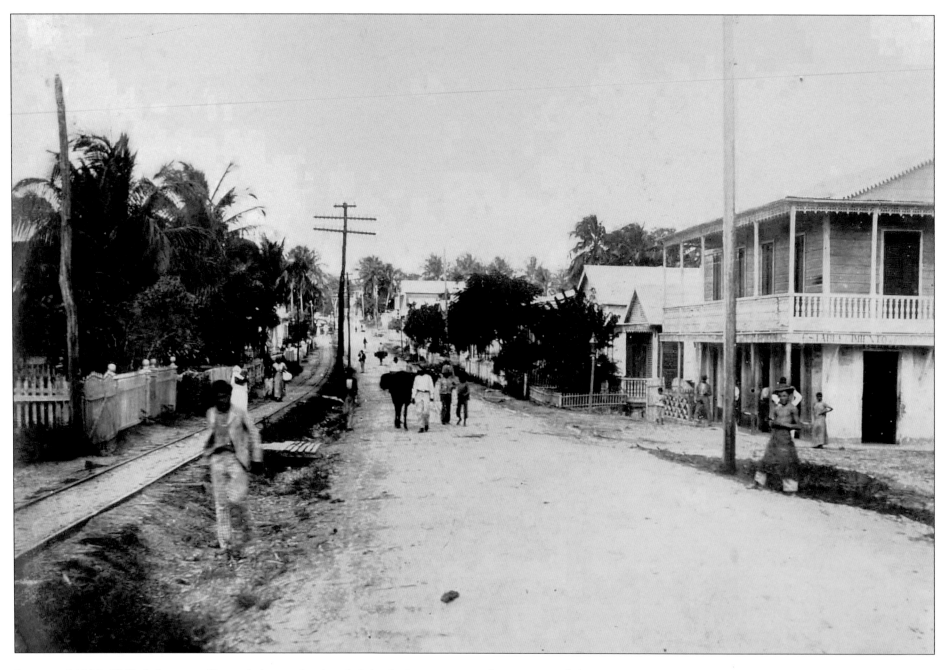

In around 1900, El Vedado was still mostly barren land and Calzada, Línea, and Calle 17 were the only actual streets. The other roads were simply spaces cleared in the undergrowth and rocks. Although modest, the houses had patios on all sides with gardens either at the front or all around. They were lifted up on plinths tall enough to protect them from the frequent flooding caused by the terrain and their proximity to the coast. Copied from houses in the south of the United States, these wooden constructions were very popular. Since the turn of the twentieth century, the homeowners in this neighborhood tried hard to promote its expansion, and it is not by accident that this was the first area to have electric lighting.

During World War I, Cuba became the biggest sugar-producing country in the world and it underwent an economic boom known as the *Vacas Gordas* (Fat Cows). El Vedado grew rapidly and became the neighborhood of choice for the Cuban middle classes that had become rich from politics and speculation.

The Hotel Presidente—part of which can be seen on the left in this photograph—was built here in the 1920s in accordance with the latest specifications in the United States. It was one of the first hotels to be built outside central Havana and was successful in attracting tourists to El Vedado.

Located in El Vedado and a replacement for the Espada Cemetery, the Columbus Cemetery was considered complete with the opening of the chapel. The work of the engineer Francisco Marcótegui, it is a domed building designed in the Byzantine-Romanesque style, a precursor of the eclecticism that would become popular much later. It contains paintings by the Cuban artist Miguel Melero, who was a disciple of the Italian painter Guiseppe Pirovani and who undertook the design of the Espada Cemetery at the beginning of the nineteenth century.

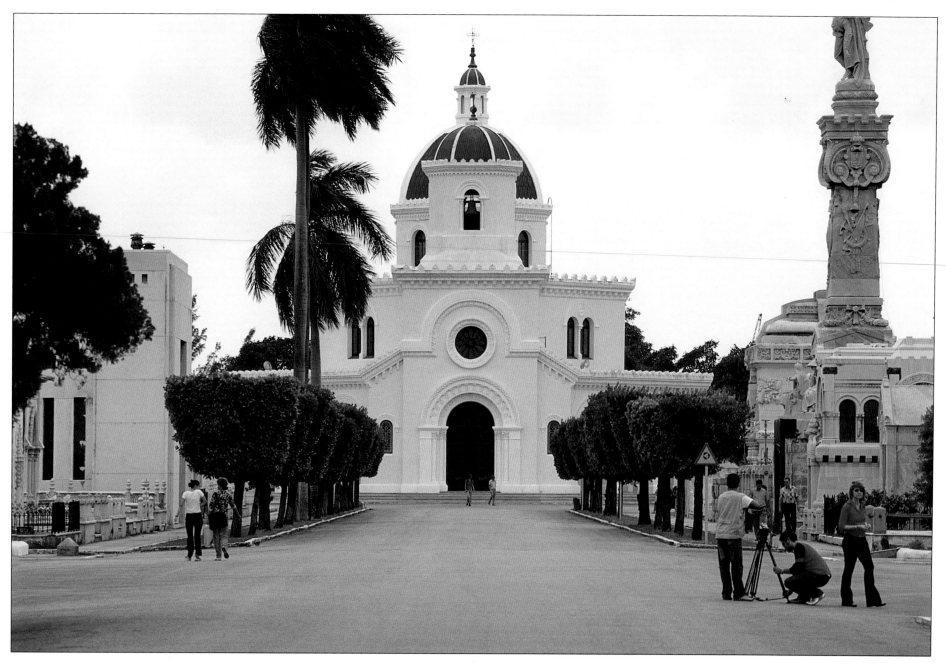

Today the cemetery has become a tourist attraction due to the intricacy of the sculptures incorporated into many of the tombs. It is laid out on a grid much like a small city and even has distinct "suburbs." The main avenue is lined with the tombs of the best families in the country from the first half of the twentieth century. At the heart of the cemetery, where the main avenues cross, stands the chapel. It is still in an excellent state of repair and mass is performed there daily.

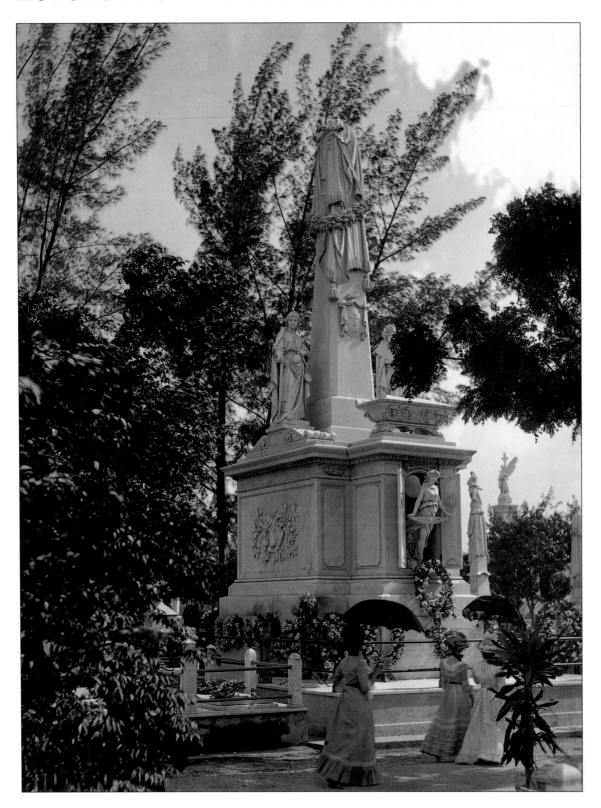

The dedication on this monument reads: "To the eight innocent students shot by volunteers in Havana on November 27, 1871." This mausoleum in Columbus Cemetery pays homage to those students who were victims of the fanaticism of the Spanish colonial government. Erected in 1890, it was designed by the Cuban sculptor José Villalta Saavedra. It is considered one of the most important monuments of the 1890s and even a milestone in Cuban history because it was put up when Spanish troops still had control of the island.

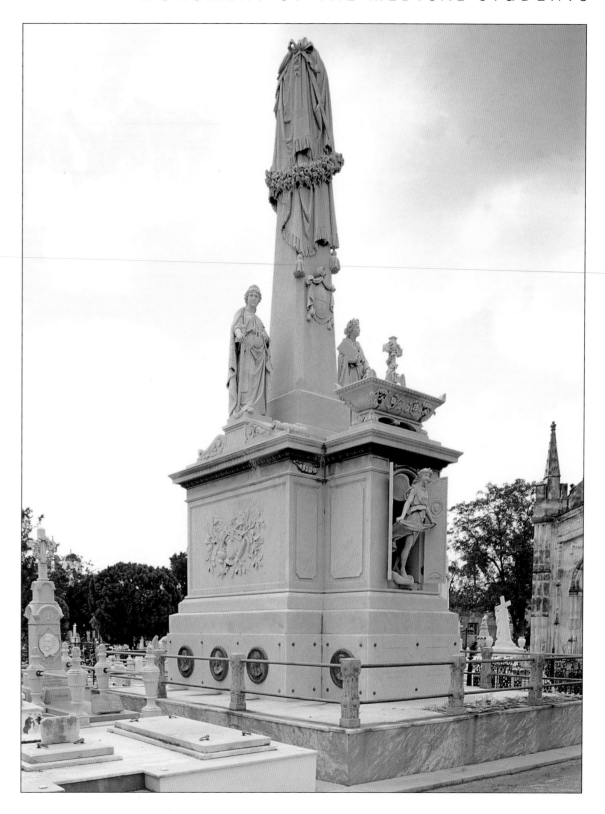

The monument can still be seen in the Columbus Cemetery. It is made of marble brought from Carrara in Italy. The artist carved women representing values and principles relating to the event: accountability, justice, and innocence. As sculpture did not become a mainstream art form in Cuba, Columbus Cemetery is perhaps the best place to see works of this genre. This mausoleum is an example of the extraordinary tombs that can be found here. The cemetery was declared a Cuban national monument in 1987.

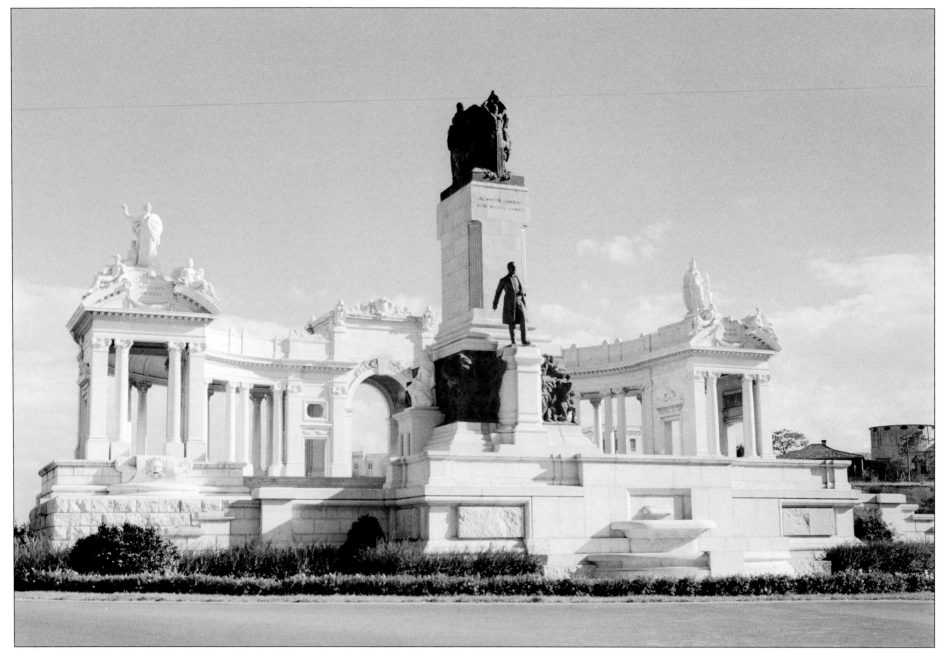

José Miguel Gómez was a general in the War of Independence and went on to represent the Liberal Party. He served as president of Cuba from 1909 to 1913. After his death his supporters erected this monument in his memory on Calle G, later known as Avenida de los Presidentes. The intention was to place statues of each successive Cuban president along this avenue, which extends from the Castillo del Príncipe to the coast.

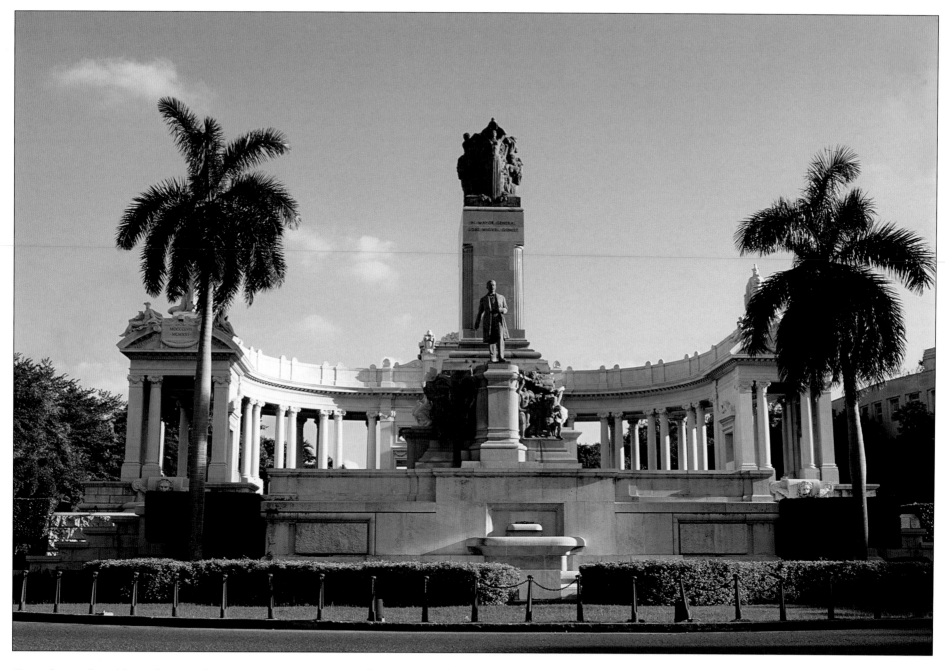

Carved out of marble and stone, the monument to José Miguel Gómez was done by Italian sculptor Giovanni Nicolini, whose design was no doubt inspired by the monument to Victor Manuel in Rome. It is a statue of the general flanked by two allegorical figures representing strength and magnanimity. Three fountains and six figures represent the number of provinces on the island at that time. There are also central sculptures symbolizing time, history, liberty, truth, law, and peace. To raise its profile yet further it was slightly elevated, and a traffic circle was constructed to allow vehicles to drive around it.

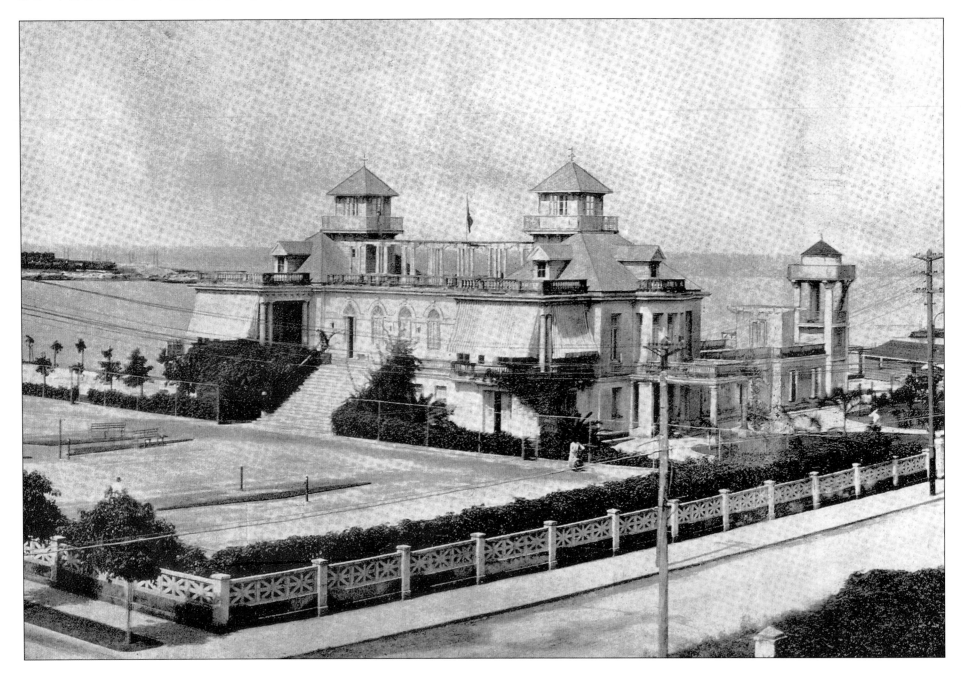

Tennis was introduced to Cuba around 1885 by employees of an English rail company who built a small court on some land on Calle San Lázaro. In 1902 a group of young Cubans set up a club, which also organized tournaments. In 1917 this club was opened in the El Vedado district, where Calle 12 meets Calzada. The complex was designed by the Cuban architects Rafecas and Toñarely and contained a magnificent building surrounded by gardens and courts for playing tennis and other sports such as baseball, polo, and basketball.

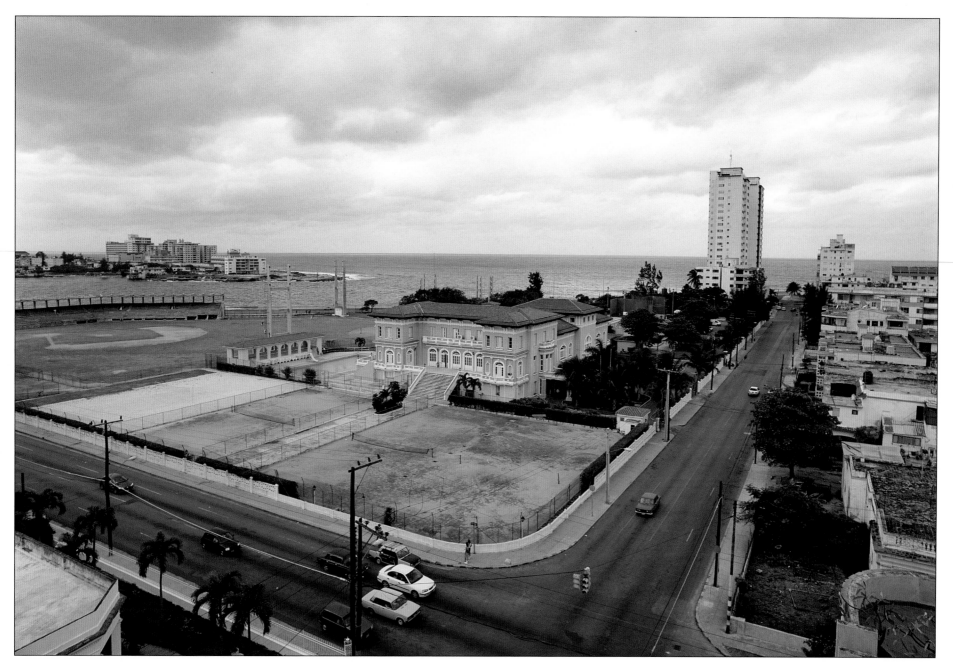

With slight modifications to the building undertaken a few years later, the complex by the coast that was once the El Vedado Tennis Club is now the headquarters of the José Antonio Echevarría social club. The magnificent tennis courts are still used and in the past have been the venue of both national and international tournaments. In the distance the skyscraper where Calle 12 meets the Malecón can be seen. It was built in the 1950s, when buildings of that type were popular in El Vedado, and after the revolution it became residence halls for medical students with government scholarships.

The main entrance to the University of Havana, an impressive set of steps, is on Calle San Lázaro. The campus comprises a series of buildings interspersed with parks and gardens, which together make a pleasurable learning environment. This photograph dating from around 1940 shows one side of Plaza Cadenas, named after the engineer who was one of the university's most illustrious rectors. Opened in 1939, this square contained plants and benches, and on its four sides stood the university library, the law school, the rector's office, and this building, which belonged to the science department. Designed by Pedro Martínez Inclán, this building was opened in 1936.

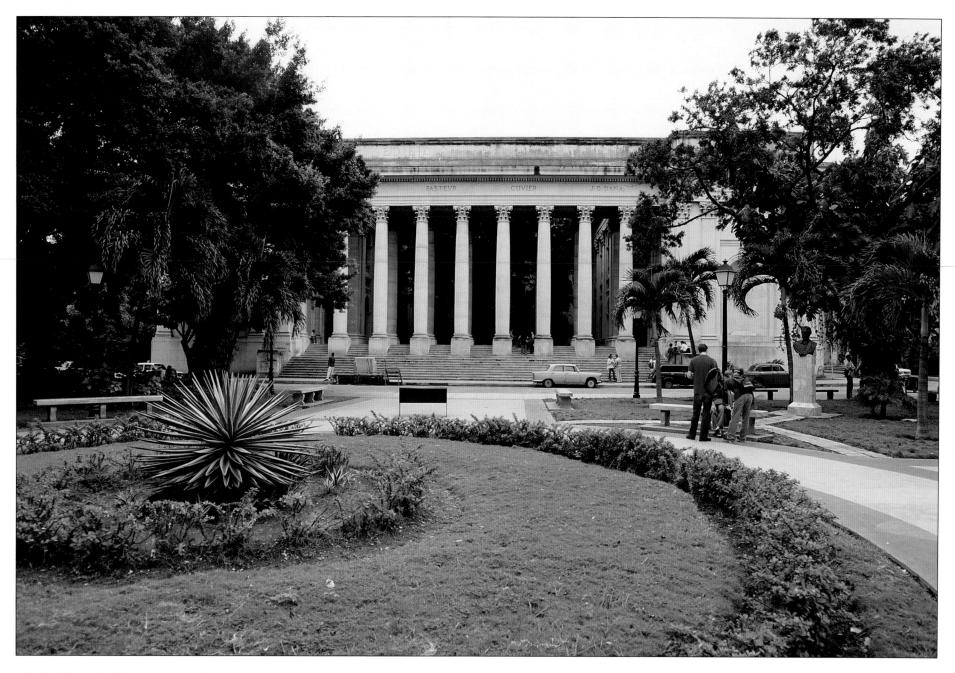

The building has been preserved in its original state with the majestic colonnade dominating the facade, which now belongs to the mathematics department. The internal balconies look over a central courtyard that over the years has been embellished by the steady growth of foliage and trees planted there. Many still call the square Plaza Cadenas, but its name was changed in the 1970s to Plaza de Ignacio Agramonte in honor of the young lawyer who was the protagonist of many heroic exploits during the War of Independence.

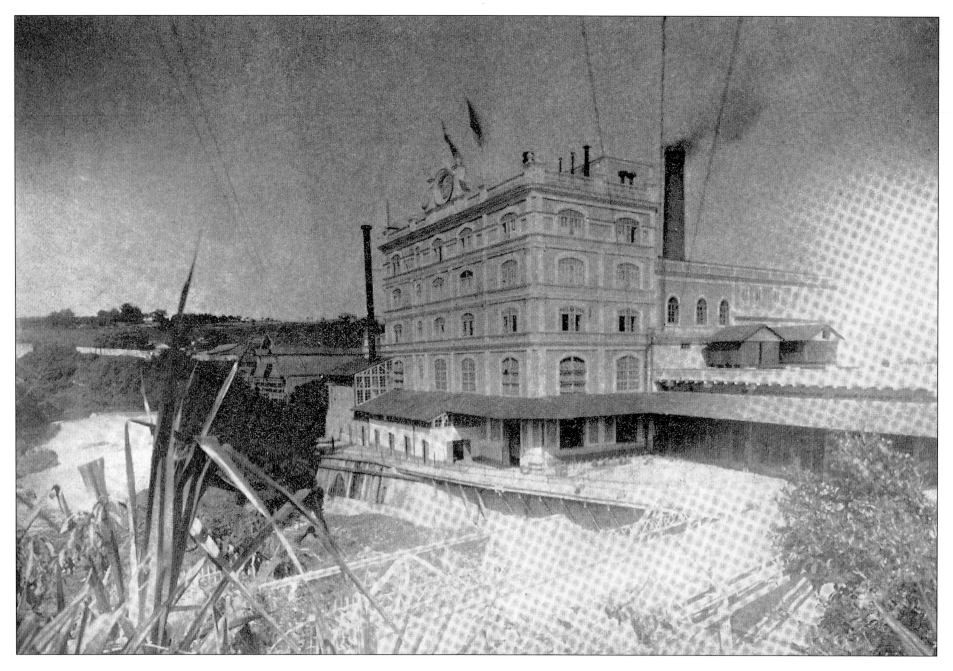

At the end of the nineteenth century there were two great breweries in Cuba: La Tívoli and La Tropical. The latter was owned by the industrialist Blanco Herrera and was located near the river in the district of Marianao, more specifically in the area called Puentes Grandes. The production plant had ample room for the access and loading of the many carts that distributed the goods. In 1916 La Tropical produced around 200,000 bottles per day; it combined with the La Tívoli brewery to produce nearly all the beer consumed in the country. La Tropical beer was one of the best loved in Cuba at the time and received numerous awards at various international expositions around the world in the early twentieth century.

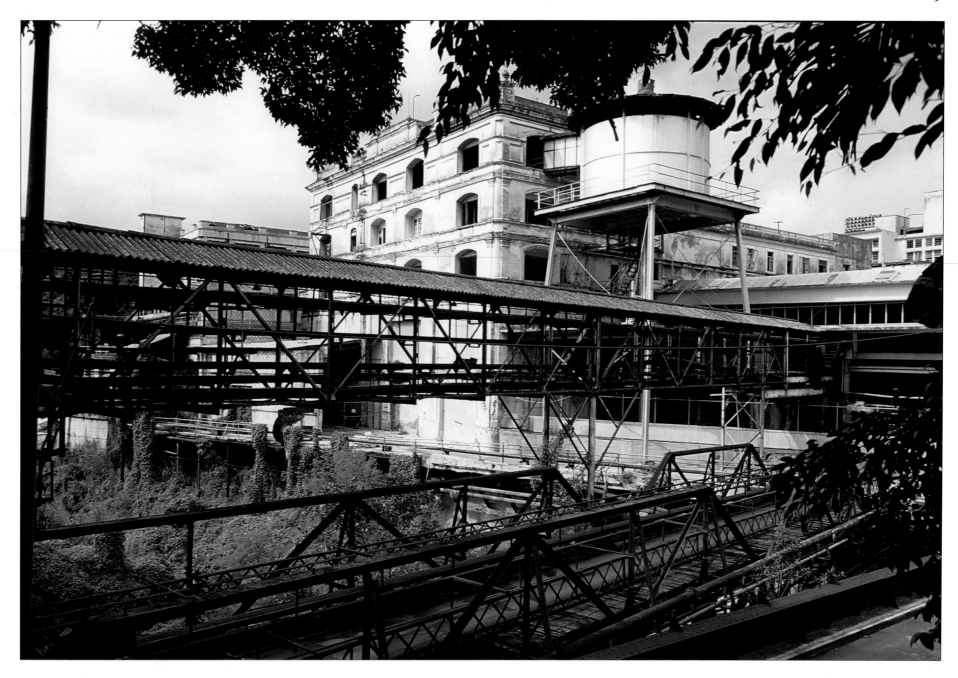

La Tropical beer is still produced, but this brewery has fallen into disuse. However, according to recent reports, the grounds may be turned into a museum dedicated to the industry. Today the original machinery used in the production of the beer can still be seen in the main building. The grounds also contain the La Tropical gardens and the Pelota Stadium, both built by the Blanco Herrera family and once very popular with the local residents.

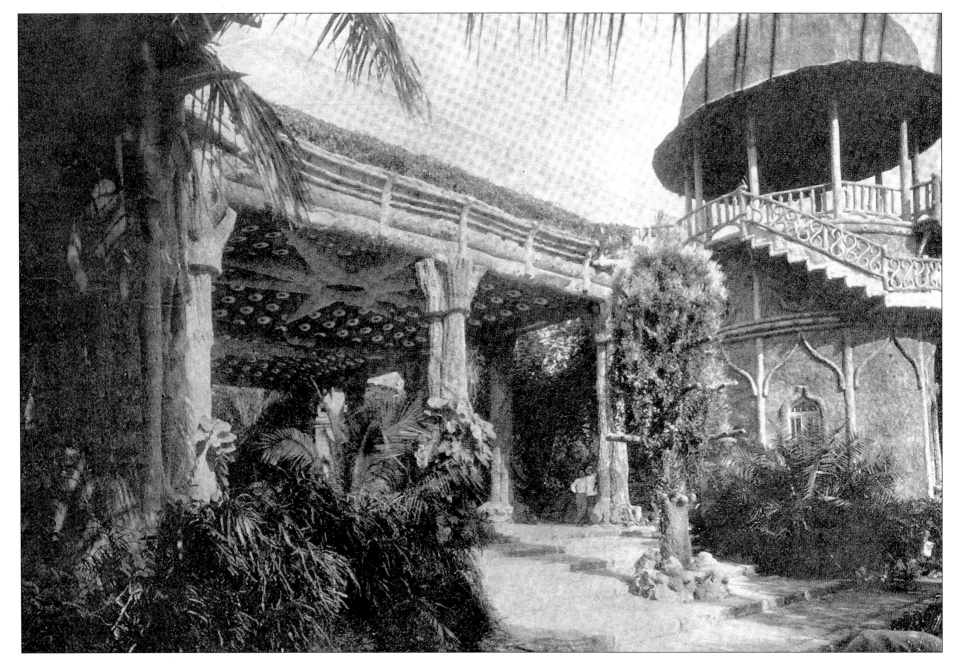

During the first decade of the twentieth century, the grounds of the La Tropical brewery were extended, creating these famous gardens. They opened in 1912 with the aim of giving the city a rural setting for public celebrations and other recreational activities. There were grottoes, mazes, waterfalls, outdoor bars, refreshment stands, and a dance hall large enough for 500 couples. There was also a neo-Arabic castle that was decorated in a style very reminiscent of the Alhambra in Grenada.

The gardens at La Tropical were very popular with the locals, and some of the country's greatest bands have played at dances held here throughout the twentieth century. The "Bárbaro del Ritmo" (Barbarian of Rhythm) Benny Moré, whose music touched a whole generation, played here, and countless Havanans have spent an evening dancing to Juan Formell's band, Los Van Van. Unfortunately, the grounds are now very dilapidated, although the pavilion in the picture has been fairly well preserved.

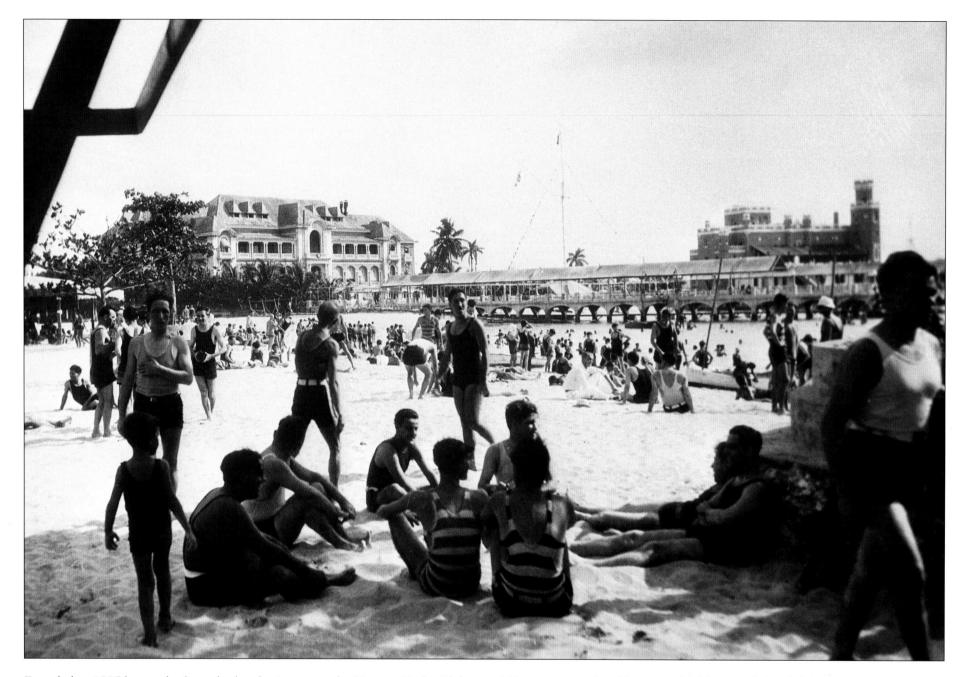

Founded in 1885 by youths from the local aristocracy, the Havana Yacht Club was located on Marianao Beach and organized regattas and other nautical events. Members would depart from Havana Bay every afternoon and sail to the beach; years later they would sail to Cayo Hueso. It had a custom of giving a black ball to those whose membership application was rejected. In 1924 the old house was replaced by a new building, and the club boasted a long pier and a wide beach where its members—all from Havana's most distinguished families—could relax. This photograph, dating from the 1930s, shows the busy beach in the summer.

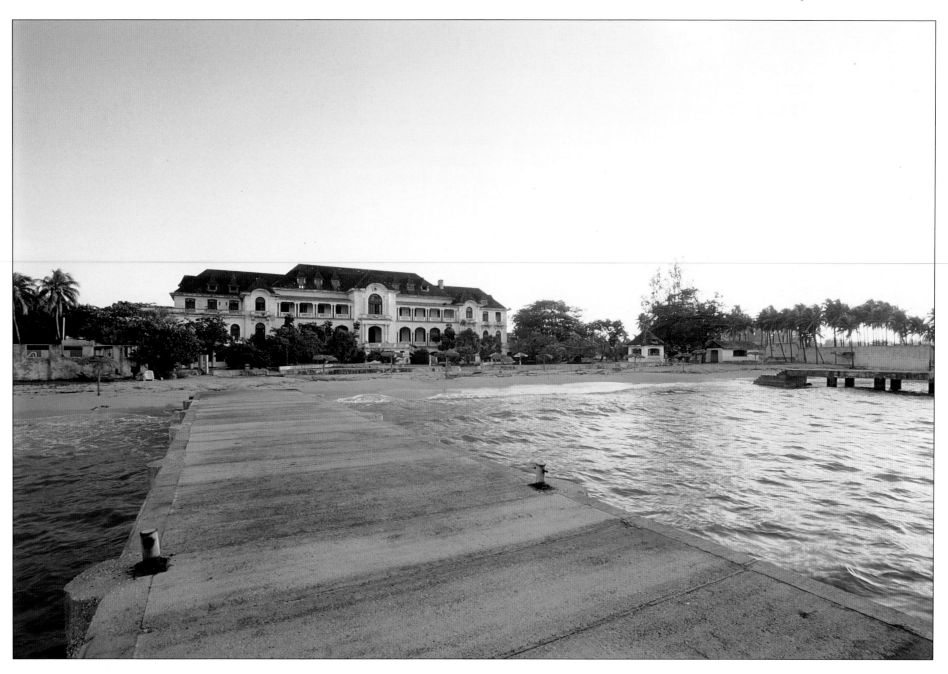

After the revolution, all the clubs that had flourished in the first half of the century along Marianao Beach became accessible to the public. Many of them, like the Havana Yacht Club, had built modern facilities for their members. The lack of organized maintenance has unfortunately meant that many have fallen into disrepair. Today the former Havana Yacht Club is now the Julio Antonio Mella social club and is maintained by a committee. The building has not been returned to its former glory, but the beach is still very popular on hot summer days.

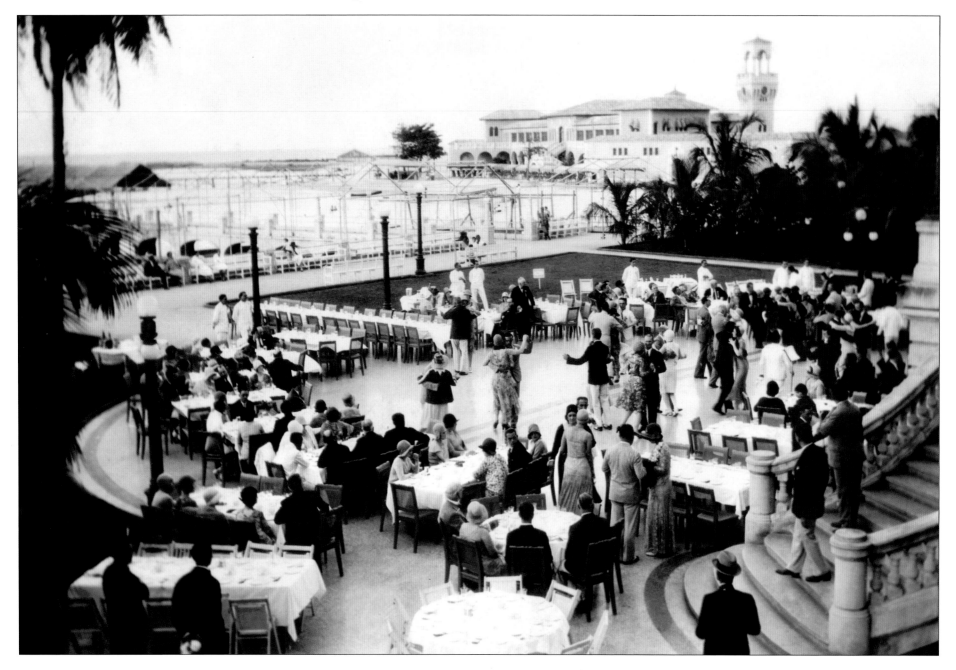

The Havana Yacht Club offered its members and guests many forms of entertainment. The building contained billiards rooms, restaurants, cafés, and large rooms for holding dances and parties. In summer, after relaxing on the beach or sailing, members could then attend events held on the grounds. These were very popular with the younger members, who made the most of every opportunity to do what has always been a favorite Cuban pastime: dancing. This photograph from the 1920s shows a Sunday afternoon dance.

In winter, the grounds of the club stand empty at all hours of the day and night. The outdoor patio where the dances were once held has disappeared and is now covered by the plants that make the building look inviting. The beautiful marble staircase can still be seen sweeping down from the first floor.

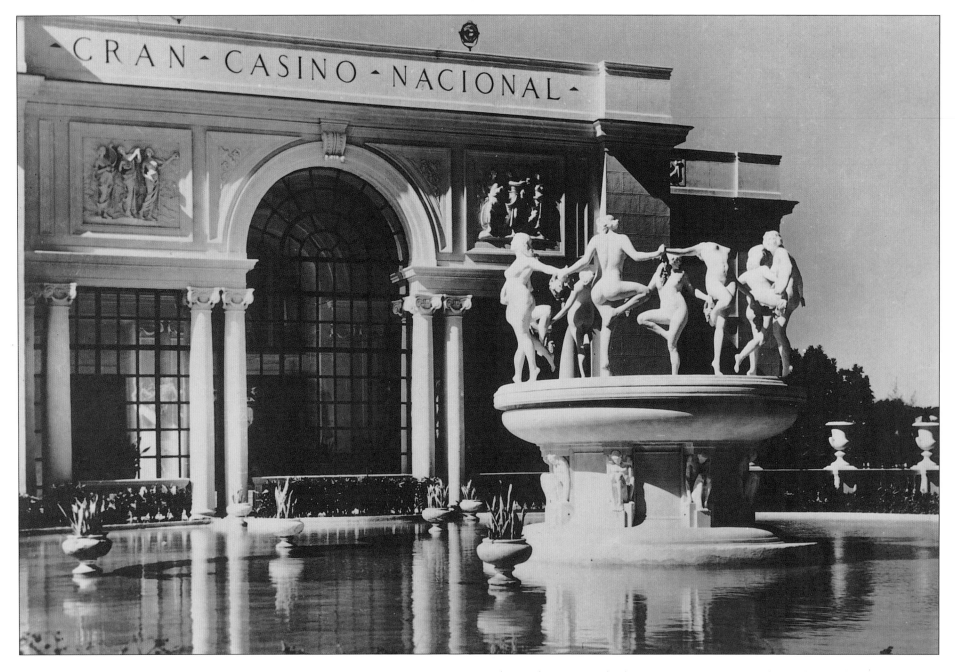

This sculpture outside the Gran Casino Nacional was the work of the Italian artist Aldo Gamba, who designed various sculptures around the city. It shows a group of women positioned around a fountain, dancing in different poses, and was designed to preside over the entrance to the casino opened at Marianao Beach in 1920. When the building was expanded in 1928, the fountain remained at the main entrance beside the grand circular driveway.

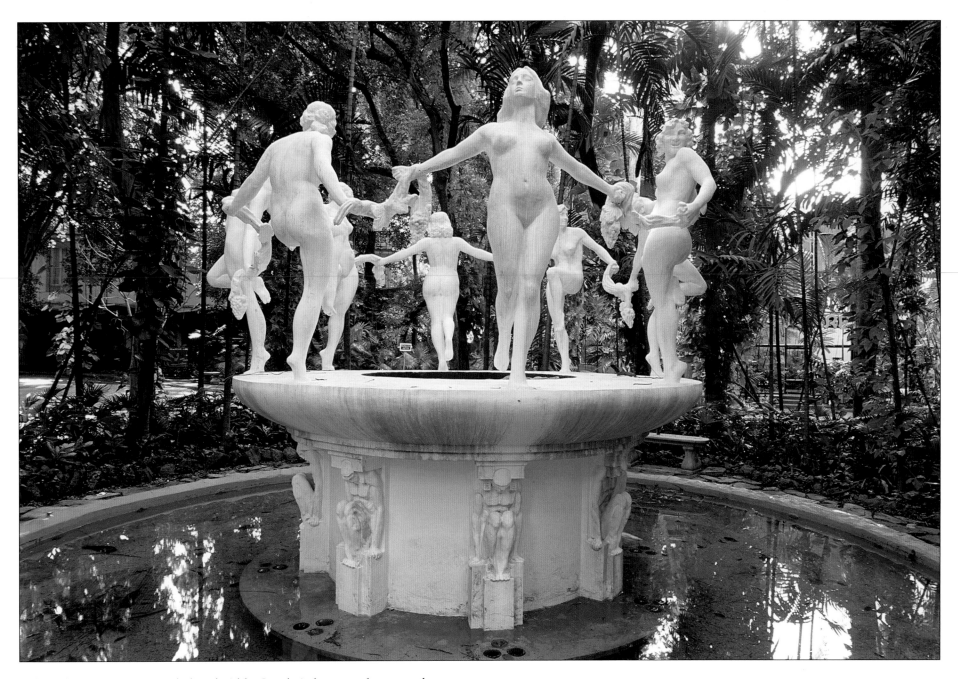

When the Casino Nacional closed, Aldo Gamba's fountain featuring dancing women with intertwined arms was transferred to the famous Tropicana nightclub. Opened in the 1950s, it became one of the most popular venues in the city. Nat King Cole sang there, as did other popular artists of that era. The fountain can be found at the main entrance and fits in well with its new surroundings.

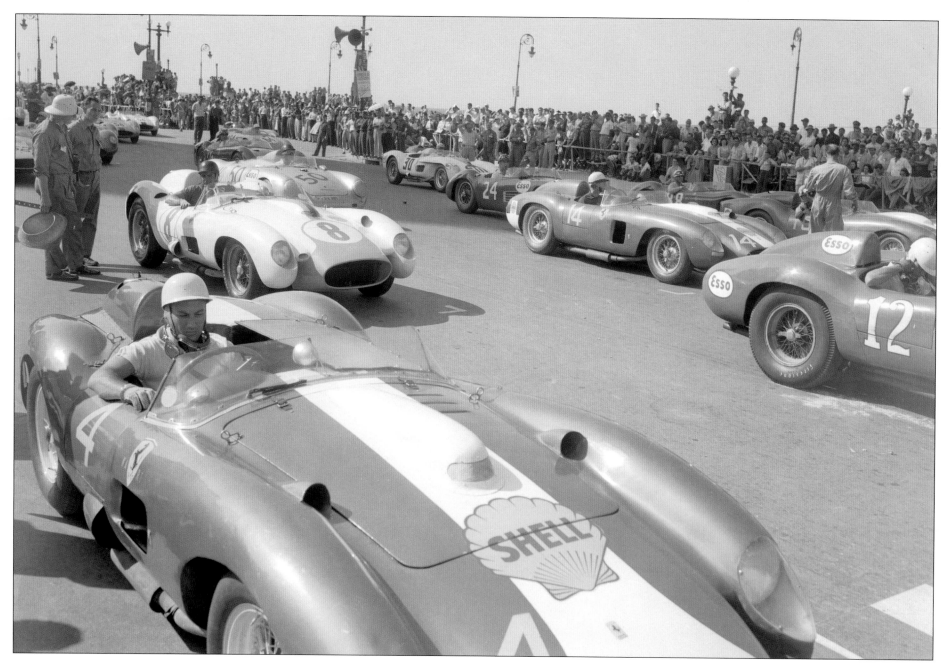

Despite the poor condition of Cuban roads, car racing was popular in the country from the turn of the twentieth century. Events of this type were common on the few roads that had been surfaced. Over time, the number of races increased, the most famous being those from Guanajay to Havana that ended on the Malecón. In 1958, the Havana Grand Prix—a 310-mile race— suddenly gained notoriety when its most famous participant, Juan Manuel Fangio, was kidnapped by revolutionary forces attempting to draw the attention of the world's press to the Cuban struggle against Batista. In the foreground is Britain's Stirling Moss, who avoided kidnap. The race had to be cut short when a car skidded into the crowd, killing several spectators.

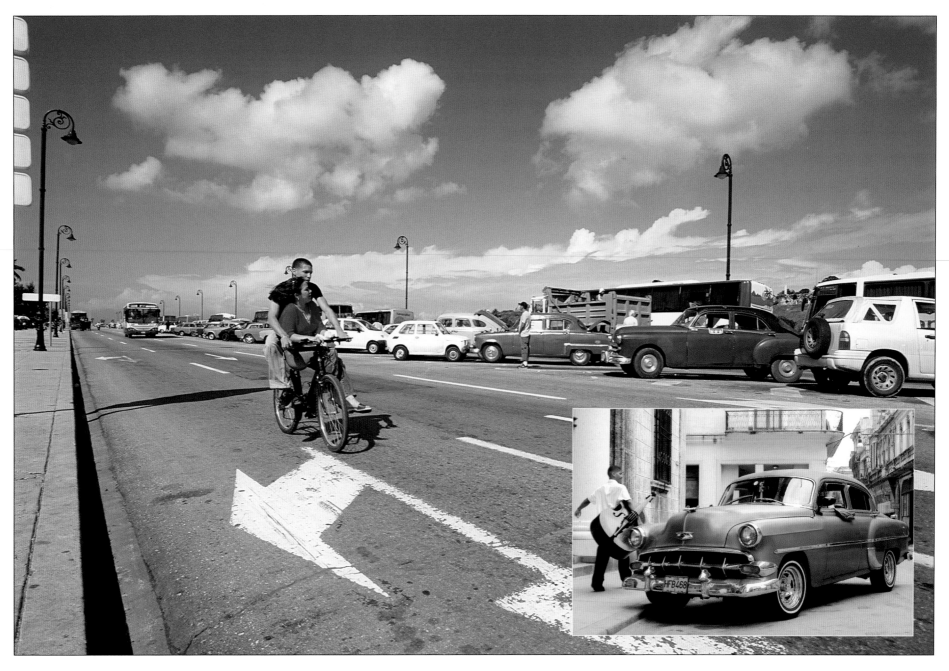

After the 1959 revolution, the car races died out, but today young people organize secret races on the outskirts of the city. Historically, Havana was always a city where the latest car models could be seen. The first car arrived on the island in 1898 and Fiat was the first company to break into the Cuban market. When World War I brought the importing of European cars to a standstill, American automakers flooded the market. According to the press at the time, in 1920 there were approximately 15,000 cars on the streets of Havana. Today the city has little traffic, but much of it is made up of cars from bygone years. Soviet Ladas (inset) can be seen alongside classic American cars of the 1940s, 1950s, and 1960s.

The house on the Finca la Vigía was Ernest Hemingway's Cuban home. Located in the heart of San Francisco de Paula, a small village about nine miles from Havana, the history of the house harks back to the nineteenth century, when the Spanish used it as a barracks. It was then owned by a succession of families until the writer rented it in 1939 and bought it the following year. He would only leave the house to visit Cojímar, the fishing village that inspired him to write *The Old Man and the Sea*, or to sit in La Bodeguita or El Floridita sipping daiquiris while writing in his notebook.

The house lay empty for a number of years after Hemingway's death in 1961. In 1964 the state turned it into a museum in his honor. The Hemingway Museum is now one of the most popular destinations for visitors to Havana. The museum comprises the house and all its gardens, which are preserved in their original state. The writer's habits and literary and artistic tastes are reflected in the objects contained in each of the rooms. His collection of bullfighting memorabilia, his magnificent library, numerous personal effects, and even his dogs' graves at the side of the house can all be seen. Hemingway's memory is cherished by all Cubans and in particular by the fishermen from Cojímar, who paid for a bust of the writer with their meager savings.

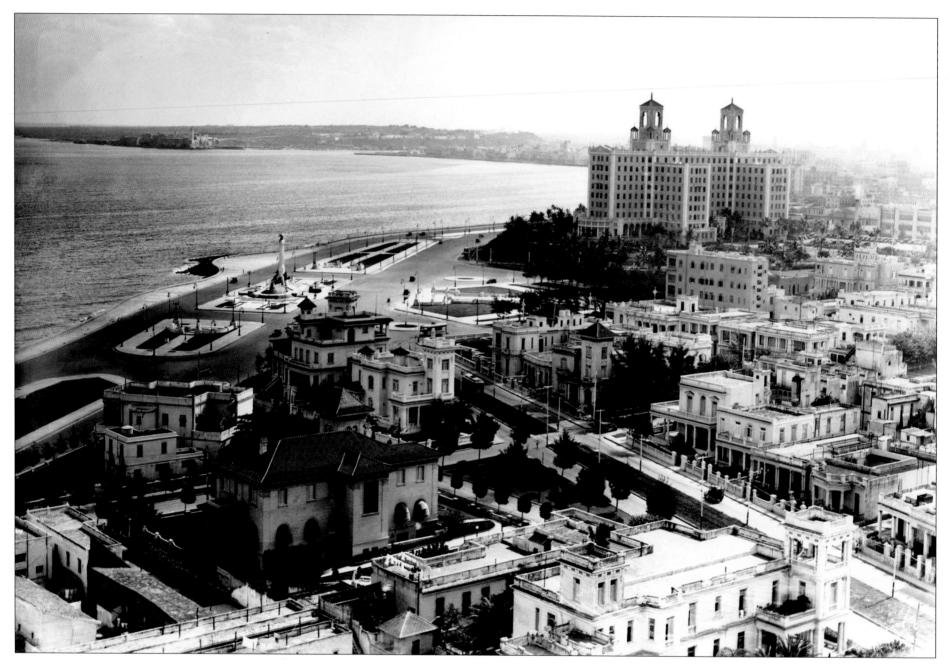

By the 1930s, El Vedado was the most exclusive neighborhood in the city and was a symbol of the new era of prosperity that Havana was enjoying at this time. Here, the old houses were replaced by grand palaces owned by the nouveau riche looking to make their mark in the area. At the time of this photograph, the area was at its peak. Its entrance had been enhanced by the park and a monument to the crew of the USS *Maine* on the Malecón, and by the recent opening of the modern, twin-towered Hotel Nacional. It was the hotel of choice for celebrities and many show-business figures, such as Buster Keaton, Ava Gardner, and Marlon Brando, stayed there. In the 1930s, Havana was a haven for tourists attracted by the climate, culture, and architecture.

In the 1940s, Miramar replaced El Vedado as the area of choice for wealthy Cuban families and by the 1950s it was the most fashionable suburb. However, at this time skyscrapers became prevalent and El Vedado once again rose in popularity as the skyline changed. Their luxurious apartments commanded spectacular views of both the city and the coast. These buildings were notable for the modern techniques used in their construction, the best example of

which is El Focsa, still the biggest apartment building in the country. The Hotel Nacional remains in the same spot and the celebrities that come to Cuba still like to stay there. It retains its ancient grandeur and has a celebrities' bar, where there are pictures of famous people who have stayed at the hotel. Havana has recently enjoyed a boom in tourism again, with new visitors attracted by the city's unspoiled charm.

INDEX